Sirens

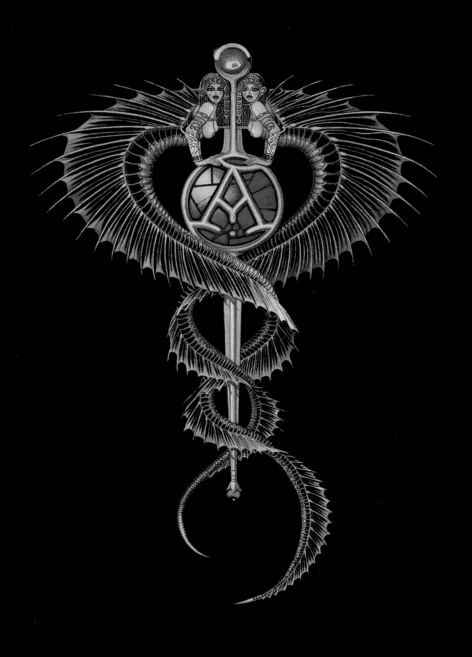

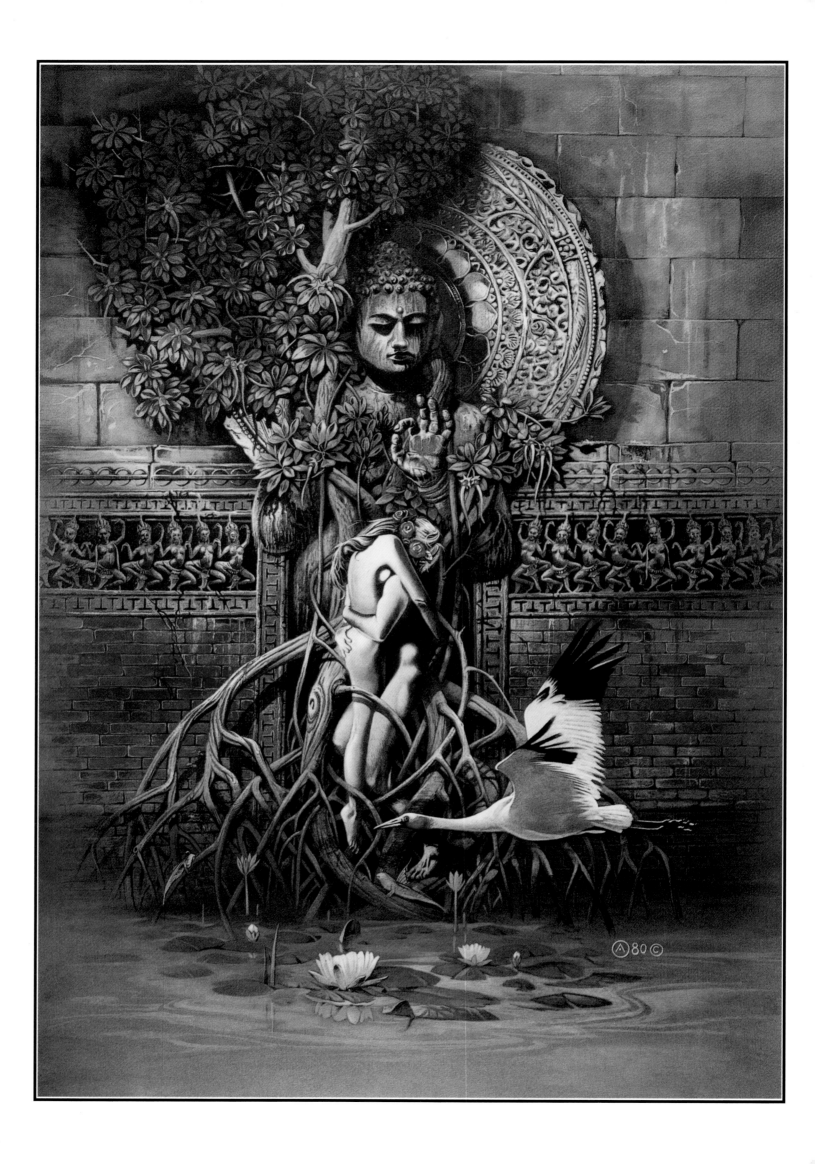

Sirens

The second book of illustrations by
Chris Achilleos
Text by Nigel Suckling

Anna 1980

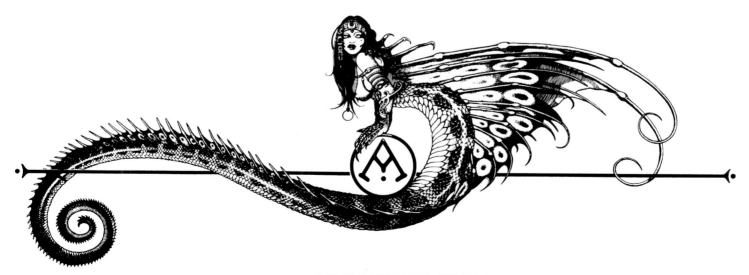

FOUNDRY
PUBLICATIONS

Sirens

Compiled and designed by Chris Achilleos
Text by Nigel Suckling
Foreword by Ray Harryhausen

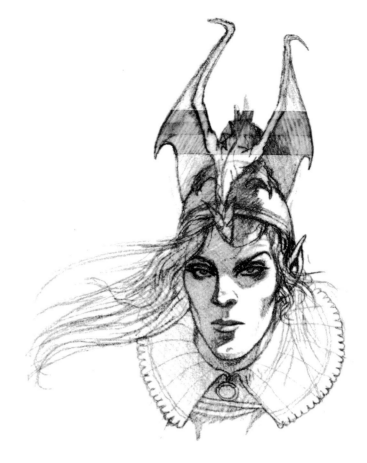

Published by:
Foundry Publications Ltd
The Foundry
24-34 St Marks Street
Nottingham NG3 1DE
Great Britain

First Edition 1986
Reprinted 1991, 1992, 1993, 1994
First Foundry edition 2000

Limpback : ISBN 1 903676 01 0

Printed and bound at SAF - Tiskarna Koper,
Slovenia, www.safcomics.com

FOUNDRY
PUBLICATIONS

(page one) Personal monogram design 1982
50 × 40 cm.

Waterproof inks, gouache and airbrush on
watercolour board.

(page two) LOVERS 1980 72 × 51 cm.
Illustration for book cover.

Watercolour and gouache on coloured stretched
paper.

A complicated design but enjoyable to paint.

(previous page) Personal letterhead design.

(above) Study of ELRIC's head for the painting
on p. 56–57.

Graphite on tracing paper. S/S to original and
painting.

My interpretation of one of Fantasy's most tragic heroes.

(overleaf left) EAGLE MONUMENT 1981
64 × 40 cm. Illustration for book cover.
Previously unpublished.

Waterproof inks and gouache on watercolour
board.

*This was done to appear together with the STARSHIP
CAPTAIN on p.73. The figure would stand under the
Eagle and the lettering appear in the blank above.*

(overleaf right) Detail from REBEL RAID
p. 46–47.

To my mother

Nothing that is really good can be got without labour and hardship, for so the gods have ordained.

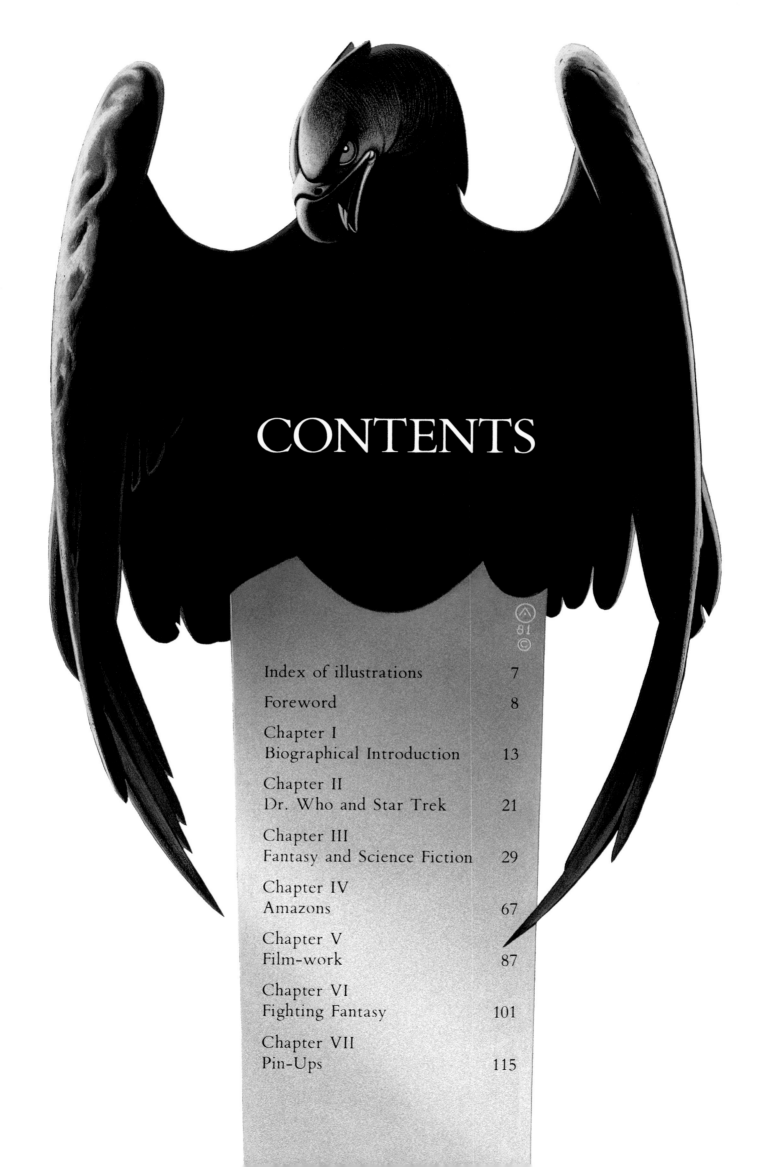

CONTENTS

Index of Illustrations

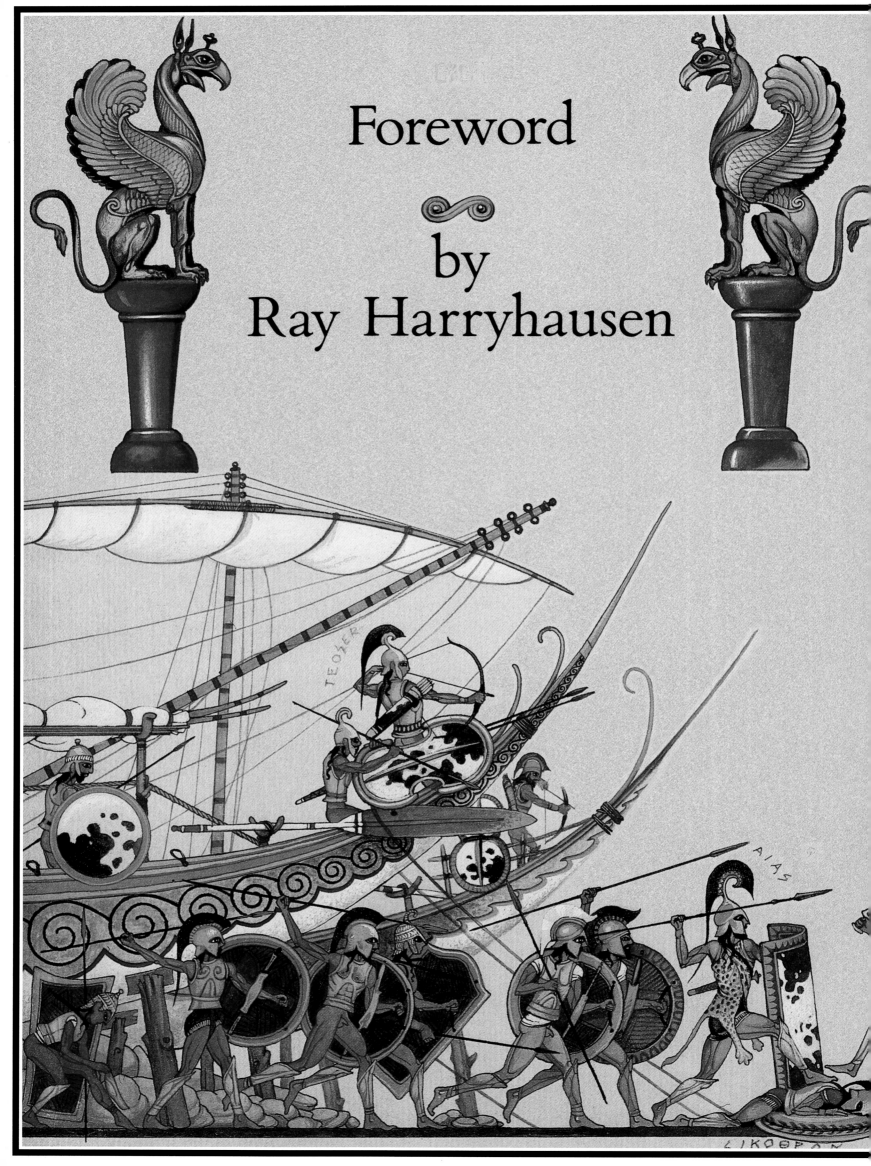

Foreword
by
Ray Harryhausen

The art of illustration goes far back to our pre-historic heritage of the cave man days. Early man found during the dawn of history that he could communicate to others of his species, by the use of drawings, his thoughts and interpretations of the world around him.

"One picture is worth a thousand words" is a statement that has haunted me most of my life. As a young boy I used to sit for hours riveted to the illustrated books of dinosaurs as restored and painted by Charles R. Knight. The engravings of Gustave Doré and John Martin, with their mysterious use of light and shade and dramatic grouping of crowds, had a grandeur about them that appealed to my Gothic, Germanic background. This influence, at an early age, still makes me prefer to do my pre-production designs for films in tones of black and white rather than glorious colour. I was fortunate indeed to become a part of the ultimate in moving illustrations, the motion picture.

As a rule, anything that has to be produced in three dimensions has to first be conceived as a two dimensional drawing. Early in film history

the makers realized how important it was to go to the trouble of making continuity drawings as well as detailed sketches of key sequences. Willis O'Brien went to great lengths, with his *King Kong*, to first realize the production values in the form of magnificent sketches, in two dimensions, before plunging into the long and tedious process of animation. He had Byron Crabbe and Mario Larrinaga render large and exciting dramatic concepts. Cecil B. De Mille always stimulated his writers and crew with highly visual versions of the essence of his picture before he went into actual production. Even long after a film is completed the two dimensional theatrical poster is an important factor in making the public aware of the picture's content.

In today's book market of thousands of paper backs, a good, powerfully illustrated cover on a series of sometimes mediocre stories, can stimulate sales galore. Men like Frazetta, Boris, and Achilleos have devoted their whole life to producing two dimensional concepts of the inner workings of the imagination. It is their job to paint a visual concept that will capture the es-

sence of the many thousands of printed words inside. The illustrator's job is also to titillate the potential buyer into taking a chance on a story or writer he may never have heard of before.

It is a profession that not only requires an intellectual and analytical approach, but a strict discipline in learning and perfecting techniques which are best able to transfer the invisible idea, or concept, into a concrete image of artistic soundness.

Aside from the monetary aspect, these men do their job, obviously, because they love it. Inspiration can really only come if you are in love with what you do. Chris Achilleos's drawings reflect that great love of visualizing the unlimited vistas of the world of fantasy.

Ray Harryhausen

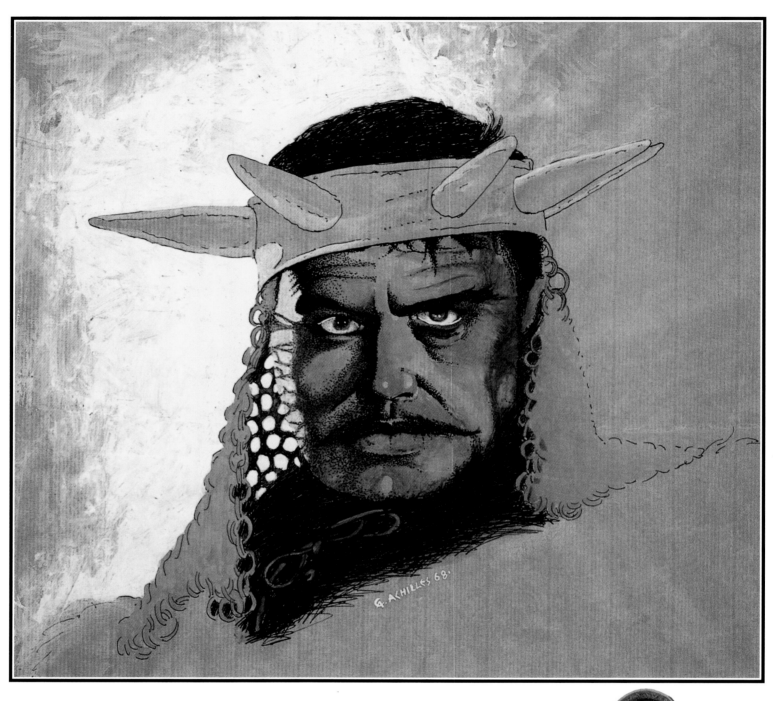

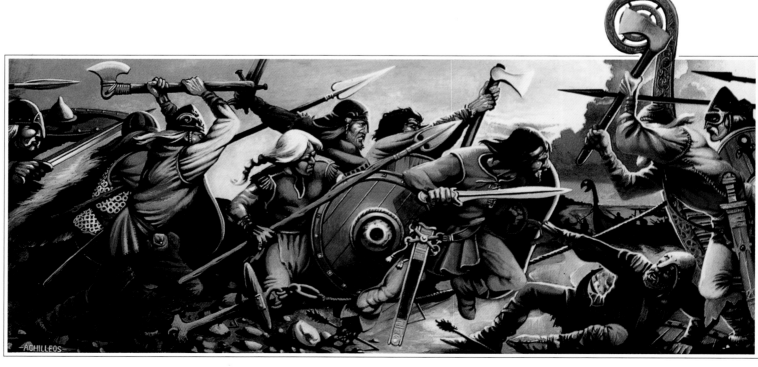

Chapter I
BIOGRAPHICAL INTRODUCTION

(pages 8–9 and 10–11) THE MYCENAEAN EPIC OF TROY 1982 printed same size.

Ink-line and watercolour on coloured paper.

A chapter heading design for a personal project to compile and illustrate the complete story of the siege of Troy 1225 BC.

(above left) Orson Welles as MACBETH 1968 28 × 27 cm. Collection Mr & Mrs Blandon.

Ink-line and gouache on brown paper bag.

One of my favourite memories of art college is of the outdoor classes. During one of these on the Thames Embankment I came across a picture of Orson Welles as Macbeth and the only thing I had to paint on was the wrapper of a Rolling Stones LP.

(below left) THE DAWN VIKING RAID 1971 49 × 26 cm. Illustration for book-cover. Collection Mr & Mrs Isaac.

Gouache on watercolour board.

One of my favourite covers from the Brian Boyle Studio days, from a series of four to which I gave a wrap-round uniform cover design.

(above right) REDHEAD 1966 59 × 42 cm. A home exercise.

Oils on hardboard.

1947 Chris Achilleos was born in Cyprus and grew up in the countryside with few influences beyond his immediate environment. He had little contact with Western culture but it is significant that the few contacts he did make still shine in his memory; such as school expeditions to Famagusta to see *The Ten Commandments* and *Alexander The Great* at the cinema, and bubble-gum cards of Hollywood Cowboy heroes with unpronounceable names which inspired endless cowboy and Indian battles among the Cyprian orange groves.

More perilous games were played with the British Army which was occupying the island at that time, curfew dodging was one favourite and raising national flags to annoy the troops. Fantasy and reality almost collided on one occasion when Achilleos was mistaken for a sniper on a church tower and suddenly found himself the target for real guns. Luckily for him and us he was a nimble lad.

He had little to do with art as a child but there was one hint of his future calling in the shadow-puppet theatre he and his friends created, charging their audiences a penny or a potato to see the show. He remembers the details vividly still, the scavenging of precious cardboard and coloured cellophane from his grandmother's grocery shop and hingeing the puppets' joints with melted nylon comb-teeth; but at the time it would have taken a prophet to recognise that this was more significant than any of his other activities. Art only became an abiding obsession after his family's removal to England in 1960.

1960 The reasons for this were various but mostly because his father had died some years before and his mother felt better able to provide for the boy and his three sisters abroad. Achilleos had spent nine months in England in 1958 but still it felt like being transported to an alien and hostile world. Not only did the weather seem malevolent after sun-baked Cyprus but London was a brick and concrete nightmare where often you could hardly see where you were going for the fog. Worst of all for a child of twelve, the natives were hostile for no reason other than that the family was foreign.

From its former spaciousness, home shrank to a tiny two-bedroomed flat with surly neighbours. School became a vast Comprehensive where Achilleos was put in the lowest possible form and given baby books to teach him English. The journey between the two was a Wild West venture through enemy territory but with greater stakes than in the games he had

played with his friends. In the face of this hostile environment Achilleos' imagination turned inwards.

There was one consolation for the sudden shattering of his private Golden Age — the wealth of visual entertainment now available to him. Television and comics opened doors to new worlds where language hardly mattered.

Comics particularly captivated him as they were then at the height of their flowering in Britain. He eagerly devoured all that came his way but, as with so many boys of his generation, the *Eagle* was his favourite and Frank Bellamy became one of his first artistic heroes. Soon he began seriously to try his own hand at drawing.

From its initial grimness, life at school gradually improved; the bullying eased as friends were made and the strange tongue and alphabet were laboriously tamed. Tamed but not happily mastered and Achilleos concentrated his efforts on art and craft subjects where language did not matter greatly. It was somewhat to his own surprise that he eventually found himself in the sixth form taking A Level Art and being required to do little but paint and draw all day while the other sixth-formers staggered around with bursting briefcases.

Then he applied to art college, only to learn that he was unlikely to be accepted through the normal channels because he lacked enough of the required academic qualifications. However, there was a vocational course at Hornsey art college which might take him purely on the merits of his work.

It was one of those occasions where in retrospect one is tempted to see

(below left) ROBERT MITCHUM 1971 30 × 28 cm. Medium exercise. Collection Mr & Mrs Whitbread.

Waterproof inks and gouache on watercolour board.

This exercise proved very useful in the long run especially for the kind of work I have done for **Men Only** *mag.*

(centre) COMIC STRIP 1967 67 × 44 cm. College exercise.

Ink-line on watercolour paper.

An ambitious project of translating a novel **Tell Them In Sparta** *by Rodney Milton into comic strip form in the spirit of Frank Bellamy's Heros the Spartan strip in the Eagle comic; sadly this is as far as I got. Given the chance to continue perhaps I would still be doing this kind of work now. At this time Bellamy was my hero and I regret never having had the chance to express my admiration and love of his work to him personally before his untimely death.*

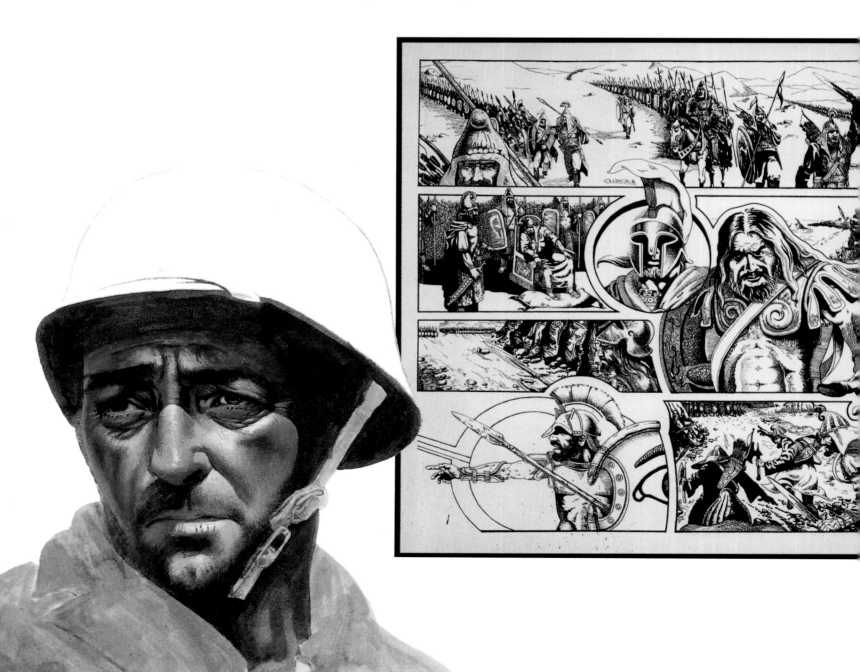

the hand of Fate tilting the balance of events because when he was called for an interview his school portfolio was away with another application. All he had of worth was the work he had done at home, comic heroes and villains mostly or cutaway drawings of aeroplanes and ships, often done on wallpaper because no other was large enough. It was this work which won him his place.

1965 For reaching Hornsey, which had a high reputation at the time, Achilleos gives much credit to the encouragement of his school art teacher, Hugh Gordon.

The broadly-based vocational course lasted a year, then he chose to specialise in Scientific and Technical Illustration because it seemed the only course that might teach him how to apply line and colour to a surface in order to create realistic images, how to become a good illustrator which was and is his central ambition. He was suspicious of Fine Art from the beginning, and still is.

However, his appetite for three-dimensional cutaway drawings of gearboxes and the like soon became jaded and his pen began to stray into more lively and familiar territory. An example of this, done in class time while his tutor Colin Rattray turned a diplomatically blind eye, is the comic strip shown on pages 14–15. The obvious force of his talent won him greater freedom as time passed and his tutors were proved wise in the end because he not only developed his own interests but managed to graduate from the course with high honours.

He now thinks this may have been helped by his already having had

(below right) THE ROMAN 1971
32 × 29 cm. Medium exercise. Collection
Mr & Mrs Blandon.

Gouache over flat transfer colour on line board.

Although satisfied with the result I saw little point in sticking down flat colour when I could use coloured paper, which I have done since.

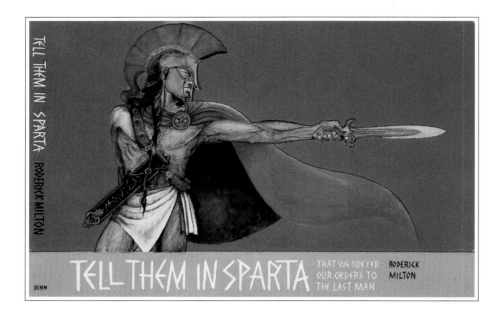

(left) TELL THEM IN SPARTA 1967
53 × 30 cm. College exercise. Collection
Mr & Mrs Isaac.

Gouache on watercolour paper.

This was my first chance to attempt a book-cover illustration, so I again used my favourite book of the time.

some work published on the cover of a best-selling book.

1968 This project introduced to him by Colin Rattray, was to help illustrate a book published by the newly formed Mitchell Beazley to accompany the first American space mission to the moon. *The Moon Flight Atlas* with text by Patrick Moore. It proved a fair blooding for a would-be technical illustrator because the book was produced at a shattering, round-the-clock pace but somehow he survived the initiation and is proud of never yet having missed a deadline for an illustration. Well, almost never.

1969 On leaving college Achilleos was recruited for a proposed encyclopedia to be published in weekly parts, but it never came to fruition and after a few months of rather aimless activity he was turned out into the world.

This was a nervous time as he was due to marry his girlfriend Angie soon. For a while he struggled with moderate success as a freelance technical illustrator, doing more work for Mitchell Beazley amongst others, but then an old ambition resurfaced — to illustrate book covers. Looking around the bookshops he felt sure he could do better and so rang Tandem Books to inform them of this. They rather kindly put him onto Brian Boyle Associates who supplied their covers and on the strength of his portfolio he won a commission for a short series of covers which marked the beginning of a long association, first as a direct employee and then as a freelance.

With Brian Boyle he learned under pressure all the different aspects of cover design, lettering and layout as well as illustration, as generally he was entrusted with a job from start to finish. It was a time he enjoyed despite the hectic pace of life at the studio, but after a while changing circumstances forced him to go freelance again. By this time he was married and had gained a daughter, Esther, so it was with some relief that he joined the *Arts Of Gold* studio in Covent Garden in 1972.

1972 Here he was a general illustrator which meant doing any work that came along — advertising, lettering, photo retouching or whatever. Through an associated agency, *The Illustrators*, his work was introduced to *Men Only* magazine, a connection which remains to this day and is largely responsible for the series of pin-ups for which he has become as renowned as for his fantasy illustrations.

Meanwhile, he was still freelancing for Brian Boyle who gave him a commission for the first three pilot *Dr Who* book covers. Another commission was for the Edgar Rice Burroughs *Pellucidar* series.

Two tragedies happened at *Arts Of Gold*. A personal one was a fire at the studio which destroyed much of Achilleos' early work. The second was the death of the studio's founder and boss, Clive Burroughs, in a motorcycle crash in 1975; after which the company was disbanded. Achilleos went freelance again and has remained freelance ever since.

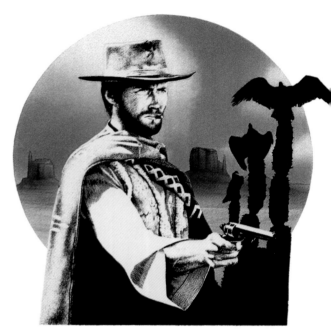

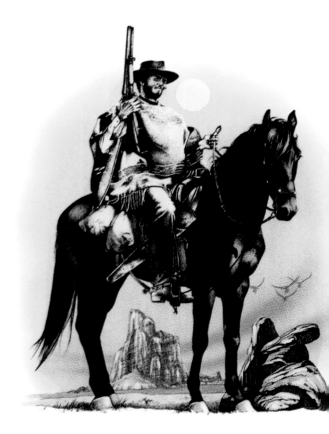

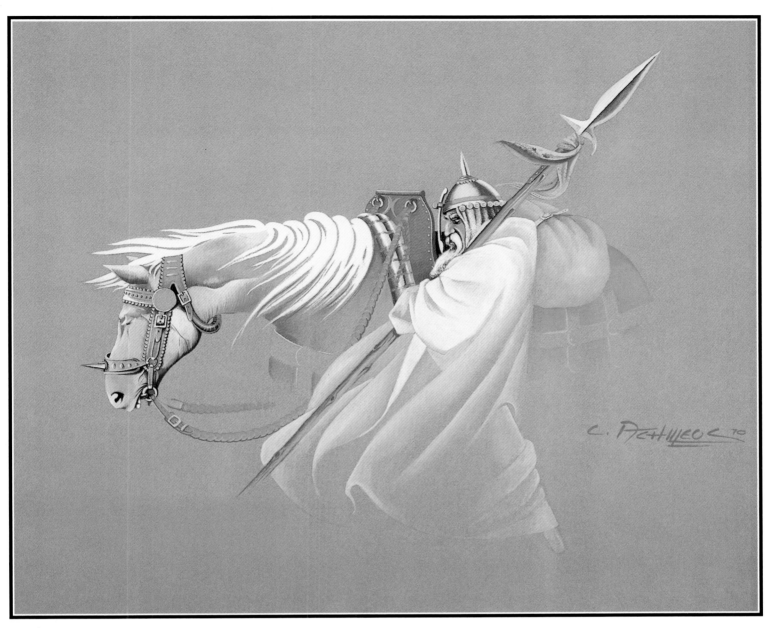

(above) THE OLD CRUSADER 1970
55 × 44 cm. Medium exercise.

Watercolour and gouache on stretched coloured paper.

My first of many pictures done on coloured stretched paper. Note the adolescent search for an arty signature.

(left) THE MAN WITH NO NAME
A. 1974 29 × 27 cm. B. 1974 53 × 30 cm.
Illustrations for book covers. Collection
Mr & Mrs Isaac.

Ink-line, waterproof inks and airbrush on line board.

Altogether I must have done at least ten of this series based on the Clint Eastwood spaghetti Western films.

In the next two years some of his major commissions were for the *Scorpio* series by Alan Burt Akers, two trilogies by Robert E. Howard, the *Gor* and *Raven* series and a few unconnected Michael Moorcock books. But his main work was with the *Dr Who* books which were now appearing at monthly intervals and taking up a full quarter of his time. To begin with this was welcome but as success came in other fields of cover design he felt a growing pressure to move on. This he did in 1977, a ferociously busy year in which he also gained a second daughter, Anna.

1977 It is Achilleos' opinion that the years 1977–78 marked the high spot of Science Fiction and Fantasy publishing, a period when anything in the genre was rushed into print almost regardless of quality; a recklessness which was to have its backlash, but for an illustrator at the time it was exhilarating.

In 1977 Roger Dean approached Achilleos on behalf of Dragon's World with the proposition of collecting his work into a book. He was very doubtful to begin with about whether he had enough material but by the end of the year his portfolio was bulging with new work. Almost a quarter of the pictures which appeared in the book *Beauty and the Beast* were done in that year.

To date *Beauty and the Beast* has sold over a hundred thousand copies and has appeared in four different language editions. Achilleos' one reservation about it is that it does not show the full range of his work at the time.

1978 The book's publication was a landmark in Achilleos' career but the consequences were not quite what one might have expected. There came no rush of interesting commissions; rather the reverse. The telephone began to ring ominously less often. His fame was spreading at home and abroad

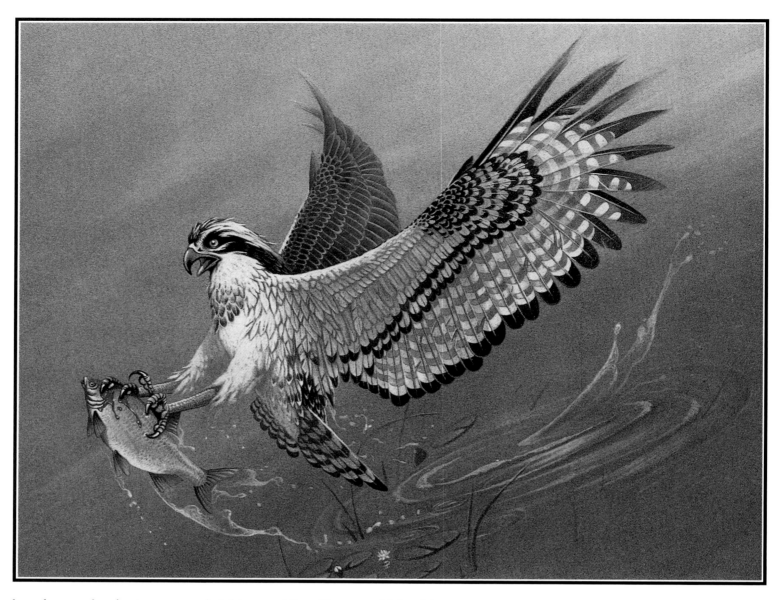

but day to day business was shrinking rapidly. He now thinks this was partly because he grew too self-indulgent at this time and tended to exceed or stray from the limits of his commissions. His pictures took on a much grander scale and therefore took more time, but they were not what his clients expected. He wanted to work on a grander scale but there was simply not room for it in the book-cover or magazine illustration field. Whatever the merits of the paintings in themselves, they did not suit the purposes for which they had been commissioned. Two examples of this are *Shipwrecked Fugitives* (page 33) and *Lovers* (page 2).

But it was not only possible self-indulgence that caused problems at this time, there was also a slump in the British Science Fiction book market. This despite the start of a boom in SF films led by *Star Wars*. Books slumped and suddenly publishers seemed to become intent on trying to disguise their Science Fiction as something else. Achilleos and many other illustrators suddenly found themselves out of favour, particularly those specialising in space hardware.

In compensation, second rights of his covers were selling well in Europe and he was mentioned favourably in an *Encyclopedia Of Science Fiction* published by Octopus Books in 1978. Also his work appeared in magazines like the French *Metal Hurlant* and the American *Heavy Metal*, but for a while he almost stopped producing any new SF work.

1979 At home he was still in demand with *Men Only*, who have seen him through several lean periods, and there were other demands for his pin-ups. In 1979 a portfolio of them was published under the title *Amazons*, examples of which are shown in a later chapter.

A commission he would love to have accepted was for a mermaid to appear in a calender, the result of a short-lived and unhappy liaison with an agency.

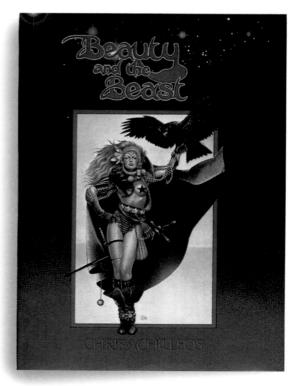

(top) THE OSPREY ATTACK 1978
54 × 42 cm. Illustration for a Dutch magazine. Private collection.

Painting nature is always a pleasure and I try to fit it in whenever possible.

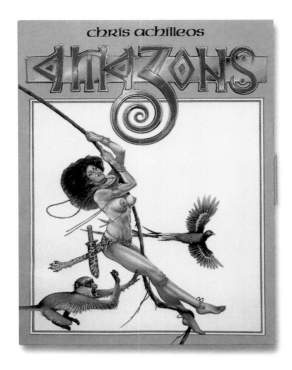

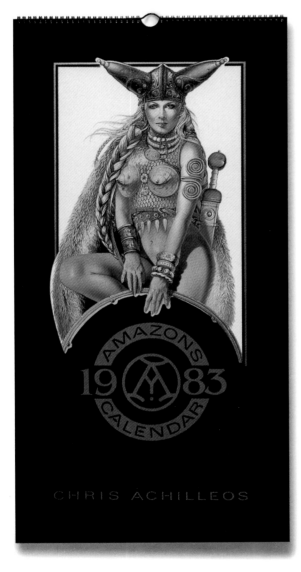

(opposite below) The book BEAUTY AND THE BEAST publ. 1978 by Paper Tiger.
(above) The portfolio AMAZONS publ. 1979 by Paper Tiger.
(below) The calendar AMAZONS publ. 1982 by Iguana.

The chance had to be turned down because the clients insisted on keeping the original artwork. Although he needed the commission, Achilleos offered to slash his fee and so in effect buy his own artwork back but they remained adamant.

1980 However, he did gradually become drawn into the film world, first through book covers such as the Clint Eastwood *Dollar* series and then through promotional work on films themselves. His first major commission was for the animated film *Heavy Metal* in 1980, contributing to the design of characters as well as producing the final promotion poster shown on pages 88–89.

Also at this time he began to do graphic work for an old college friend, Roland Blunk who recognised that he was more than just another Fantasy illustrator. In this work he uses a highly realistic style not often associated with his name, producing some of his finest airbrush paintings which unfortunately there has been no room to include in this book.

In the period 1981–83 Achilleos was kept busy with pin-ups (in which Science Fiction elements were now taboo), various advertising projects, mostly non-SF book covers and video cassette covers. Some film promotion work came his way and Scandecor produced posters of two of his Raven pictures. One of these, *Standard Bearer* (page 74) later appeared as a jigsaw puzzle after the discreet addition of a top to her costume. An *Amazons* calendar was published and, having more time on his hands than before, Achilleos began some samples for a still unrealised dream of illustrating the *Iliad*.

1983 On the whole this was not a very happy period, with many projects which came to nothing and little demand for his Fantasy work, but in 1983 Kate Bush paid him a compliment by adapting one of his Raven costumes (the one appearing on the cover of *Beauty and the Beast*) for a video recording and some promotional material.

Another compliment was his being featured in the Orbis *Advanced Airbrush* book as an example of one of the best airbrush artists in the country, examining his technique and showing some of his work.

This year also saw the beginning of a revival of interest in his Fantasy skills with a commission for the covers of a series of *Startrek* books.

1984 The momentum gathered pace in the following year after his introduction to Ian Livingstone of Fighting Fantasy fame. *White Dwarf*, the role-playing game magazine, began featuring his pictures on the cover and he also supplied covers for the Livingstone books published by Puffin. Since then he has branched out into other aspects of the genre.

1985 In the same vein, 1985 saw the appearance of *Out of the Pit*, a Puffin book by Steve Jackson and Ian Livingstone featuring 250 monsters from the worlds of Fighting Fantasy for which Achilleos did the cover and some inside work.

Also he began work on this book, which he has compiled and designed as well as supplying new pictures, and is due to start work on Jeff Wayne's new project *Spartacus* for which he is supplying artwork for the record sleeve and inside booklet cover.

The immediate future for Achilleos looks lively, with the impending publication of a series of portfolios of his *Dr Who* covers, some 3-D models of his characters and, more bizarrely, a probable book showing tattoos based on his pictures plus some original designs.

For the long-term future Achilleos is keen to become more closely involved with the film world, which he sees as the ultimate extension of the illustrator's art, would like to compile more calendars and thematic portfolios, and then there is his governing ambition of one day illustrating a book about the siege of Troy, about which more will be said later.

In a different vein, he would like to try his hand at teaching his skills to others, though only if he could do so on his own terms. To his mind too few of the realities of life as a working illustrator are taught in colleges. He would like to teach students some of what he has learned over the past fifteen years, to save them from also having to learn the hard way.

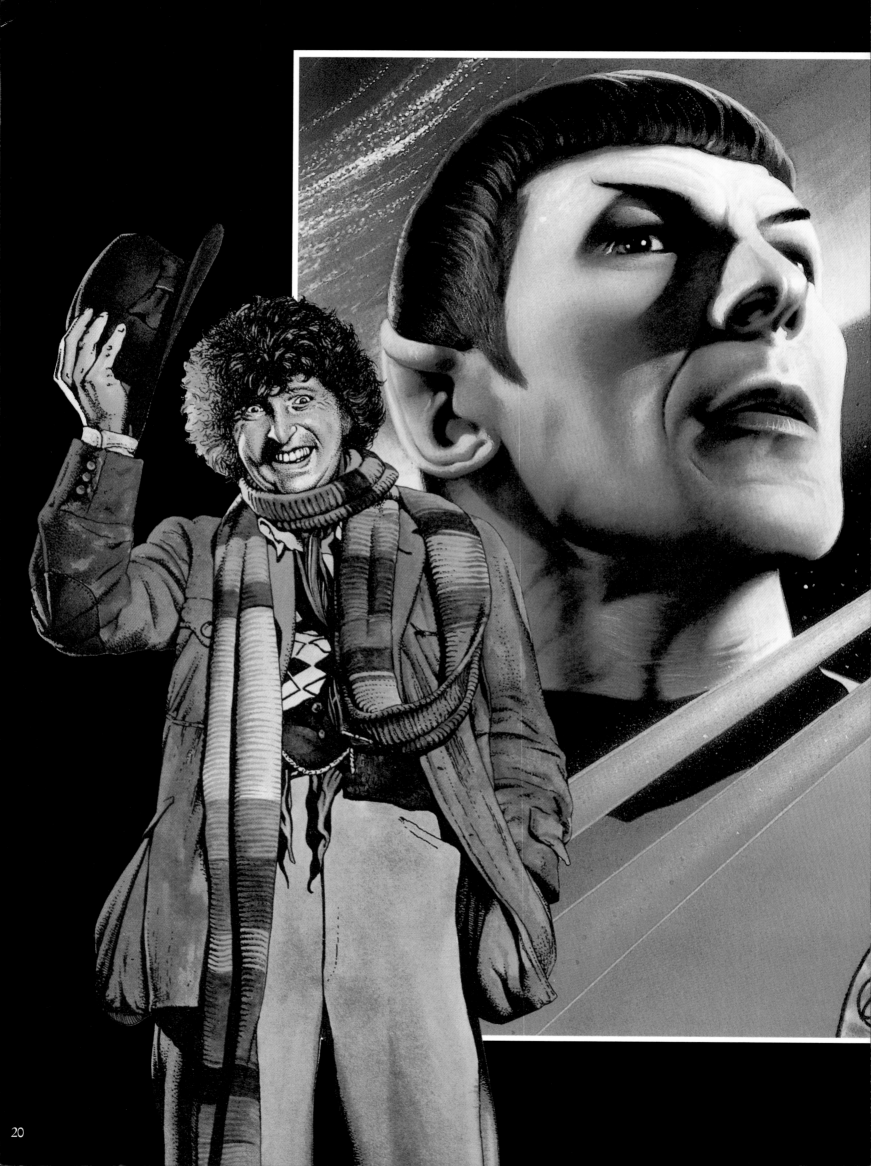

Chapter II

DR. WHO AND STAR TREK

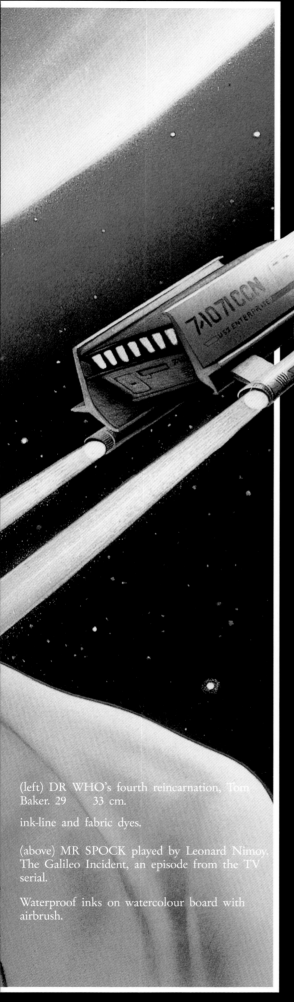

(left) DR WHO's fourth reincarnation, Tom Baker. 29 33 cm.

ink-line and fabric dyes.

(above) MR SPOCK played by Leonard Nimoy, The Galileo Incident, an episode from the TV serial.

Waterproof inks on watercolour board with airbrush.

Achilleos remembers the first appearance of Dr Who on television fondly. He spoke little English at the time but he loved it, little imagining he would one day become intimately involved with the series.

His first commission for three *Dr Who* book covers came in 1973. By a curious twist of fate his early hero Frank Bellamy had recently done some illustrations of the show for *Radio Times* magazine and Achilleos was asked if he could produce something similar. It was not the only time this happened. On another occasion he was asked if he could produce work in the same vein as Frank Frazetta, who was also an early hero.

With Dr Who he struck gold and in the next few years produced over thirty book covers, becoming something of a cult figure in his own right with the readers. Letters came in by the dozen and there was even talk by the editor at one point of forming an Achilleos fan club; but pressure of other work forced him to move on in 1976.

Six years later and much to his surprise he was approached by the Dr Who Appreciation Society with the offer of a commission to produce a limited edition print to celebrate two decades of the series. Achilleos was somewhat wary at first, lacking reference material and feeling sure he must have been forgotten, but was bowled along by the enthusiasm of the Association's president, David Howe, and in the event the print run was sold out easily.

Now there is talk of a second print. Also a series of portfolios of Achilleos covers is due to make an appearance in 1986, published by Titan Books. The commemorative print is reproduced here on pages 24–25.

Further links with the show are the invitations he receives for signing sessions at Dr Who conventions.

Which of the Doctors does he find easiest to draw? Patrick Troughton and John Pertwee because of the cragginess of their faces. The hardest? Tom Baker, but not because there is anything wrong with his face. It is his hair that is the problem, too many tight curls.

Once established, the formula for the book covers became quite strict but in a few cases Achilleos managed to break the rules, as when he left out the Doctor's face or introduced comic-style lettering to indicate the croak of a pterodactyl. These aberrations were not very popular with the publishers but in his own opinion they help liven up the series.

Achilleos was also a fan of the other best known Science Fiction entertainment on television, *Startrek*, but his first involvement came only in

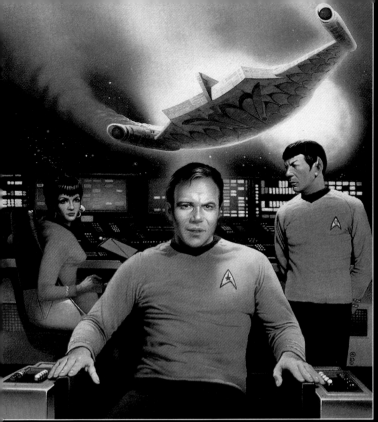

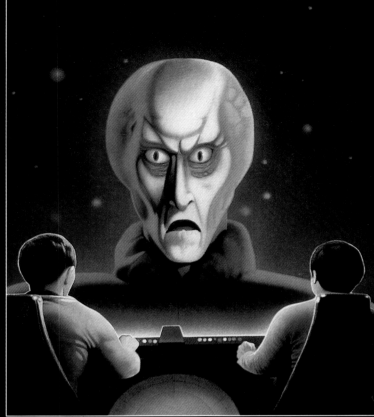

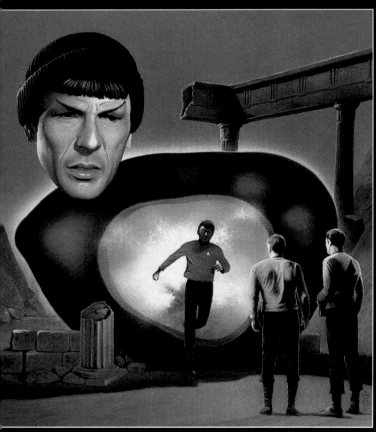

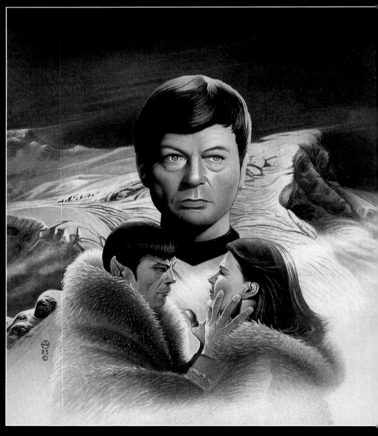

1983 when he was commissioned for the covers of a reissued series of twelve *Startrek* books, each containing several stories from the TV series. It proved a demanding job not only because of his own innate perfectionism also because of the howls of protest he knew would greet any mistake he made, justifiably in his view.

Another problem was the shortage of research material because the publishers could supply none of any use. He had a few tapes of his own but scarcely enough for the job. Luckily Titan Books put him in touch with an ardent enthusiast, Jean Donkin.

She came to his rescue with piles of tapes and printed material and a

(above left) BALANCE OF TERROR 1983
62 × 38 cm.
(above right) THE CORBOMITE
MANEUVER 1984 61 × 39 cm.
(below left) THE CITY ON THE EDGE OF
FOREVER 1983 61 × 38 cm.
(below right) ALL OUR YESTERDAYS 1983
62 × 38 cm.

(right) THE IMMUNITY SYNDROME 1984
61 × 38 cm.

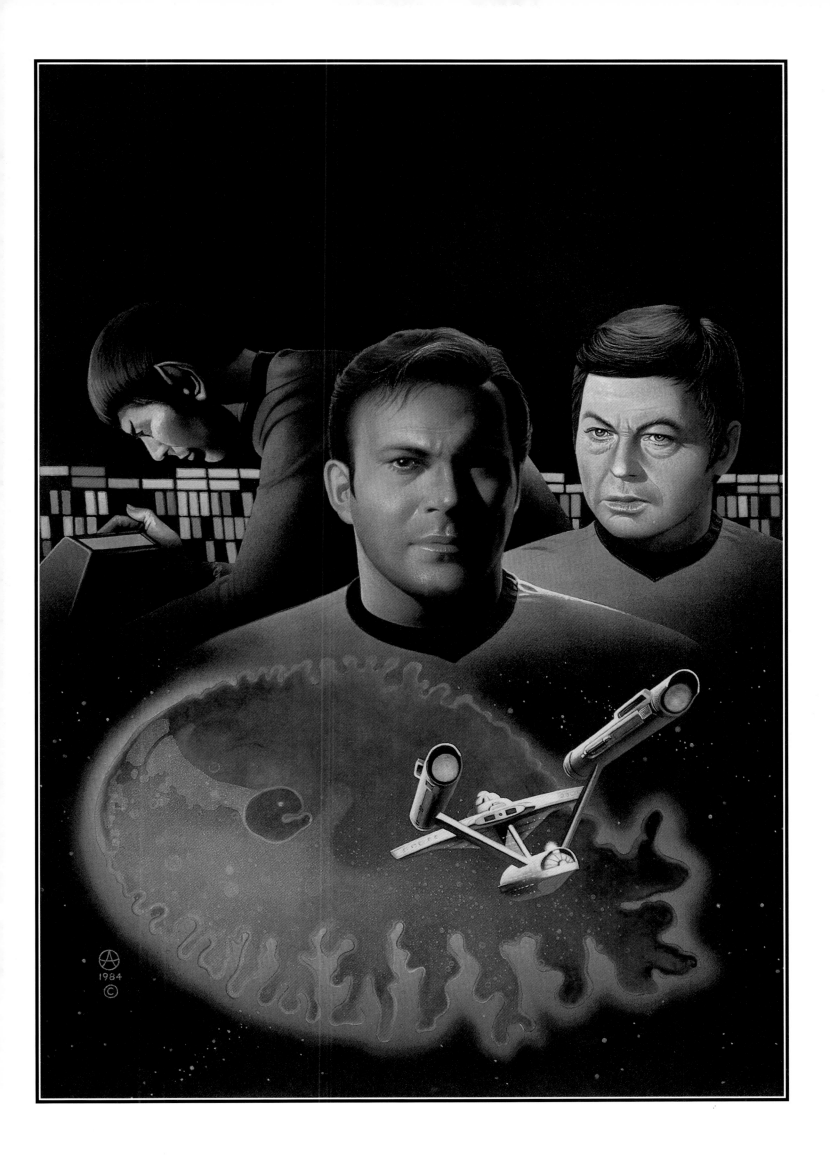

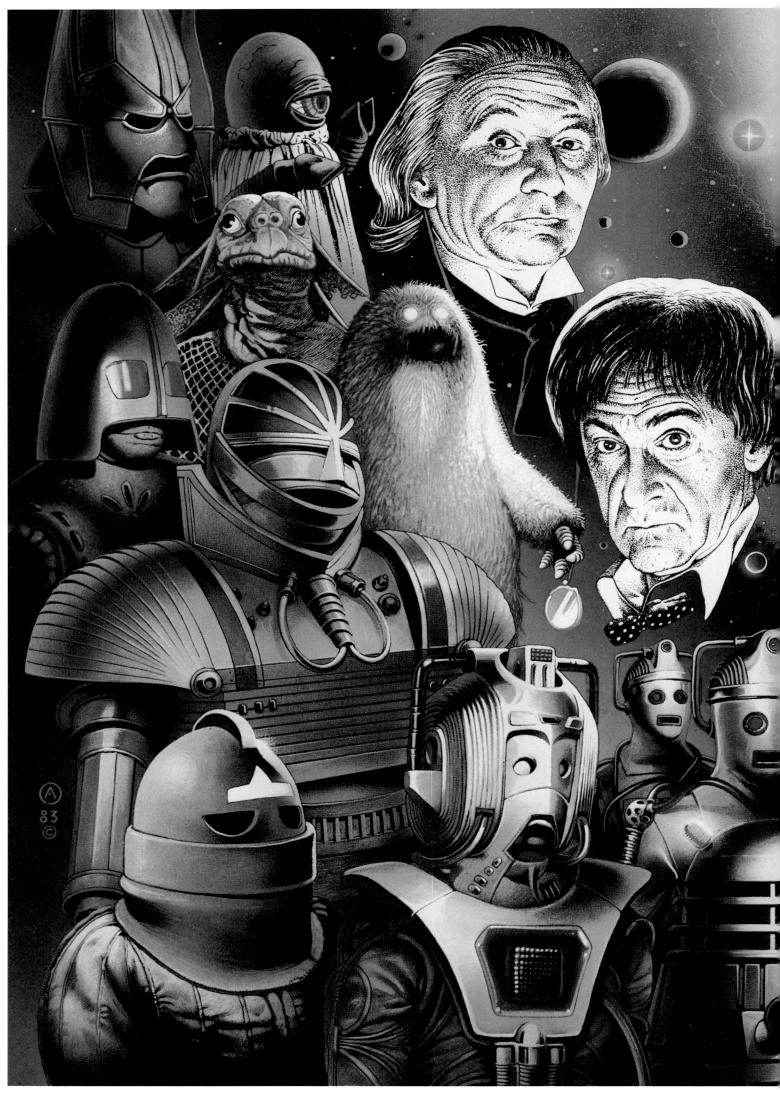

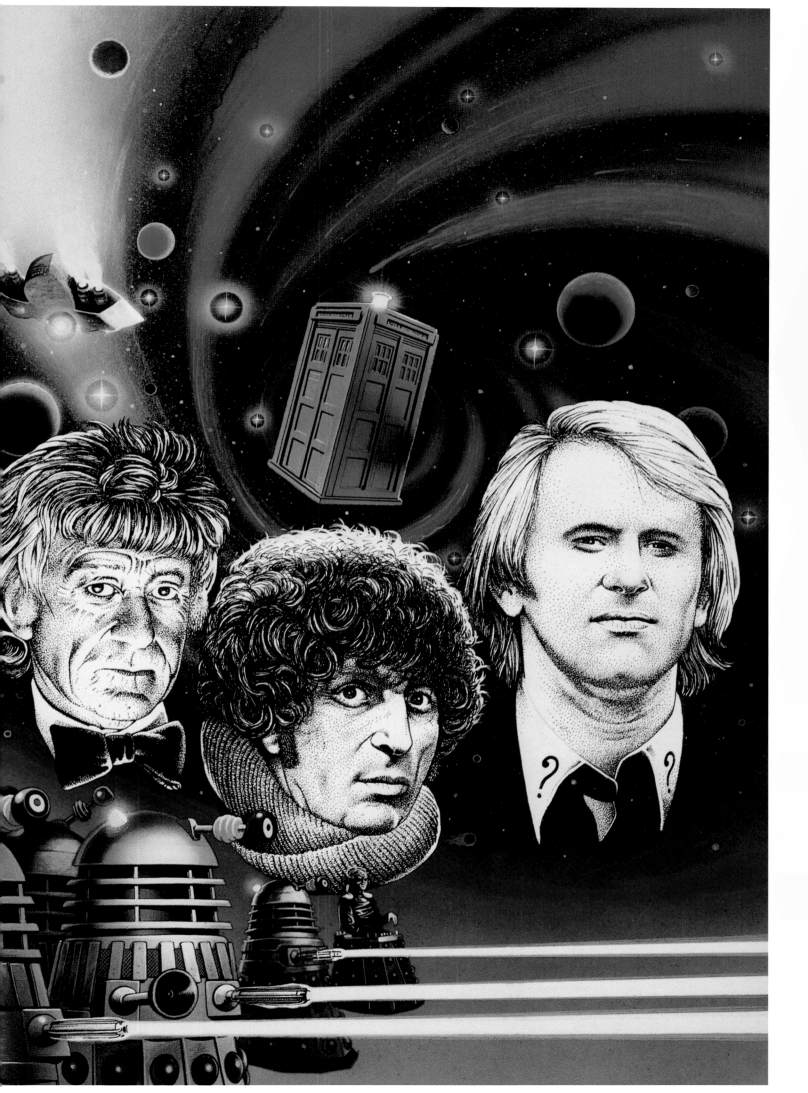

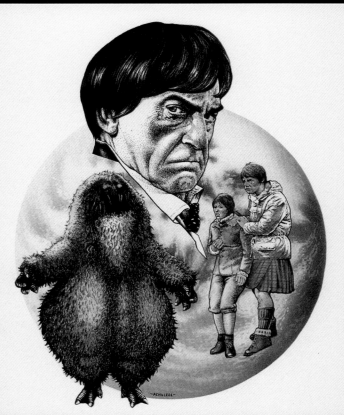

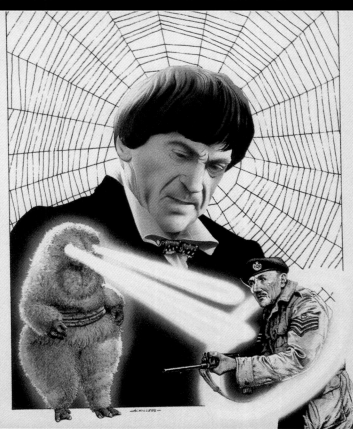

nine of information stored in her head and many thanks are due to her that the series has so far survived the scrutiny of the most critical Trekkies. Accuracy has been pursued even down to reproducing the light quality of the illustrated episodes and the garish colours of television at the time, which have given rise to puzzled comment from those not in the grip of *Startrek*'s spell.

Since each book contained several stories selection was necessary. Often the choice was dictated by the available reference material but otherwise Achilleos was guided simply by personal preference.

Both *Dr Who* and *Startrek* are in a lighter vein to Achilleos' usual Science

(previous pages) THE FIVE DOCTORS 1983 71 × 50 cm.

(above left) DR WHO AND THE CARNIVAL OF MONSTERS 1977 51 × 32 cm.
(above right) DR WHO AND THE ICE WARRIORS 1976 39 × 30 cm.
(below left) DR WHO AND THE ABOMINABLE SNOWMAN 1974 53 × 32 cm.
(below right) DR WHO AND THE WEB OF FEAR 1976 53 × 38 cm.

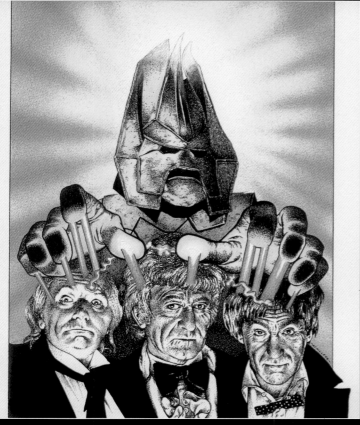

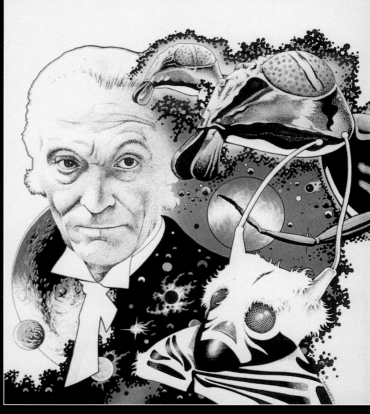

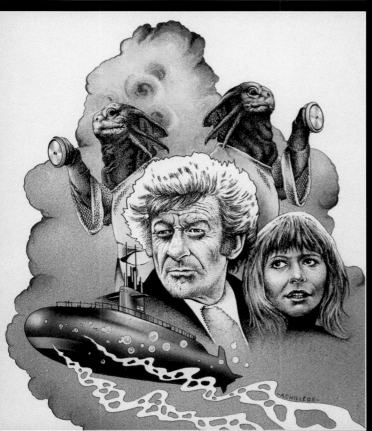

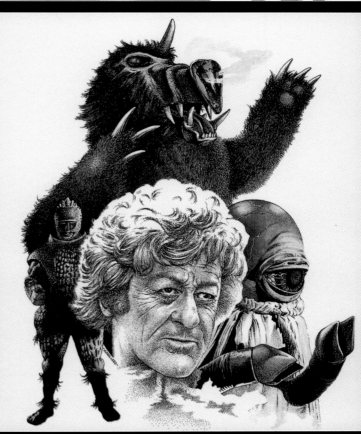

(above left) DR WHO AND THE THREE
DOCTORS 1975 52 × 33 cm. Collection D.J.
Howe.
(above right) DR WHO AND THE ZARBI
1973
50 × 37 cm. Collection D.J. Howe.
(below left) DR WHO AND THE SEA
DEVILS 1974 46 × 36 cm.
(below right) DR WHO AND THE CURSE
OF PELADON 1974 43 × 31 cm.

Fiction work but he was no less happy to work on them than, say Robert E.
Howard's books. Just as he is often happy to do work that has nothing at all
to do with Science Fiction or Fantasy. All aspects of illustration interest
him, what would drive him mad is to be given no variety and asked to do
just the same subjects over and over again. This applies to all aspects of his
work. What he fears is being pigeonholed as one kind of illustrator only
and not being given the chance to extend his range, something which can
happen as easily to an illustrator as to, say, a writer or an actor.

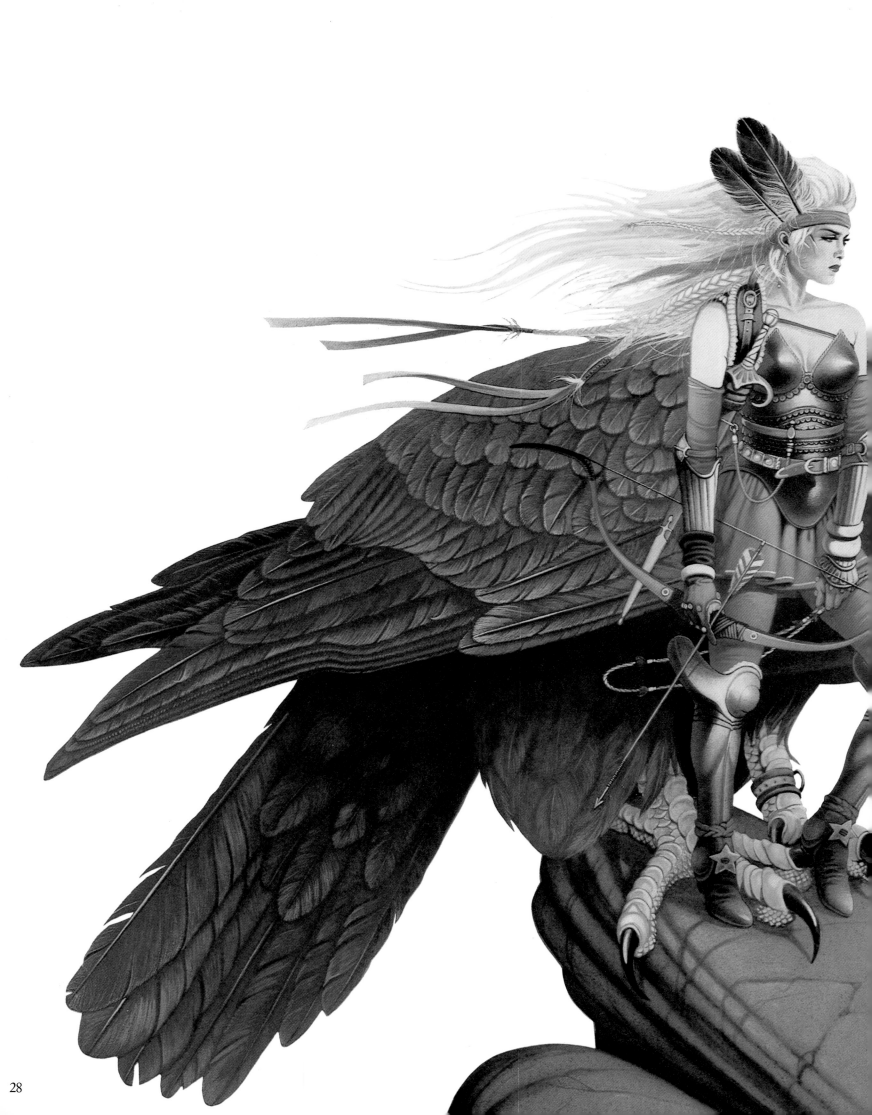

Chapter III

FANTASY AND SCIENCE FICTION

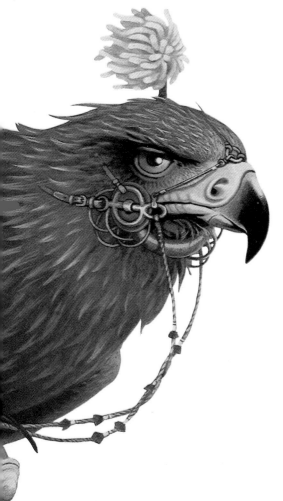

EAGLE RIDER 1984
Detail from p. 46–47.

(above right) RAGE 1981

The original of this together with others listed as missing are in the hands of JB from L.A, from whom nothing has been heard since 1983.

On one point Chris Achilleos is adamant in any discussion of his work — that he is a commercial artist, an illustrator not a 'fine' artist. That is to say, he works almost purely on commission and cannot just follow the promptings of his imagination wherever they lead; something which anyway he sees as self-indulgence. Art for him is not only his vocation but his work, his means of earning a living.

The project he would most like to be given the chance to do is to illustrate the *Iliad* of Homer, a return like Odysseus to his Greek roots after his ventures into the realms of popular Anglo-Saxon culture. This ambition has haunted him for years. A taste of what it could be like is given in the embellishments to the Foreword of this book, some of the samples Achilleos has produced to try and tempt publishers into commissioning the work from him. Unfortunately none has so far risen to the bait. Interest has been expressed in handling the completed work but not yet in funding Achilleos for the considerable time it would take.

An example of another style Achilleos would develop given the chance is the almost Pre-Raphaelite painting on page 41. *The Sirens' Remorse*, a particular favourite of his. This has never been published before and was produced specially for this book. It was chosen from a mass of possible material because to Achilleos it most perfectly captures the overall flavour of his work, the contents of this book — Fantasy, Amazons and the power and beauty of nature in all its forms.

It must not be supposed that because Achilleos works only on commission he is no more than a hard-headed professional. It is true he confines his imagination to those realms which provide him a living, yes, otherwise what would become of the mortgage? But they are also realms which he loves and enjoys. There is no conflict, he makes his living from the thing he likes doing. The only restriction which really chafes is being denied his *Iliad* project. He does not believe in unfettered imagination. To his mind the only person an artist ends up addressing when given complete freedom is him- or herself.

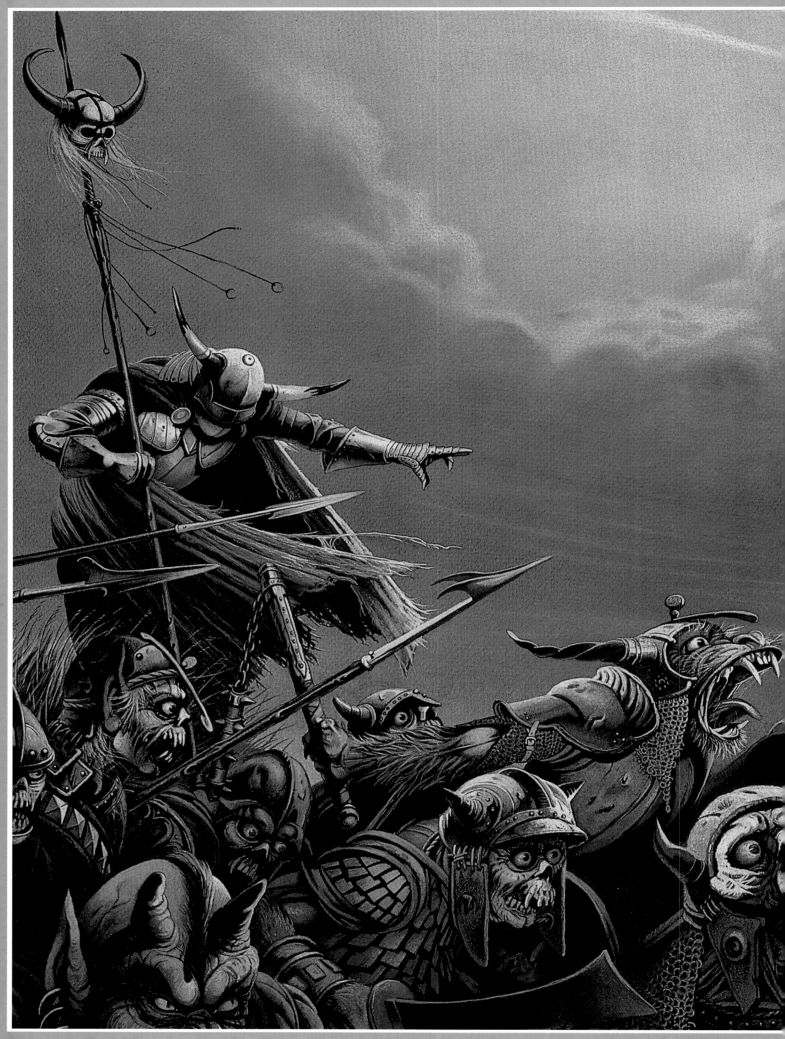

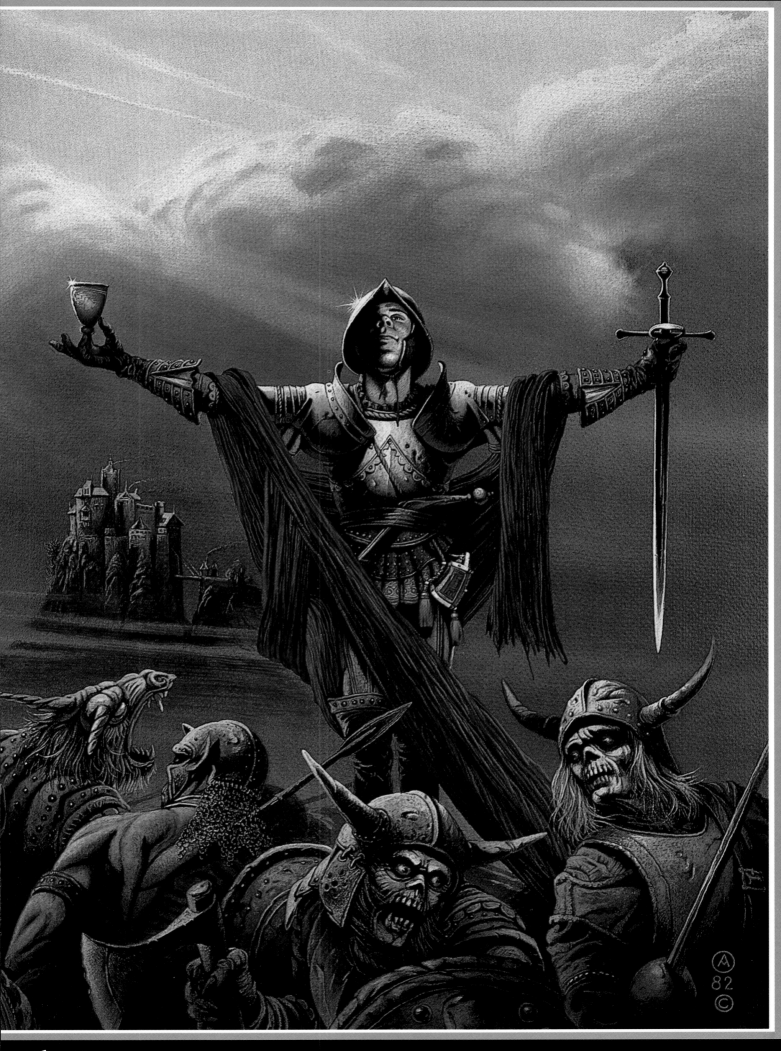

The Quest

How does Achilleos view the violence of much of his Fantasy and Science Fiction work? He admits to being slightly schizophrenic about it but points out that adventure is inextricably linked with violence. Violence and sex. More than that, he says that if you leave out these elements you are left with no adventure, not in his field. Even when they are disguised as danger and romance they are still present as an undercurrent, and his task is usually to illustrate the most exciting moments when they are right on the surface.

From the *Iliad* through Shakespeare and down to modern literature all the best adventure stories revolve around sex and violence. War and conflict, he says, brings out the best as well as the worst in human nature. He is not drawn to it by bloodthirstiness but because people and history are shaped by conflict, just as they are shaped by sexuality.

Asked to name his favourite artists, the first to come to mind are classical painters in general and Michaelangelo in particular, Carravaggio, and the nineteenth century Orientalists, Victorian Classicists and Pre-Raphaelite painters. These he sees as having been illustrators above all else, unlike the Impressionists and some others who are the only artists he regards as 'real' artists.

His first influence was Frank Bellamy, an immediate shaper of his early style. Another direct influence was Frank Frazetta, who was Achilleos' principal model when first learning the art of book-cover design and ranks equal with Frank Bellamy. Achilleos regards Frank Frazetta as a continuation of the American Howard Pyle school, which includes N.C. Wyeth, Frank Schoonover, Maxfield Parrish and Norman Rockwell. Another early influence was the work of Michael Leonard.

Other contemporary favourites include Kaluta, Giger, Moebius, Bilal, Alan Lee, Jack Kirby and Syd Mead.

At college Achilleos turned to Frazetta to learn the principles of book-cover design little realising how hard it would be to escape the master's influence when the time came to move on and develop his own style. He only managed this after a struggle, to then be asked by an art director if he had come across Frazetta's work and could he produce anything in the same style?

These days Achilleos acknowledges Frazetta's influence but no longer feels overshadowed by him. A step in this direction was the discovery that Frazetta had once had his own heroes whose influence can be traced in his work; the discovery that he had not after all sprung fully-armed from the head of the muse of Fantasy.

Now he is amused to find a new generation of artists looking to him as a

(previous pages) THE QUEST 1982
74 × 52 cm. Illustration for book cover.

Fabric dyes, waterproof inks, gouache and airbrush on stretched coloured paper.

I find Moorcock's books a pleasure to do, they are packed with possible cover material. In this picture I show an army of the dead from another dimension consisting of animated corpses, some of which have progressed into demons of rank.

(above left) Rough for THE QUEST book cover submitted to the publisher's art director for approval.

(right) SHIPWRECKED FUGITIVES 1978
73 × 50 cm. Illustration for book cover.

Fabric dyes, gouache, and airbrush on stretched coloured paper.

In this, one can see my interest in plant life, some of which I have made up myself in order to show the alien environment. In a real situation the giant is more likely to be at the front protecting the others but then you would not see them so a little artistic licence has been used.

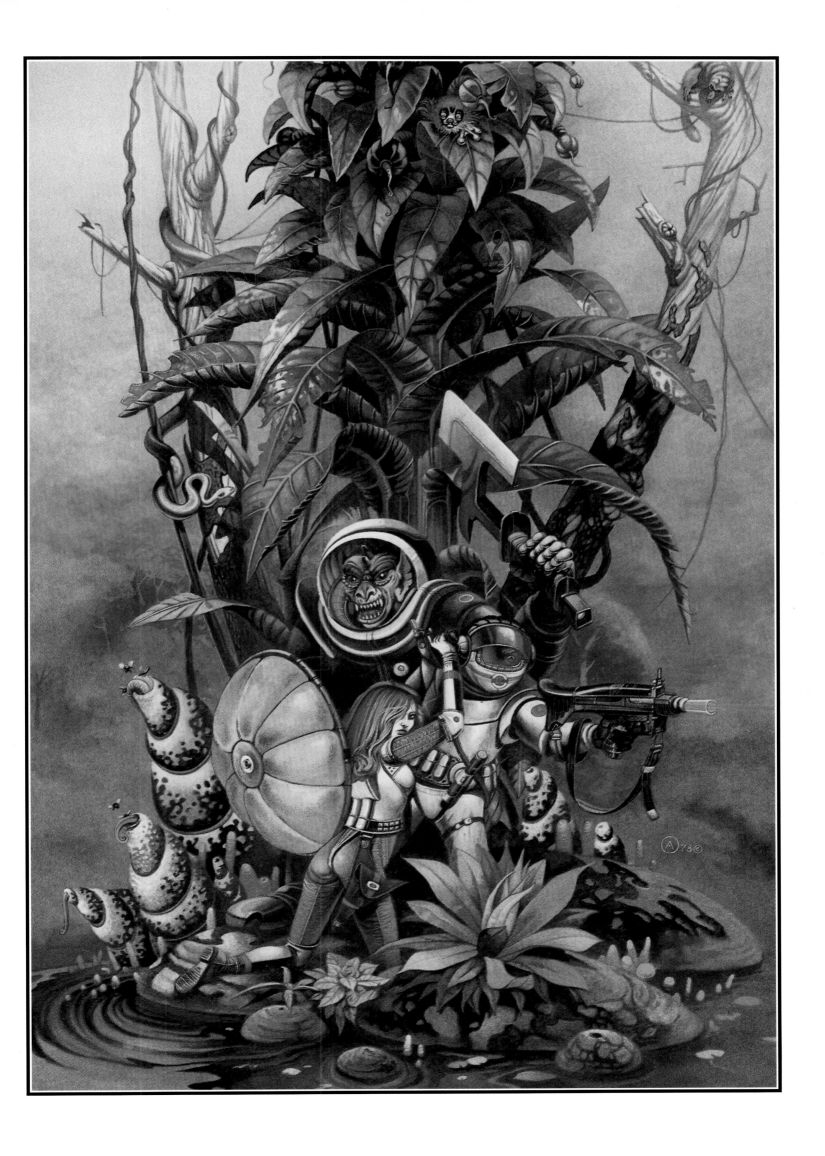

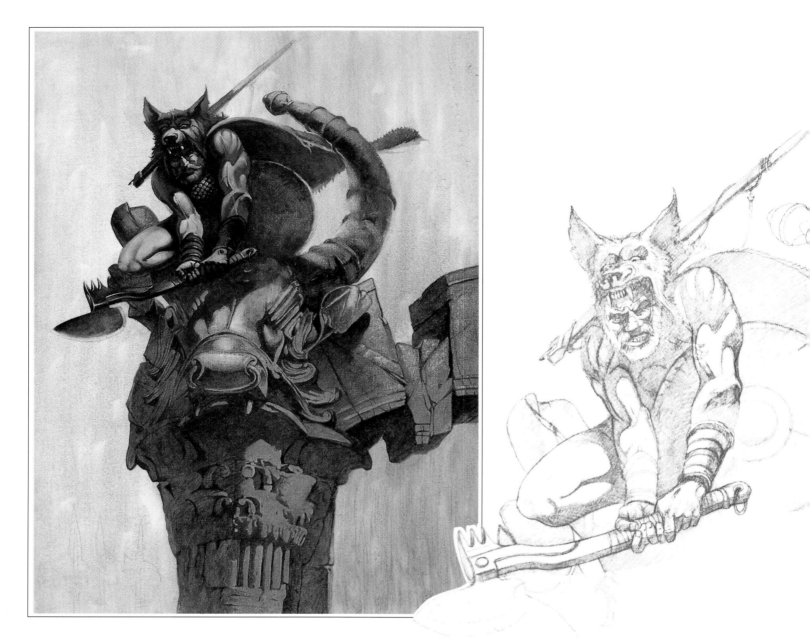

model as he once looked to Bellamy and Frazetta and wonders if they are aware of the influences on him. No-one exists in a vacuum; no-one is completely self-created, least of all artists whatever their field, be it music or literature or the visual arts.

Achilleos' first surviving book cover is a college exercise *Tell Them In Sparta* shown on page 16. Since then he has produced several hundred but lost some of the originals of his early work in the fire at Arts of Gold studio.

His apprenticeship was with Brian Boyle and the Tandem covers. Here, apart from all the technical aspects of book design he learned that a book-cover is a mini-poster which must reach out from the shelf and grab the attention of passing buyers. It was different with the editorial work he began submitting to magazines. Here the work was to be seen by an already captive audience and so in many ways it was possible to be more subtle.

In the early 1970s Achilleos had one great advantage in that he was a skilled airbrush artist. This was when the work of people like Alan Aldridge and Michael English had brought the airbrush suddenly to the forefront of illustration where before it had been seen only as a tool for technical illustration. Illustrators generally were caught on the hop but Achilleos was equipped not only to catch the new development but advance it through techniques of his own which showed particularly in the textures of his subjects.

These followed mainly from his working on water-colour board instead

(above left) KANE detail of unfinished version 1978 66 × 45 cm. Illustration for book cover. Oil paints on canvas board.
(above right) Finished drawing for above. Graphite on tracing paper.

(right) KANE'S STAND 1978 74 × 52 cm. Illustration for book cover.

Ink-line, gouache and airbrush on stretched coloured paper.

This was the first time in my life I abandoned a picture and began again. The reason being that I had a better idea and felt I had to do it. I was greatly disappointed at the result, which fell short of what I was aiming for. This happens quite often.

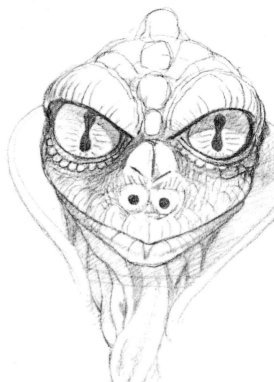

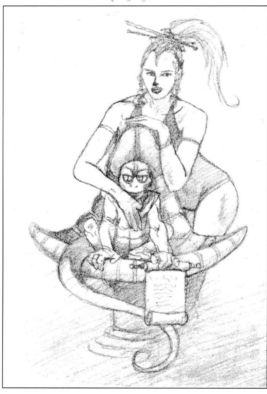

(right) THE ALIEN'S CONTRACT 1982
62 × 42 cm. Editorial illustration.

Waterproof inks, gouache, fabric dyes and
airbrush on illustration board.

One of my personal favourite pictures.

A. Study of the girl's head 18 × 14 cm.
B. Study of the alien's head 13 × 12 cm.
C. Early concept rough 11 × 7 cm.
D. Working drawing 38 × 28 cm.

All these are graphite on tracing paper.

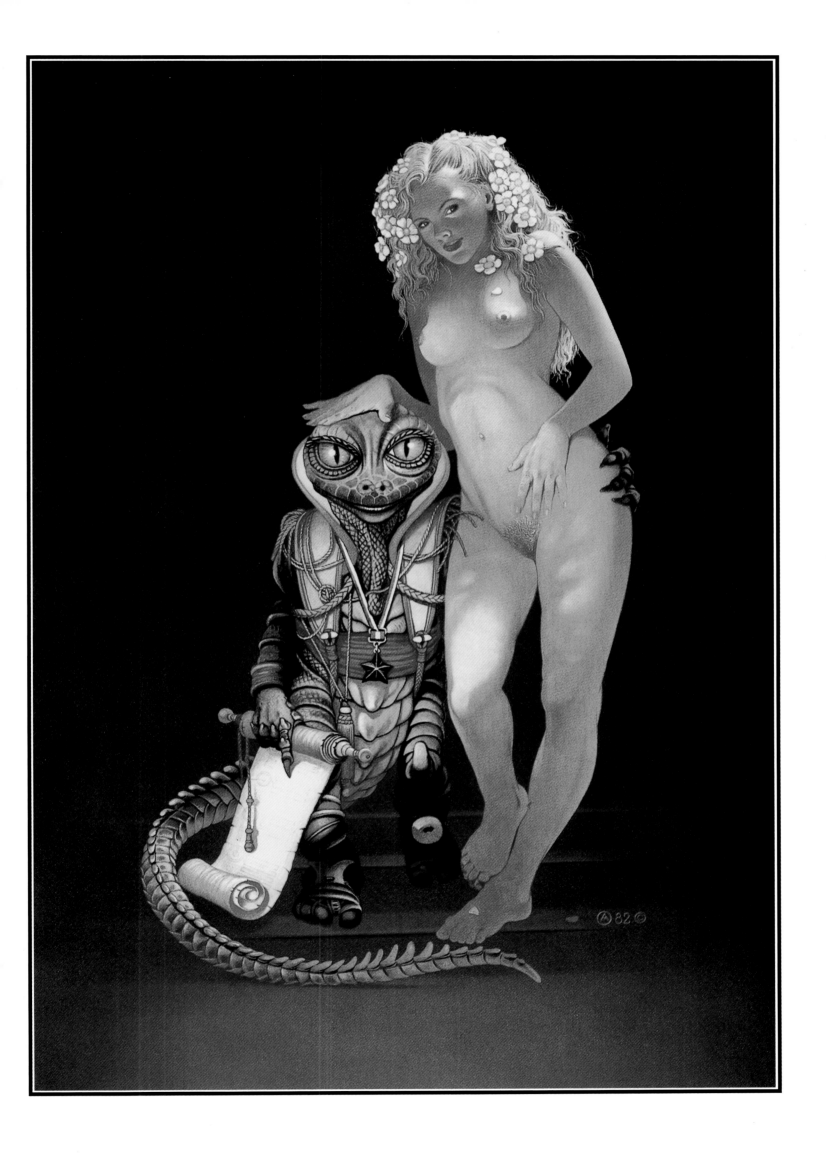

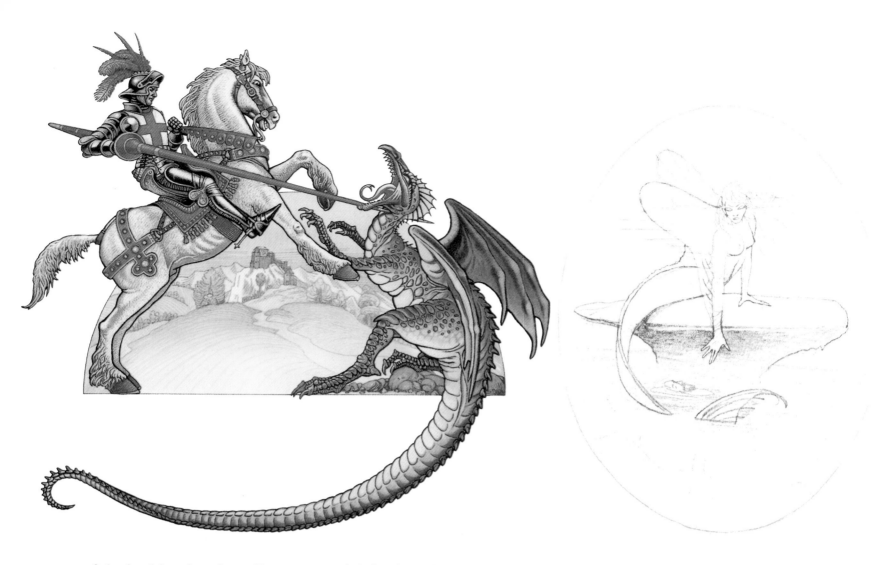

of the hard-line board usually recommended for the airbrush. On this he worked rather in the way of traditional painting, laying down the backgrounds with an airbrush and finishing off with handpainting.

A rare example of his having used the hard-line board usually recommended for the airbrush is *Model 2000* shown on page 46.

Achilleos' approach to making a picture is generally to sketch it first on tracing paper. When the design has been worked out its outline is transferred to board by tracing-down tissue and worked over carefully in pencil. Sometimes it is then inked. Then for each area of airbrushing the rest is masked off. All areas of flesh must be done at the same time but whether this is first or later depends on the amount of clothing. Then waterproof ink is sprayed and sometimes worked with a brush before it can set.

Generally only part of a picture is airbrushed. The remainder is handpainted in a variety of mediums; chromacolour cell paint, acrylic, gouache, or even fabric dye which is rather like watercolours.

The painting surface is generally watercolour board but other boards may be used, or stretched rag paper which is coloured. The subject of a picture often determines the materials to be used.

As to how he uses the materials to such marvellous effect, Achilleos quotes Renoir as saying that painting has little to do with inspiration, it is a technical job that you have to work at like any other. In the end success only comes from endless experiment. He goes on, painting is manual labour and you must go about it like an artisan, a good craftsman if you want results; Pictures don't just happen naturally like real life, a painting must be composed like a piece of architecture.

In the early 1970s 'concept' covers were all the rage for some books, that is to say the design had to capture the title or content by means of some visual trick. Achilleos did a fair number of these and with some success but was never very happy with them, always preferring straightforward illustration.

(above) THE SIRENS' REMORSE 1980
First rough concept.

Graphite on tracing paper.

This, like so many other rough idea sketches, lay in the drawer for years until the opportunity came for it to be resurrected.

(above left) St GEORGE AND THE DRAGON 1982 62 × 42 cm. Illustration for brochure cover.

Ink-line and gouache on illustration board.

(right) DEATH STRUGGLE 1978
2 × 50 cm. Illustration for book cover.

Fabric dyes, gouache and airbrush on stretched coloured paper.

(overleaf) THE SIRENS' REMORSE 1985
79 × 60 cm. Non-commissioned, done specially for this book.

Chroma-colour cell paint and airbrush on illustration board.

One of a set of concept drawings of Sirens and Mermaids which I hope one day to complete for a calendar or portfolio. This is my favourite picture to date.

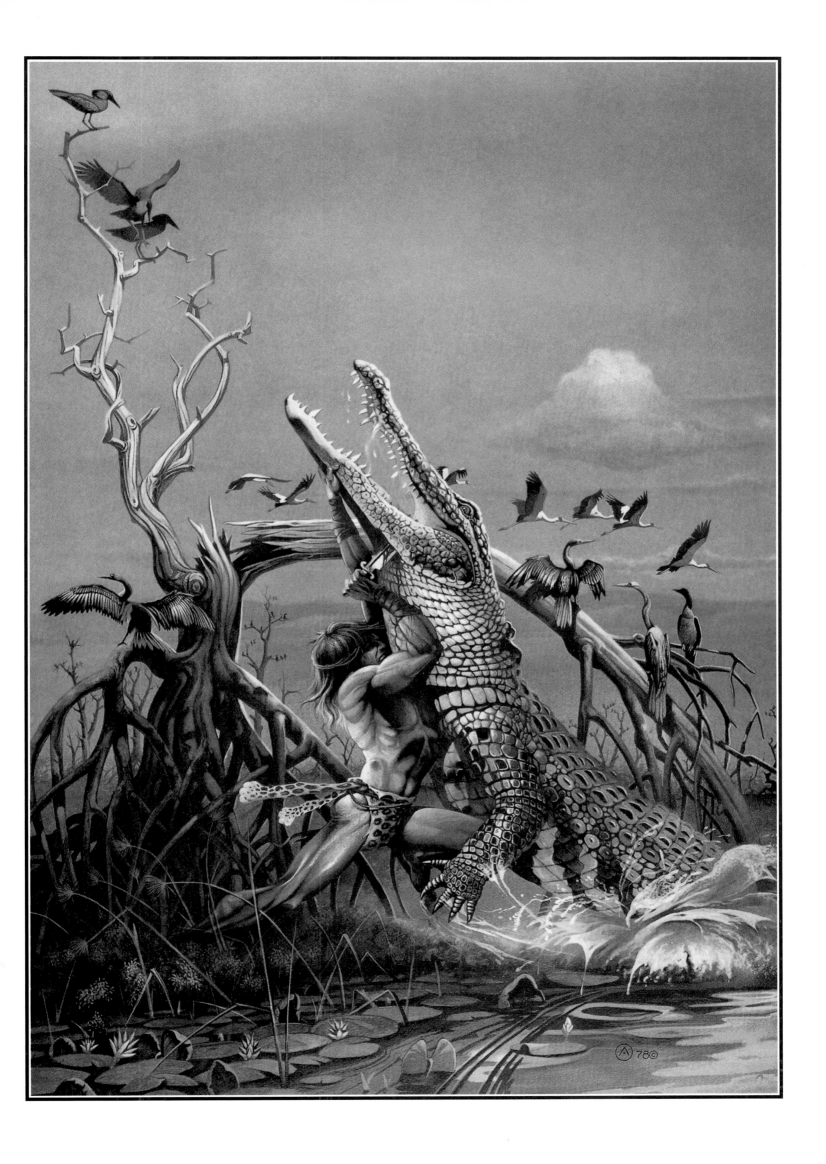

39

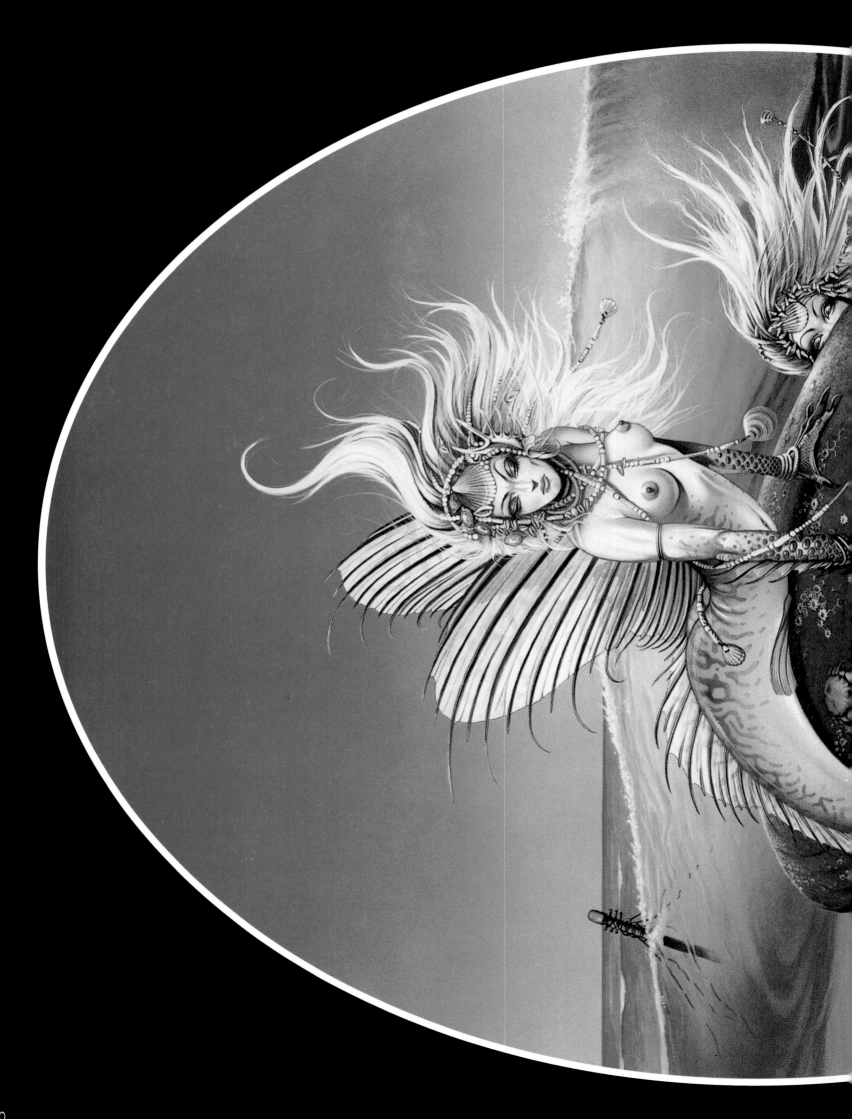

The Siren's Remorse

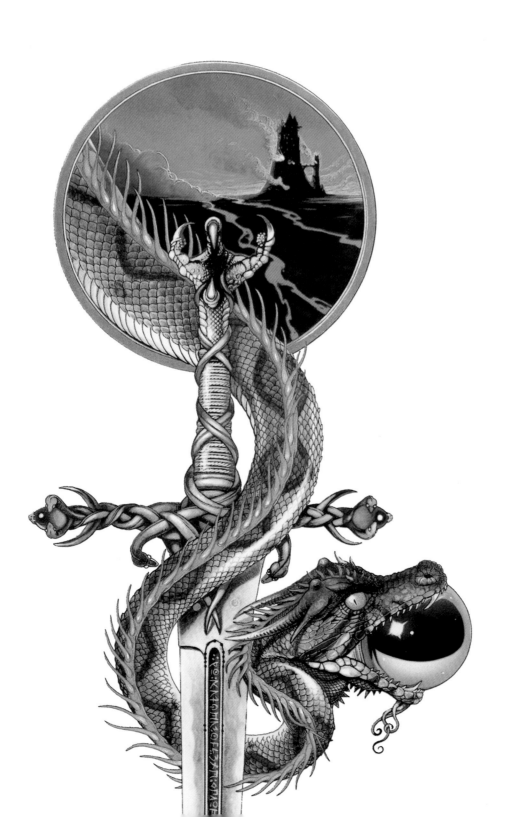

THE SWORD AND THE SERPENT 1985
38 × 25 cm. Illustration for book cover.

Ink-line, fabric dyes, gouache, waterproof inks,
gold paint and airbrush on line-board.

*In this instance I chose a graphic approach rather than
the usual all-action picture, using the serpent as a symbol
of evil in the traditional fashion although personally I
think they are nothing of the sort.*

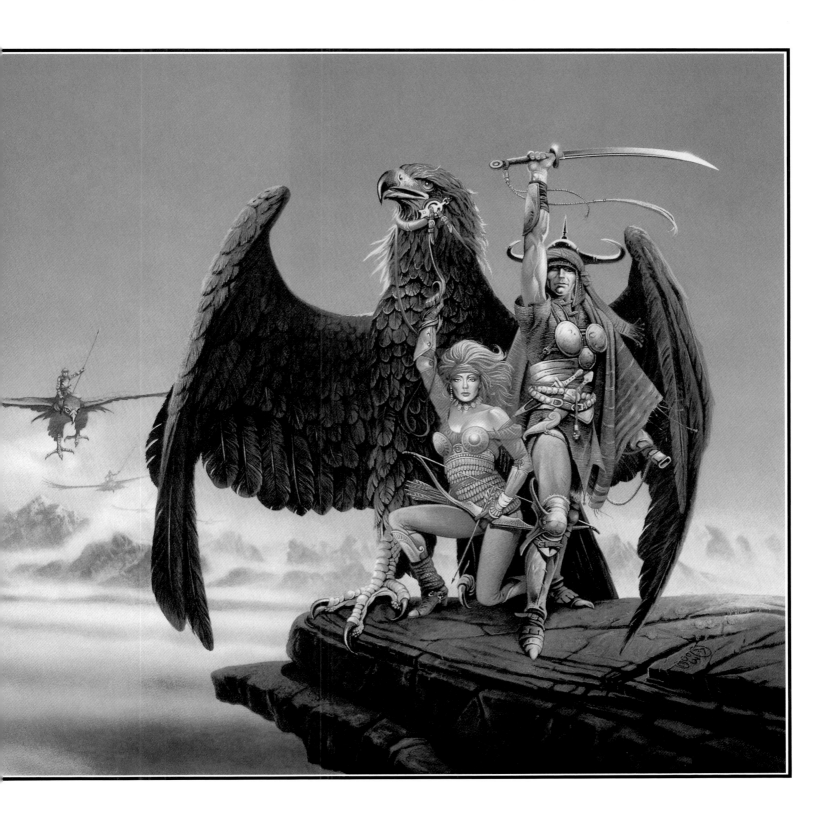

EAGLE WARRIORS 1983 78 × 62 cm.
Illustration for book cover.

Waterproof inks, gouache and airbrush on
illustration board.

*This was designed for a wrap-round cover where the
action is kept mainly on the lower right to leave the rest
free for title and copy. This can be noted in most of the
book-cover illustrations in this book.*

He feels he was lucky to leave college just as the Science Fiction
paperback market was taking off, suspecting that if he had been a few years
younger he would most likely have become the technical illustrator he was
trained to be. All down the line he feels that chance has shaped his life as
much as anything else.

In the 1970s Achilleos joined the Association of Illustrators at its
inception and was as active a member as his circumstances allowed.

One reason for joining was the vexing question of the ownership of
original work. Some publishers were prepared to return it to the artist,
fewer returned it undamaged and some refused on principle, saying it was
house policy. When they did keep it there was little guarantee of its safety.
Most of Frank Bellamy's original work was lost through the flooding of the
publisher's basement where it was stored.

There were other reasons but this was probably the main one.
Unfortunately the Association's early promise was not fulfilled, not in his

THE SLAIN SERPENT 1985 38 × 25 cm.
Illustration for book cover.

Ink-line, fabric dyes, gouache, waterproof inks,
gold paint and airbrush on line board.

*Done for the second volume of a Fantasy saga, forming
a pair with no. 39.*

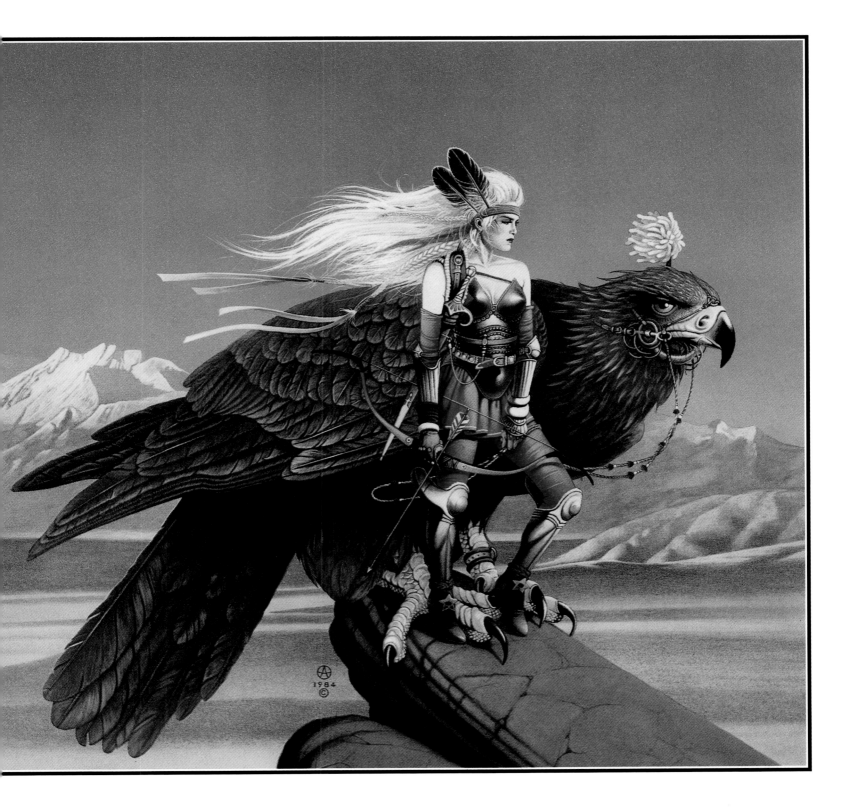

EAGLE RIDER 1984 77 × 61 cm. Illustration for book cover.

Waterproof inks, gouache and airbrush on illustration board.

A pair with no. 40.

own case anyway. Currently he finds that it hardly recognises the existence of Science Fiction and Fantasy illustrators like himself and his battles over ownership have generally had to be fought alone.

Painting by Order — the Achilleos method of tackling a commission.

When considering a commission Achilleos' first question is how soon is it due? The dreaded and inescapable deadline. Many a brilliant artist, he says, has bitten the dust because they have been unable to meet deadlines. If he has doubt about his ability to meet deadlines. If he has doubt about his ability to meet one, he does not take the job.

Then there is the question of whether it is worth it, which can depend on the nature of the work as much as the fee offered. With Moorcock books, for example, he is usually prepared to put in more work than is strictly justified by the fixed fee most publishers stick to.

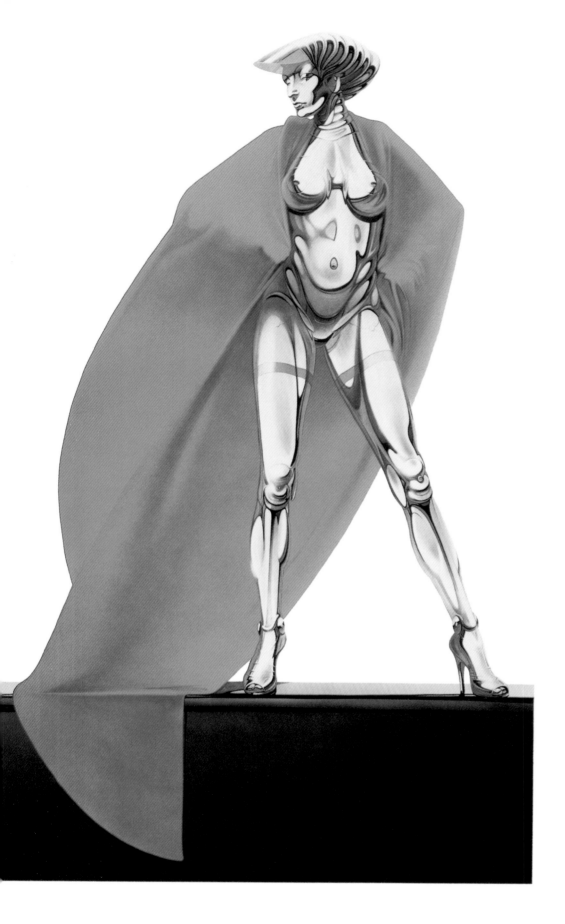

If he accepts a commission he starts work at a normal pace and steps it up as required. Sometimes this means working round the clock but fortunately this does not happen too often.

To begin with, if it is a book it must first be read and a concept roughed out, which may need the publisher's approval before going further. For a book, the composition is governed not only by the story but by the lettering, etc. which has to be accommodated.

For the painting the choice of medium is often suggested by the subject, if not it is open to experiment.

(above left) MODEL 2000 1985 80 × 55 cm. Medium exercise, previously unpublished.

Waterproof inks, gouache and airbrush on line board.

I have been waiting for years for someone to commission a robot girl, in the end I gave up waiting and just went ahead with this one. Better later than never.

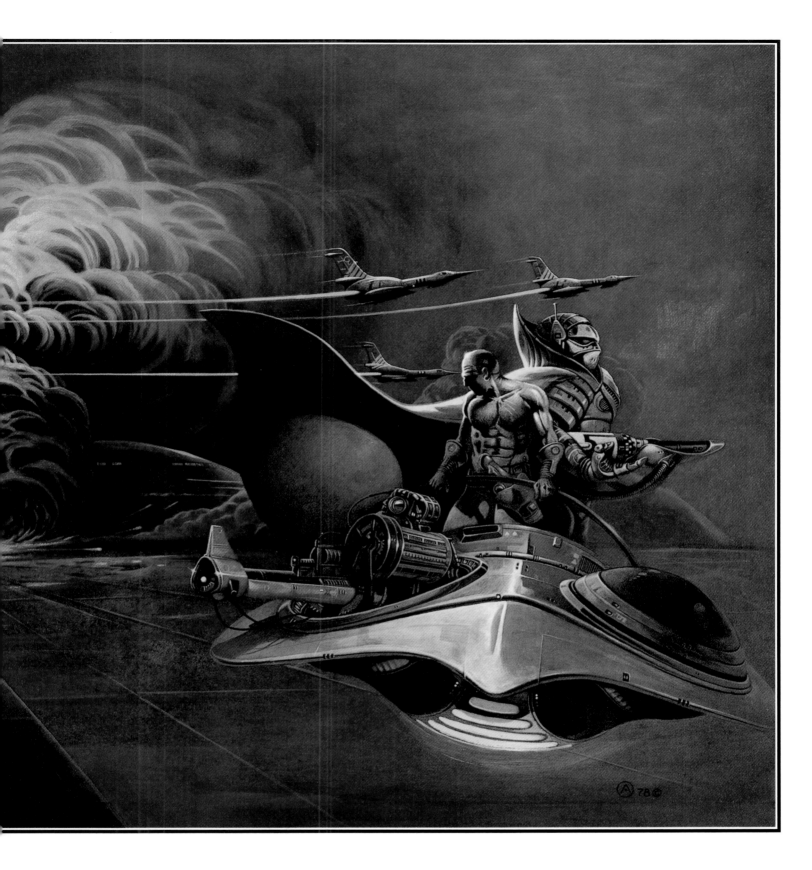

(above) REBEL RAID 1978 75 × 54 cm.
Illustration for book cover.

Acrylic paints on illustration board.

When this was first published, the cloak was attached to the man's shoulders but I never felt too happy with this so I transferred it to his robotic fellow-rebel and minder.

Rebel Raid, shown above, is one of Achilleos' favourite space hardware pictures partly because of the unusual way it came about. The board on which it is painted had been lying around his studio for years after an experiment with spilled colour. When the concept drawing for *Rebel Raid* was finished, he suddenly saw a challenge in trying to combine the two. While painting the main figures he had no clear idea of what the background was to be and he began it without any planning, just letting it take shape of its own accord under his brush.

Apart from this rare lack of planning he is proud of it being completely hand-painted, no airbrush was used.

Rebel Raid illustrates a common theme in Achilleos' work — the destruction of complex civilisations by lawless invaders. The subject has

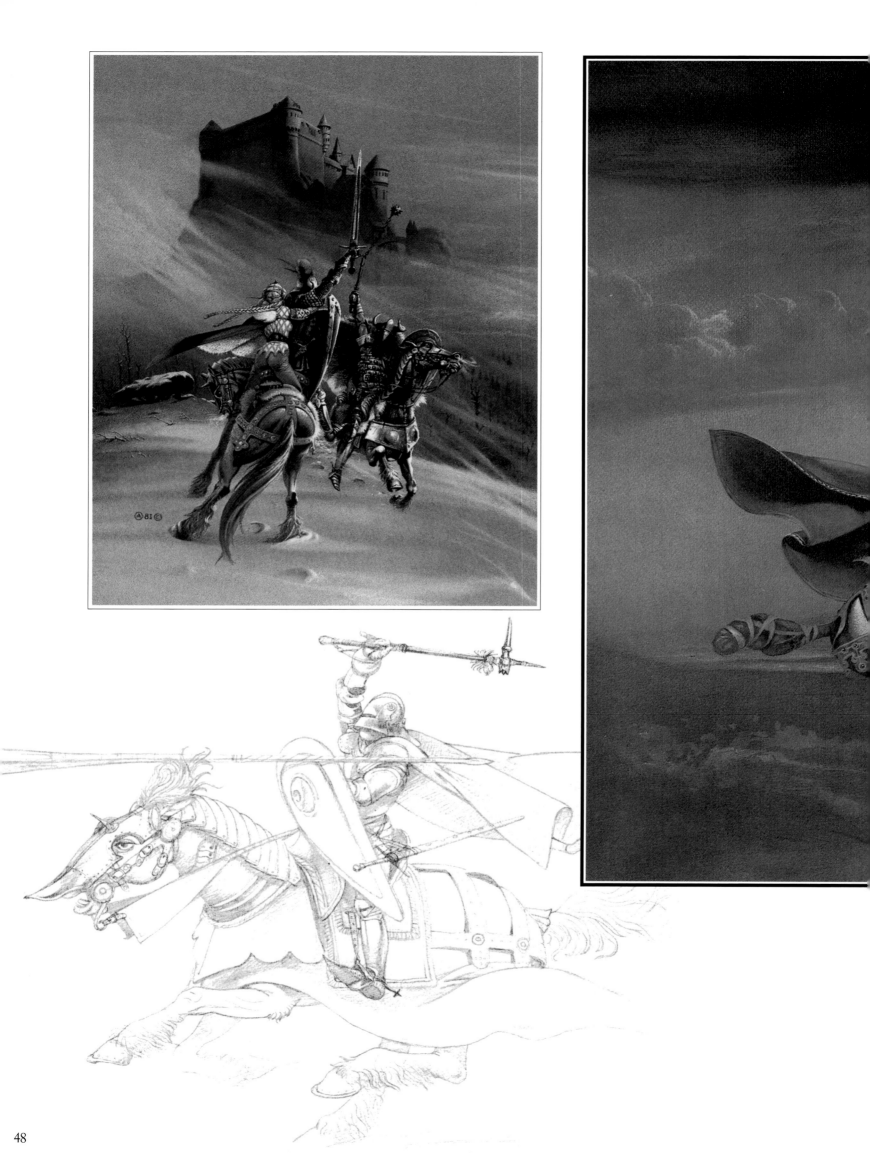

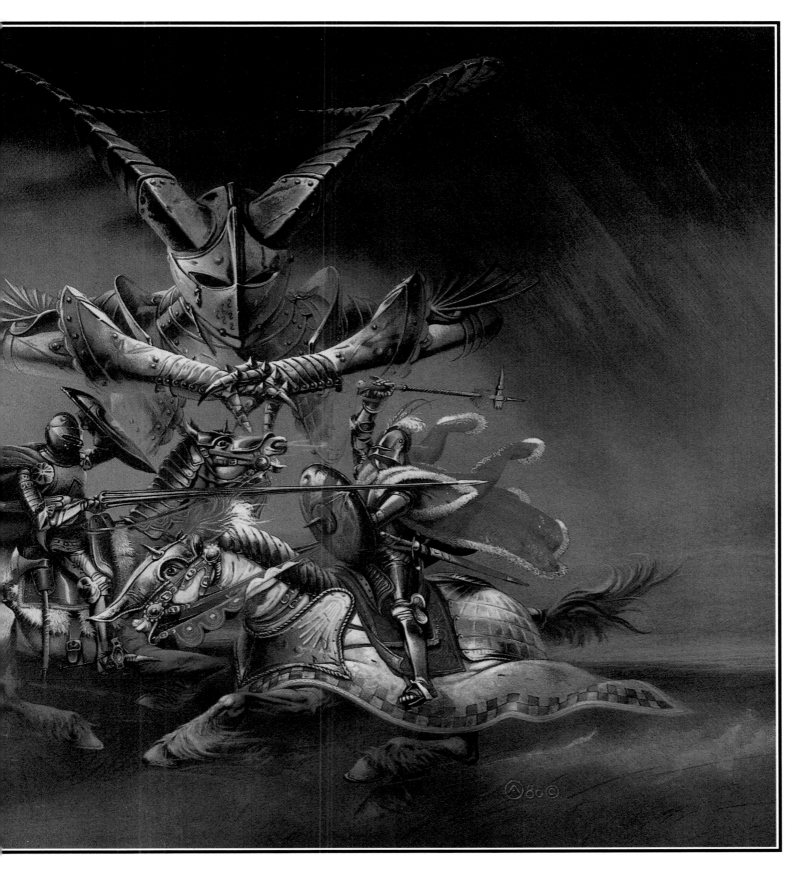

(above left) BATTLE IN THE SNOW 1981
70 × 51 m. Illustration for book cover.

Waterproof inks, gouache, pastels and airbrush on coloured stretched paper.

(above) TRIAL BY COMBAT 1980
62 × 48 cm. Illustration for book cover. Also a game-box cover for *Warrior Knights* by Games Workshop.

Waterproof inks, gouache and airbrush on stretched coloured paper.

(left) Working drawing for above.
Graphite on tracing paper.

fascinated him from childhood, whether the invaders be Vikings, Huns or space pirates, and it is far from clear in his pictures whose side he is on. This follows perhaps from the doubts he has about the value of 'civilised' societies such as Egypt, Rome or classical Greece or our own.

In person he is not an obvious anarchist but he soon makes it plain that for him the ideal life was when humans lived in harmony with nature as hunter-gatherers, pre-'civilised' in fact.

In Greek history Achilleos sees the Mycenaean age as the heroic one and the later complex civilisations as a descent into stifling rigidity and lack of individual freedom.

His fascination with the fall of complex civilisations to 'barbarians' arises

from its ambiguity. At first sight it seems a tragedy, but is it always? he asks. Apart from their marvellous buildings and roads and aqueducts were Egypt or Rome in their heydays such wonderful places to live in? Did the slaves mourn their fall? Were not their riches and splendour enjoyed by only a lucky few and is that not usually the case?

At first sight the barbarians seem the arm of evil but, he says, do they not also often bring about good in the end?

As for the Greeks, his own opinion of the Mycenaean age was shared by the people who set down and revered the *Iliad* and *Odyssey* in classical times. They also believed that man, rather than progressing, was actually regressing.

Achilleos has long admired the Fantasy writings of Michael Moorcock, whose worlds are full of this same ambiguity. Commissions for Moorcock covers have always come as a delight as apart from anything else Achilleos finds him such a visual writer that he is often spoiled for choice as to a subject.

His enthusiasm for Moorcock becomes clearer as Achilleos explains the cosmogony of his imaginary universe by means of a diagram. At the top he draws a pair of scales to indicate the balance of the universe, a balance between Law and Chaos. These two fundamental forces are forever at war, each trying to win supremacy over the other even though the universe can only continue if they remain in balance. Then there is a third force always trying to maintain this balance. This, one supposes, is where the ambiguity creeps in.

(left) NIGHTMARE 1979 78 × 53 cm. Illustration for book cover.

Waterproof inks and gouache on illustration board.

(above) PEGASUS First rough concept for Art Director's approval.

(right) PEGASUS 1979 70 × 49 cm. Illustration for book cover. Private collection, Holland.

Waterproof inks, gouache, pastels and airbrush on stretched coloured paper.

My first idea was to have Pegasus at rest by a spring on the ground. Then I wanted him high in the sky among the clouds, but have always felt that a flying horse doesn't look plausible; so I contrived this fantastical mountain-top with geyser-like fountain and petrified, coral-like flowers which formed vertical lines complementing the horizon and clouds beyond.

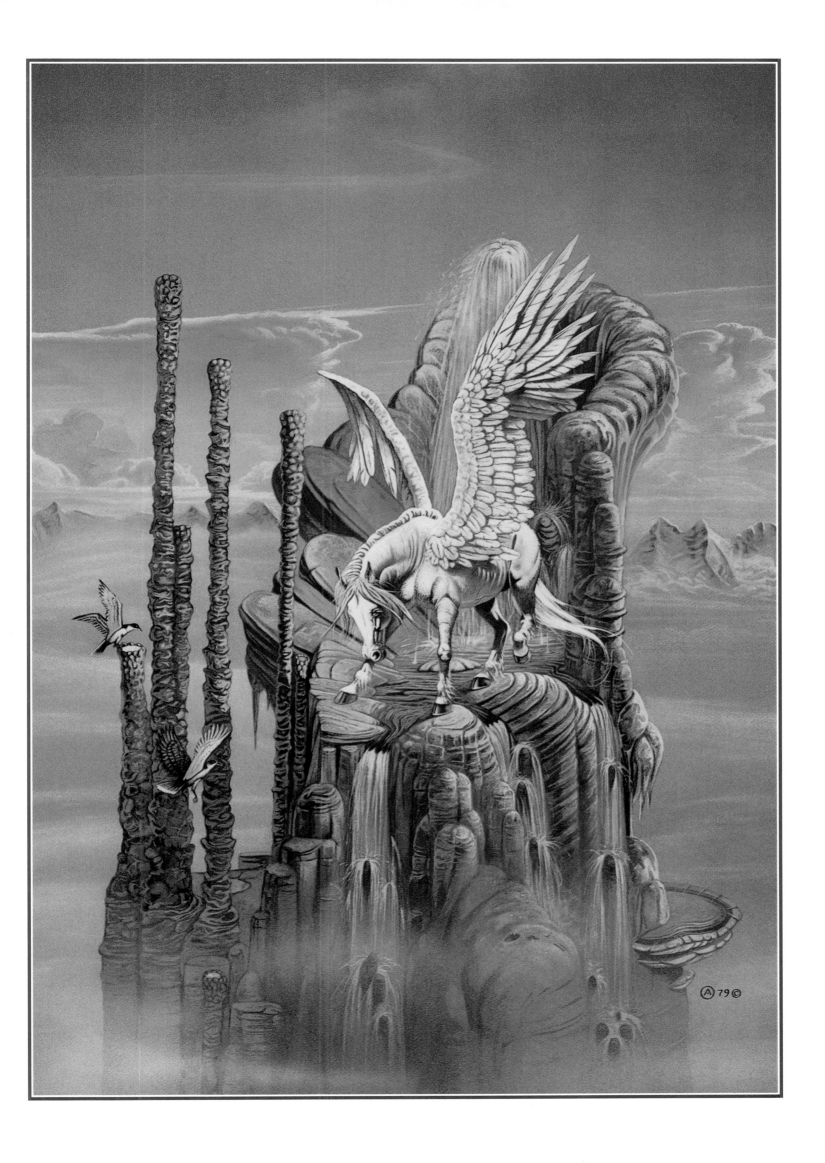

51

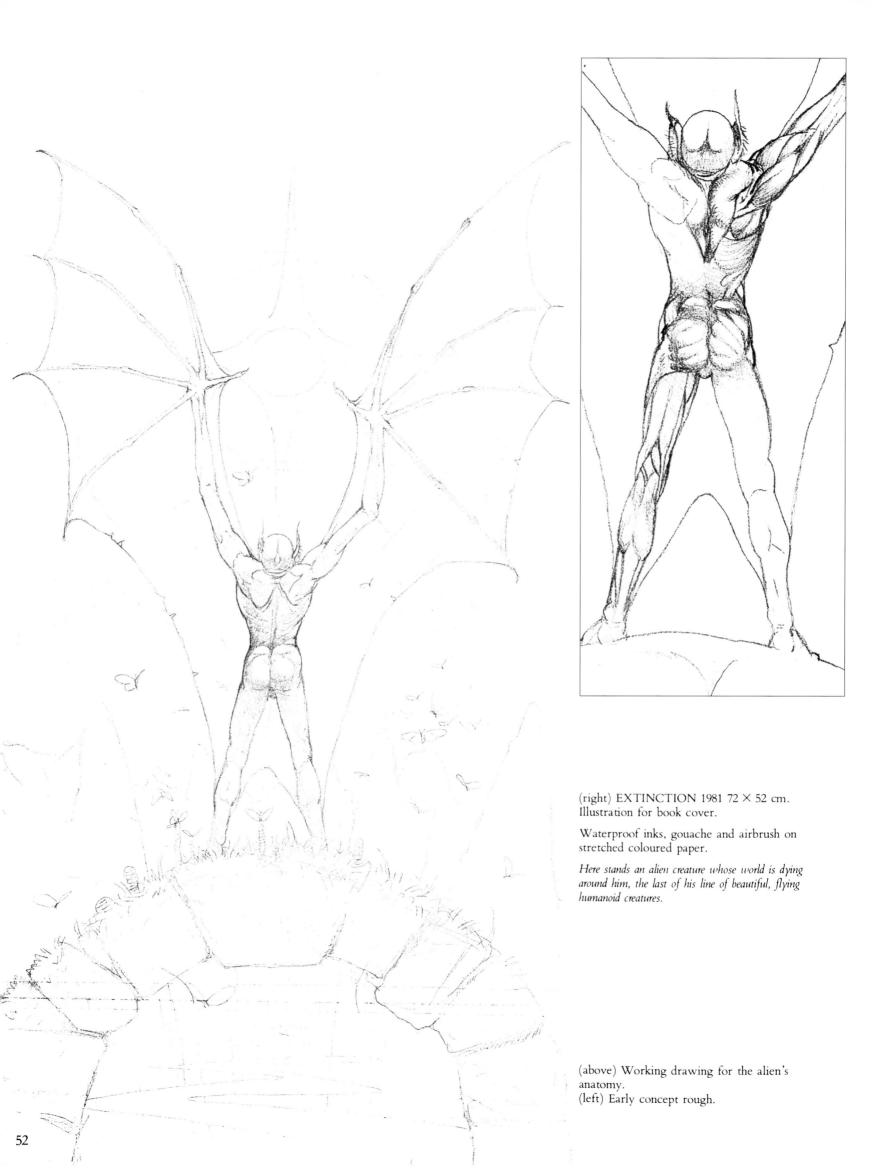

(right) EXTINCTION 1981 72 × 52 cm.
Illustration for book cover.

Waterproof inks, gouache and airbrush on
stretched coloured paper.

*Here stands an alien creature whose world is dying
around him, the last of his line of beautiful, flying
humanoid creatures.*

(above) Working drawing for the alien's
anatomy.
(left) Early concept rough.

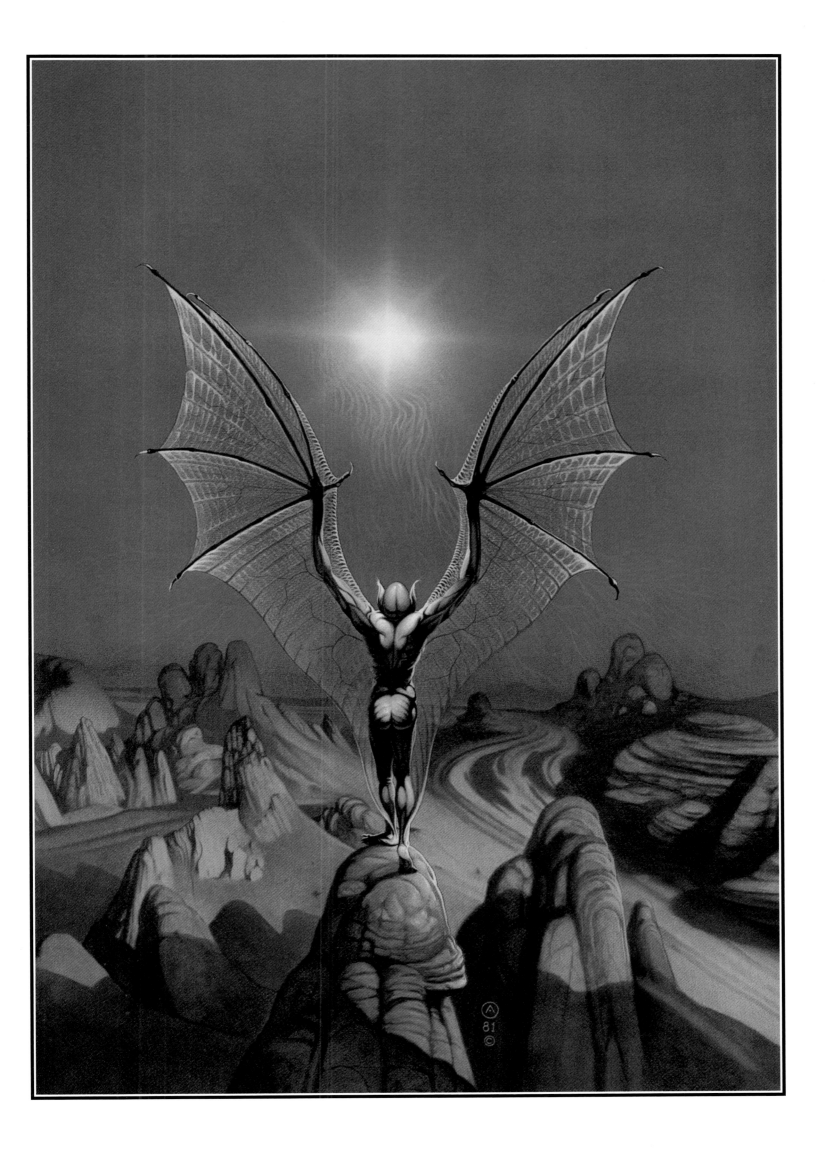

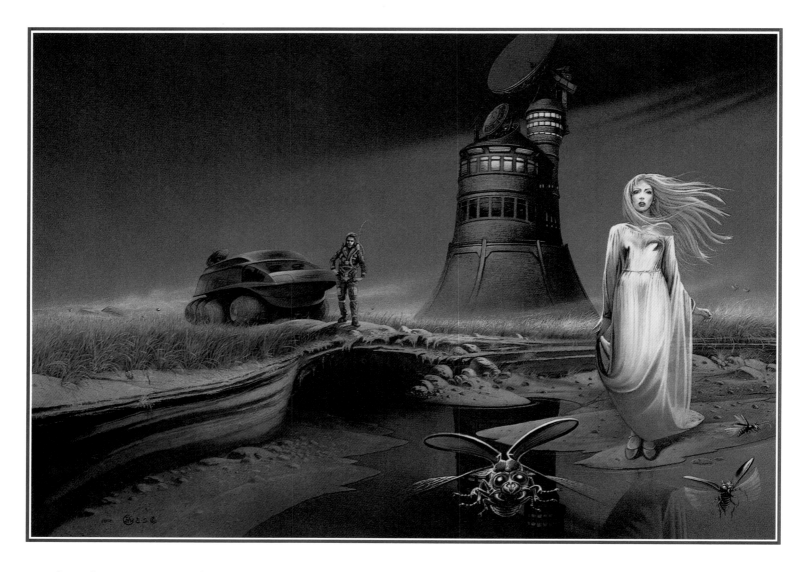

Below this are a series of planes of existence, dimensions hidden from each other except when occasionally beings pass from one to another, thus characters from Moorcock's various imaginary worlds sometimes get thrown together.

At work in these planes are certain Eternal Champions of the different powers one of whom is Elric, almost the last of a doomed race, a sickly albino who is in the power of his hellish sword Stormbringer, the stealer of souls. If ever there was an ambiguous character it is Elric.

The initial sketch of Elric was done years before Ian Hughes of New English Library commissioned the painting shown on pages 56–57. Achilleos was delighted to be able to use it at last but got a little carried away when sketching the background to the rough he submitted for approval. Only when it came to completing it did he realise what he had committed himself to. He met the deadline but only by turning it into a midnight oil job. Still, he is pleased with the result and only wishes he had been able to spend more time on the castle.

Since appearing as a book cover, the painting of Elric has also been reproduced as a poster and a limited edition print signed by both Achilleos and Moorcock. There is also a likelihood of Elric being made into a three-dimensional figure by Fine Art Casting along with several other Achilleos portrayals including some from the Raven and Amazon series.

A note on the titles of Achilleos' paintings — although most of his pictures are the result of book-cover commissions he generally prefers to give them his own titles, but these are not to be taken too seriously he says, as their main purpose is for identification. Only occasionally is he happy with them, as with *The Siren's Remorse*.

Achilleos' fame as a Fantasy illustrator has had some interesting spin-offs over the years. A while ago he discovered his images had become popular

(above) THE LONELY HEART 1983
72 × 51 cm. Illustration for book cover.
Previously unpublished.

Waterproof inks, gouache and airbrush on colour paper.

This was for a romantic novel set on a distant planet with purple skies and bleak landscape. The heroine is stranded there with her crazy scientist father until a young stranger enters the scene. Unfortunately it was never used as the publishers found the picture too depressing.

(right) ELRIC 1983. Late working drawing.

Graphite on tracing paper.

(overleaf) ELRIC 1983 92 × 67 cm. Illustration for book cover jigsaw puzzle.

Waterproof inks, gouache, fabric dyes, graphite and airbrush on illustration board.

The most ambitious picture I have ever done for a book cover. I painted the background like this and not in full colour as I intended it to be a backcloth/tapestry showing the collapse of his civilisation and not a real background. In the new era of Man that is dawning neither he nor the dragon have a place except as figures of myth and legend.

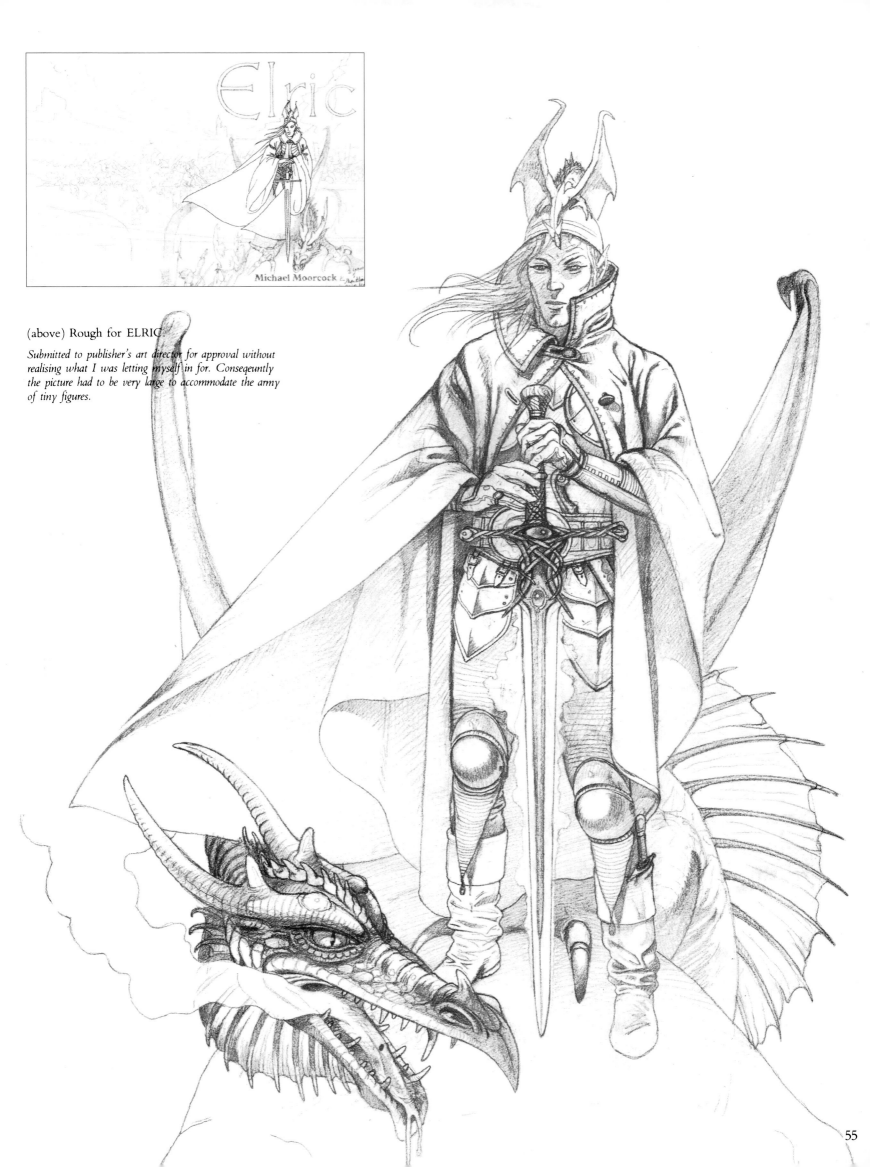

(above) Rough for ELRIC

Submitted to publisher's art director for approval without realising what I was letting myself in for. Conseqeuntly the picture had to be very large to accommodate the army of tiny figures.

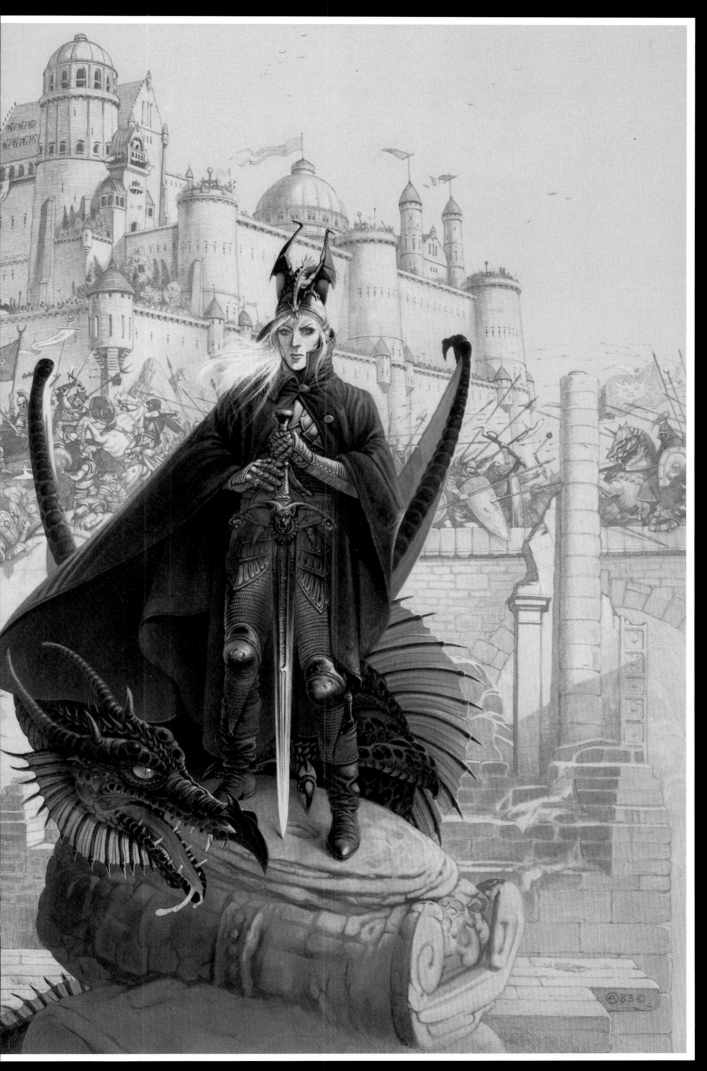

Elric

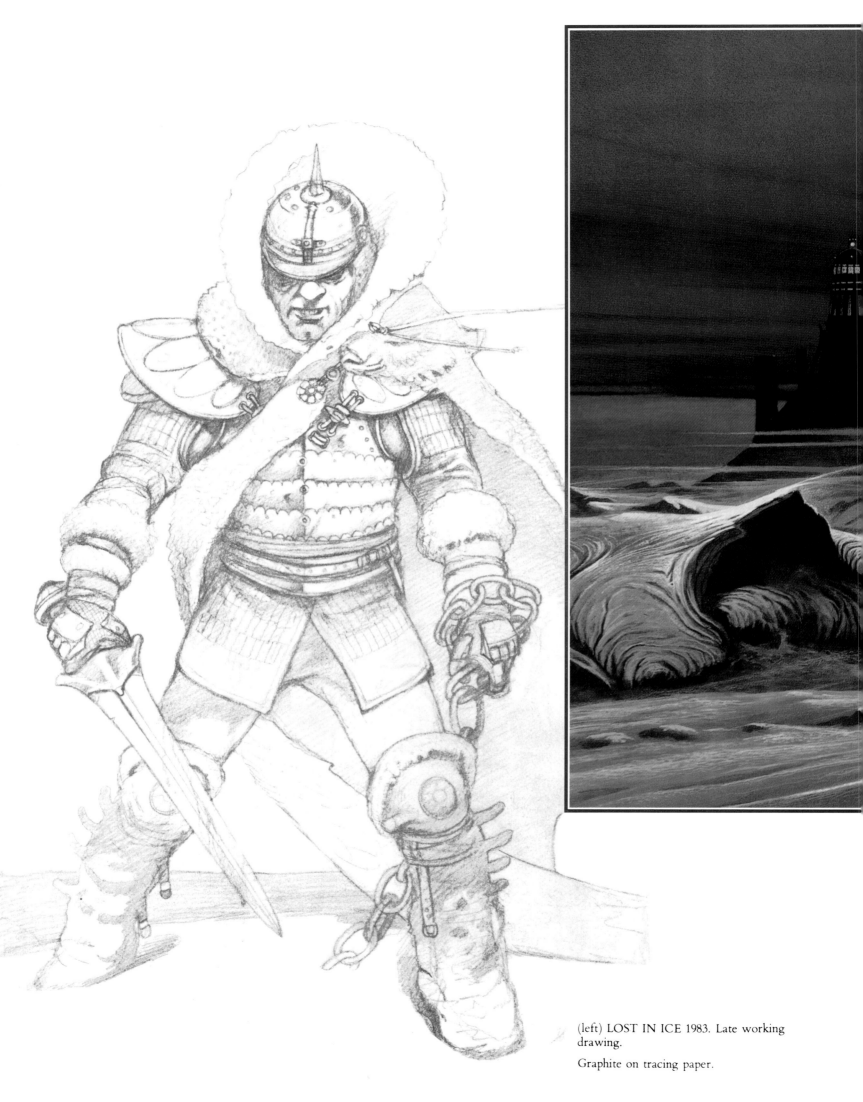

(left) LOST IN ICE 1983. Late working drawing.

Graphite on tracing paper.

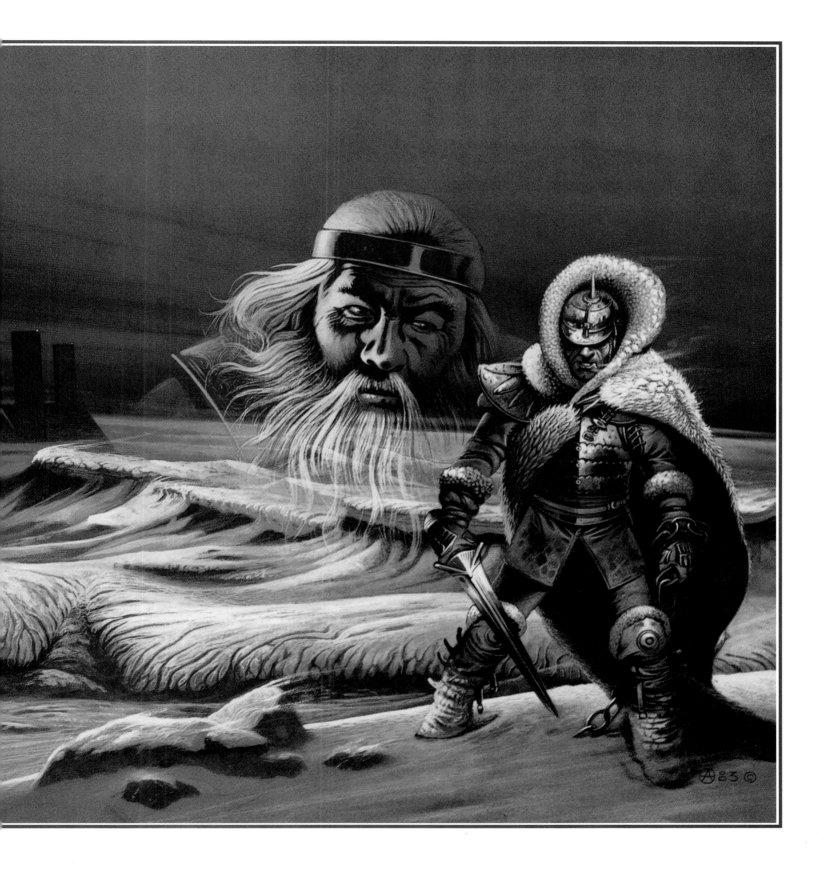

LOST IN ICE 1983 73 × 51cm. Illustration for book cover.

Waterproof inks, gouache and airbrush on coloured stretched paper.

It was nice to get away from the stereotyped barbarian wearing nothing but a loincloth even when struggling through the snow or in the melée of battle, and to get into designing a more realistic costume.

with car customisers, to the extent that one airbrush artist even advertised his ability to provide Achilleos copies for car bodies (without first asking his permission, of course).

A more recent trend is for them to be used in tattooing. Achilleos had already noticed a few of his designs decorating other people's bodies when he met Chris Wroblewski at the Frankfurt Book Fair, a photographer specialising in tattoos who told him the true extent of his popularity in tattoo parlours and suggested a book of Achilleos tattoos. Although he has some reservations about tattooing, which have been made conditions of the project, it seems likely to go ahead in the near future.

The commission for the cover of Anne McCaffrey's *Dragonquest* fulfilled a long-held ambition to paint a dragon. Usually Achilleos is careful to stick

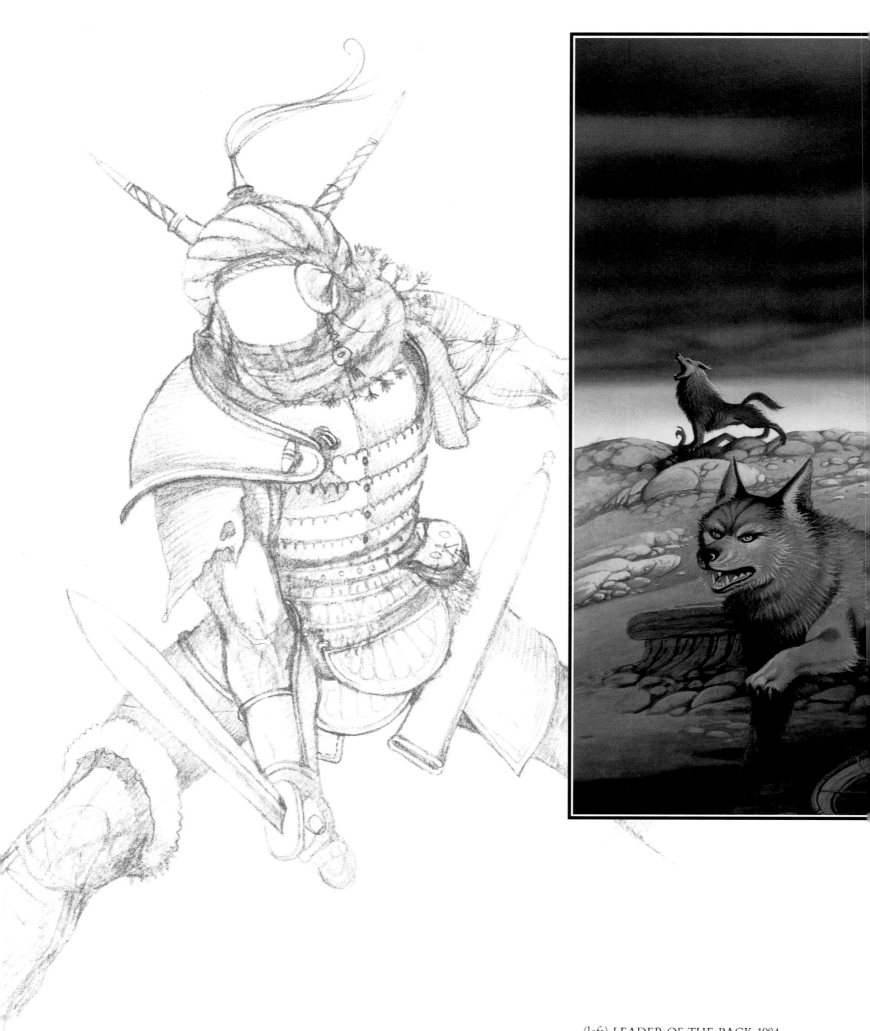

(left) LEADER OF THE PACK 1984.
Laterworking drawing shown here same size as
original, also same size as the character appears
in the painting.

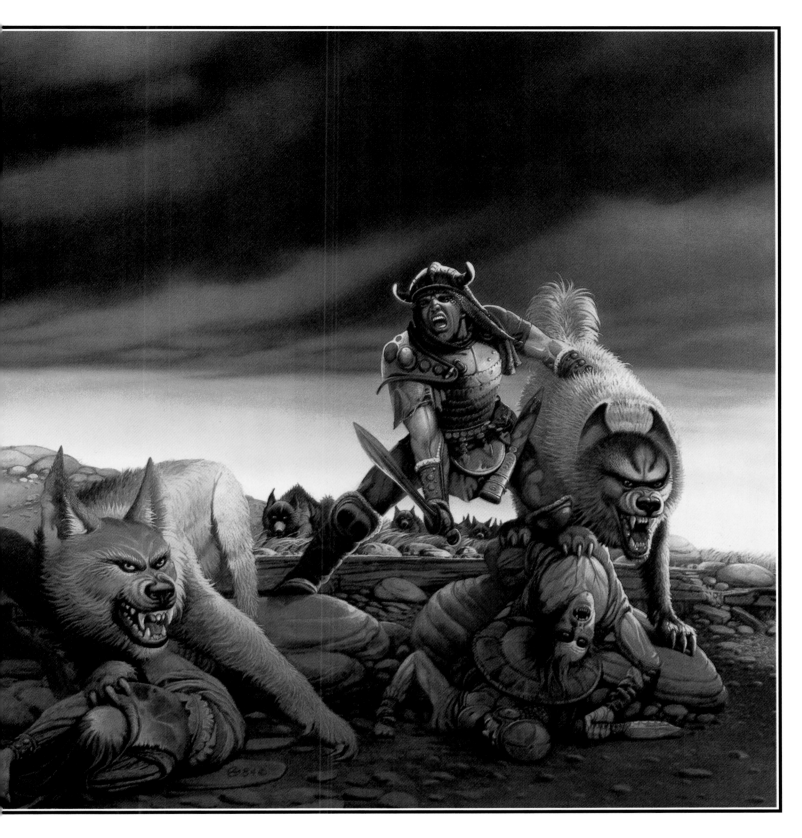

LEADER OF THE PACK 1984
77 × 56 cm. Illustration for book cover.

Waterproof inks, gouache and airbrush on
illustration board.

*What pleased me about this picture was the lighting on
the main figure. This is the final problem after
composition and anatomy in a picture – imagining the
light source and how it falls on the subjects. It can never
be perfect in the absence of studio lighting and live
models but in this case I was quite satisfied.*

closely to author's descriptions but this case was a slight exception. The
dragons in the book sounded almost horsey and very little like his own
conception of them. The *Sentinel* shown overleaf is more his own than
McCaffrey's although with the background he remained true to the spirit
of the book; he hopes she does not mind too much. The original picture is
huge, in proportion to his love of the subject.

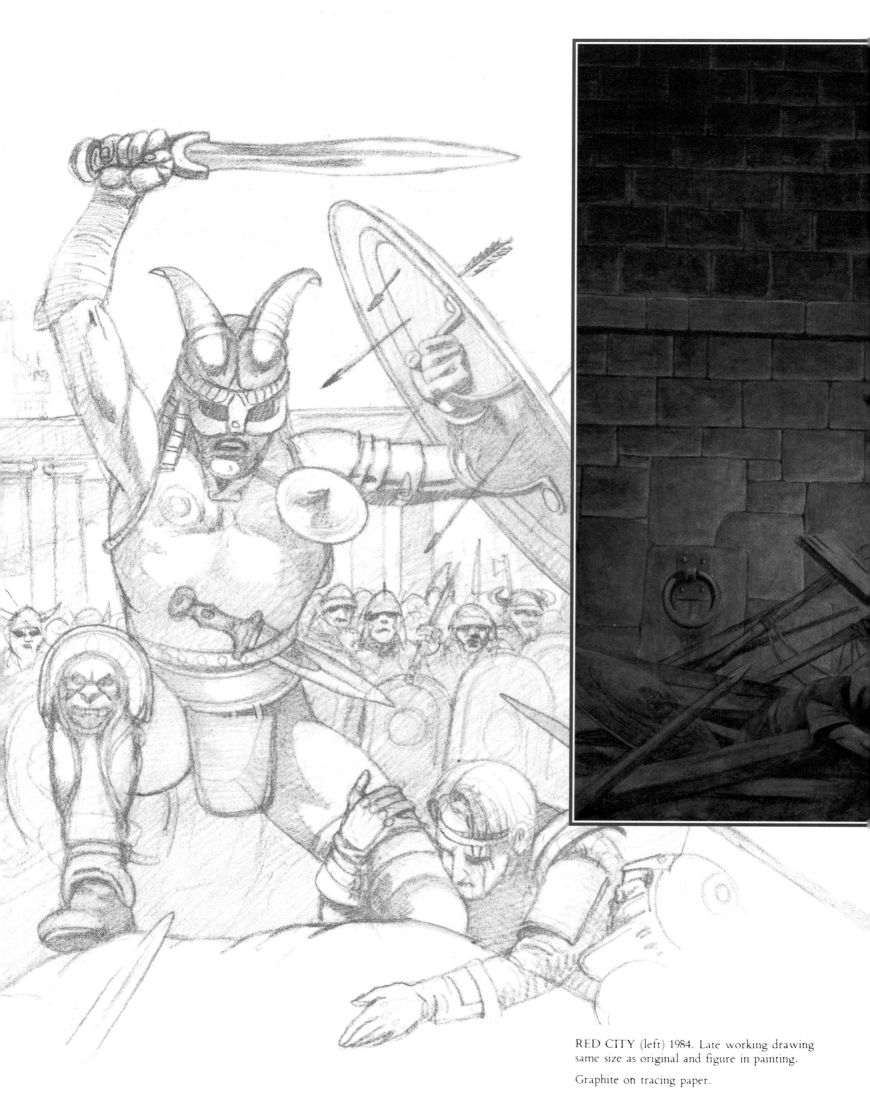

RED CITY (left) 1984. Late working drawing
same size as original and figure in painting.

Graphite on tracing paper.

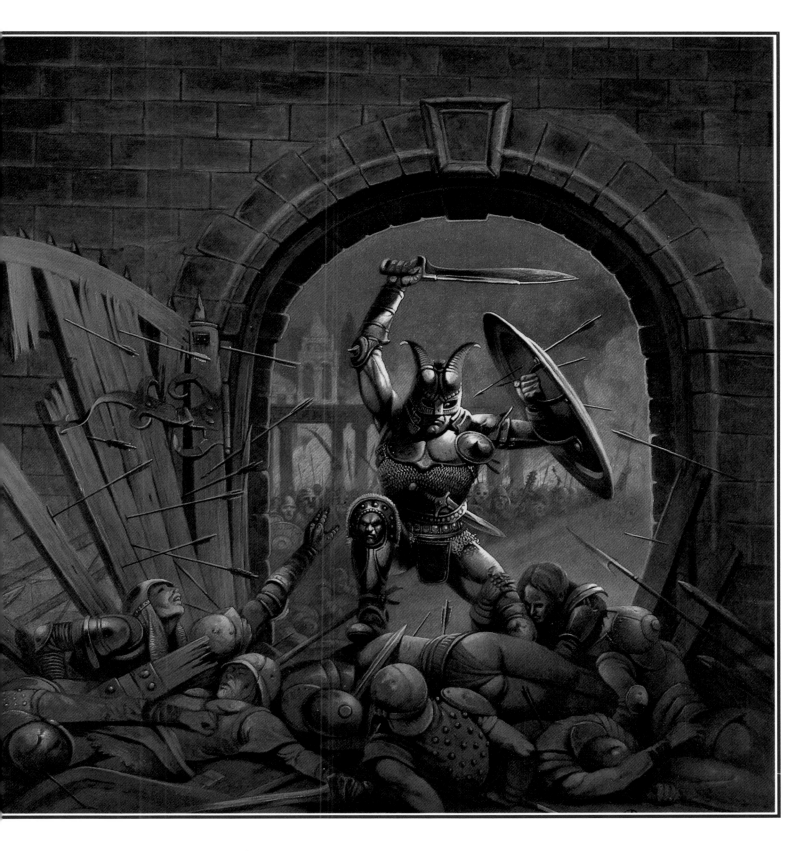

RED CITY 1984 77 × 63 cm. Illustration for
book cover.

Acrylics on illustration board.

*This completes the set of three books featuring the
adventures of the hero Eric John Stark.*

(overleaf) THE SENTINEL 1979
108 × 71 cm. Illustration for book cover.

Waterproof inks, gouache, fabric dyes and
airbrush on illustration board.

*This creature is a compromise between my own idea of a
dragon and the one in the book, this led me to give it six
limbs instead of the four which I have always felt would
make a more feasible dragon.*

The Sentinel

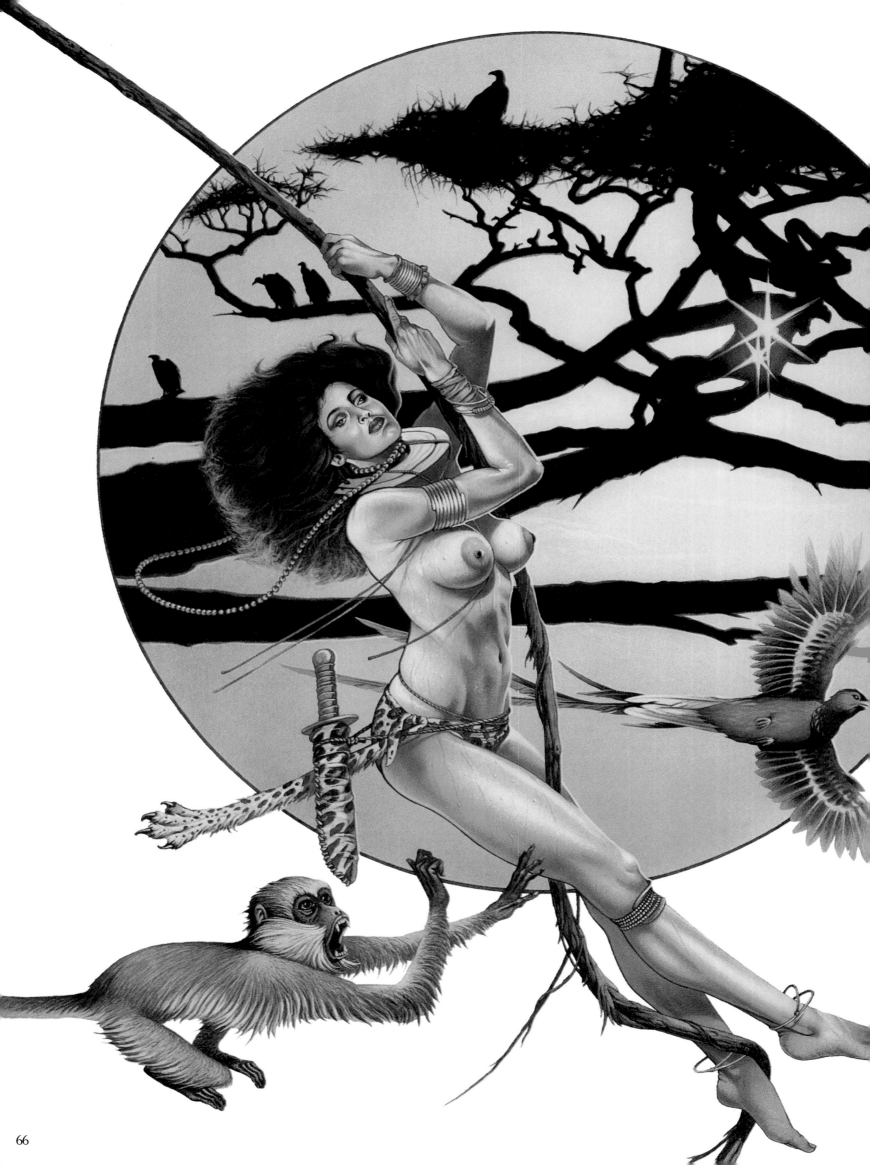

Chapter IV

A mazons — a fabulous race of female warriors in Scythia; thence coming to mean any female warrior.

In the *Iliad* the Amazons are one of several allies who try to prevent the fall of Troy. Achilles killed their queen Phentesilea in a duel and then was stricken with remorse when he removed her helmet and saw how beautiful she was.

Achilleos' occasional preoccupation with female warriors was focussed by the suggestion that he produce a portfolio of them for publication. Some of his previous work fitted naturally into the collection, as with the Raven pictures, but most were produced specifically for the portfolio and later calendar.

Their costumes range from the distant past to the distant future, Amazons through the ages, and what is most noticeable in the historical costumes is their carefully researched detail. Boadicea, for instance, on page 85 is wearing an authentic mixture of Celtic and Roman costume, the sword and corselet having been stolen from the bodies of the vanquished conquerors of her land.

Is she, then, Achilleos' idea of what the Icenian queen really looked like? Sadly no, he says. She is a twentieth century pin-up in the idealised costume of a first century Celt. If he were asked to produce a design for a serious historical film the result would be quite different; her complexion would be weathered for a start, her eyebrows unplucked and she would be wearing no lipstick. Also she would be considerably more fierce since the Celts were famous headhunters and the revenge the real Boadicea took on the Romans and their collaborators was unmercifully savage.

It is true the female in this picture has a grave look, as if aware of the tragic events which sparked Boadicea's rebellion, but it goes no further than that.

His aim in this and others of the series is simply to let the beauty of the women set off the beauty of their costumes, and vice versa. They are brought together in an impossibly ideal world in order to make the most of their essential beauty. The pictures work because they twin two of his major interests, female beauty and the technology of war which he sees as the shaping force of history.

To Achilleos this use of the weapons and costume, whether real or imagined, is not frivolous because apart from their purpose in battle these things have always had a certain glamour and beauty which is what he set out to capture.

One of Achilleos' sisters, Melitsa, is a trained fashion designer who finds his fame as a pin-up artist amusing because as a youth he found female

(above) AMAZONS lettering 1979 56 × 33 cm. Illustration for portfolio.

Waterproof inks, gouache and airbrush on illustration board.

I felt I had to do this lettering myself as what the publishers wanted to use was only a poor copy of some that had appeared elsewhere. I designed it as an object of beauty, as with any other illustration.

(left) JUNGLE GIRL 1979. Illustration for portfolio. Missing.

Waterproof inks, gouache and airbrush on illustration board.

I always felt this would make a good picture for a certain kind of movie poster.

figures impossible to draw. Rampaging Vikings and barbarians waving swords and axes were fine, they would invade any page in their hordes at the touch of his pen, but no females with any life in them. They only came later, painstakingly, and proof of his belief that anything can be achieved in art given a certain basic talent and a lot of hard work.

It may be imagined that he has a magic cupboard in which live and luscious models appear whenever he needs a fresh subject but regretfully, he says, this is sadly not so. He would love a large bright studio and beautiful models to pose for him but all he has is a crowded room at the back of his house, ideas to be given form and shelves of reference material to guide him. Also, the deciding factor, he has deadlines to keep.

All his hundreds of paintings have come from just sitting alone at work in his room. Unlike the Pre-Raphaelites, whom he envies, he has no time to go out and paint everything at first hand, going to Scotland or Palestine or wherever to capture the authentic flavour of a background and taking months or years over one picture. He must work in a hurry and so he has built up a vast collection of books to provide him with reference material.

He works like Frankenstein on his women, he says, constructing them a limb at a time and drawing on reference photographs for details, taking a head from one girl, an arm from another and so on. To fit the pieces together into a coherent whole he relies on his understanding of anatomy. Artistic licence is permitted but only occasionally and within strict limits, this is how he achieve his almost photographic realism.

His method of working underlines a fact that he repeatedly stresses, that his pictures are designs more than paintings. Achilleos is still far from satisfied with himself as a painter although he takes every opportunity to exercise this skill. He sees himself as a designer who uses painting to achieve certain effects, that is all. Pure painting with oils is something reserved for the future.

Partisan (opposite) is one of several pictures continuing the theme of the *Amazons* portfolio and calendar which Achilleos hopes one day to gather into a second collection.

Harem Guard, (page 70) is another commissioned by *Men Only*. It is an example of how he sometimes succeeds in adapting commissions to suit his own purpose, using them to pursue his own interests while still satisfying the customer.

Lovers (page 2) is an example of how sometimes he has adapted a commission to suit his own purpose and failed to satisfy the client. It dates from what he now considers his self-indulgent period. Commissioned as a book-cover, it lost much of its impact when shrunk to the necessary size.

The above picture was Achilleos' first serious attempt at a pin-up, done in his spare time at Arts of Gold studios. He was already giving work to *Men Only* at the time, but only comical drawings. It was tackled rather in the manner of Mucha, filling in definite outlines with colour and decoration. He submitted it to *Men Only* purely on the off-chance and was as delighted by its reception as they were with the work. The costume has since been slightly modified.

Celtic Queen was prompted by a passing reference to Boadicea in an article about women's breasts among other things which Achilleos was given to illustrate. Apart from the mention of her name the article had nothing at all to do with Amazons or ancient Celts but it proved excuse enough in view of the quality of the work.

In the mid 1970s this was tolerated and even sometimes welcomed but it has since become taboo with girly magazines. More examples are shown in *Beauty and the Beast*.

(above) THE GREEK AMAZON 1980 71 × 47 cm. Medium sample previously unpublished.

Oils and airbrush on hardboard.

This was an experiment to see if I could achieve the same effects with oil paint as with my usual mediums, but it didn't really work and I have not tried it again.

(right) THE PARTISAN 1982 76 × 54 cm. Illustration for calendar project, previously unpublished.

Waterproof inks, gouache and airbrush on illustration board.

This was the first picture I did for a proposed follow-up to my 1983 calendar, which never happened. Amongst others intended were a Samurai, a buccaneer, a gladiator and a cave-girl.

(left) HAREM GUARD 1980 77 × 46 cm.
Editorial illustration.

Waterproof inks, gouache and airbrush on
illustration board.

This was done for an article that appeared in **Men
Only** *magazine and I used the chance to express my
love of Orientalist subjects. Careful consideration was
given to the costume and hardware but as always a
balance had to be kept between what I wanted to do and
what the readers wanted to see. Like others in this vein,
it is not to be taken too seriously. They are like
costumes for adult pantomimes.*

(right) ELEPHANT WALK 1978/1985
96 × 59 cm. Originally illustration for book
cover.

Chroma-colour, acrylics, waterproof inks,
gouache and airbrush on illustration board.

*I never felt quite sure of the girl in this picture so I used
this chance to go over her and change a few details. But
I feel she is still upstaged by the magnificent African
elephant.*

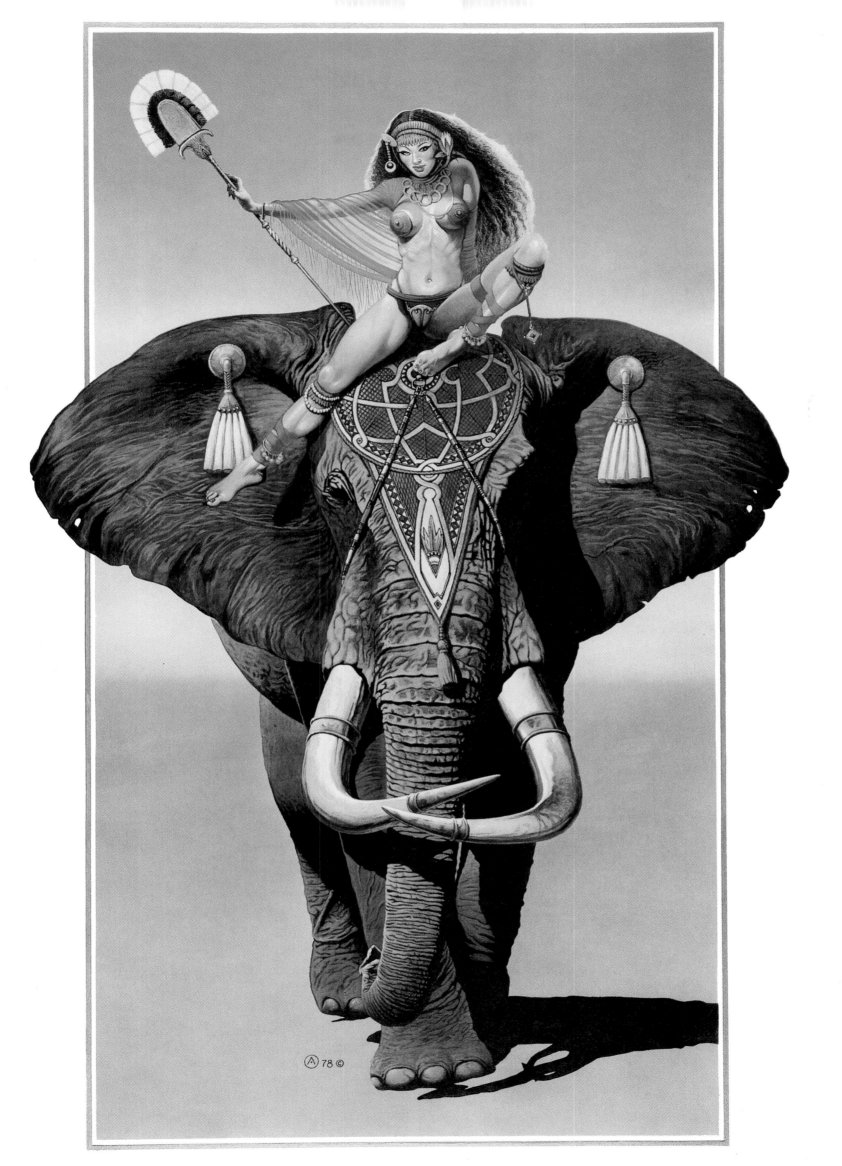

In the future Achilleos would like to produce more series of pictures. Not just another Amazon collection, for which he already has a long list of attractive subjects, but perhaps one of famous couples like Anthony and Cleopatra, Samson and Delilah, Adam and Eve or Agamemnon and Clytemnestra. Or famous women of history and myth such as Helen of Troy, Salome, Lady Macbeth and Joan of Arc. For these he is only awaiting a practical opportunity.

Whether a vampire is strictly speaking an Amazon is a question probably best left to purists and psychologists; but one thing is certain, *The Birth of a Vampire* (page 77) is no pin-up.

The original was to have Count Dracula standing over the grave to welcome his new disciple into the world but in the event there was not enough time and his place was taken by the Celtic cross as shown. This reduced Dracula to a vampire bat flitting in the foreground, much to his fury no doubt.

When he received this commission he had to choose between the vampire and a robot-girl, which were both subjects he had wanted to paint for a long time, but again the time factor decided things because for the robot-girl he would have had to experiment with technique. Time is a tyrant Achilleos has had to learn to live with.

The Indians (pages 78 & 79), while being primarily girly pictures nevertheless reflect deeper preoccupations, as with Boadicea. Red Indians before the arrival of Europeans are to Achilleos a prime example of the perfect state of Man, being hunter-gatherers living in harmony with nature instead of destroying it.

(above left) FIRST LADY 1974/1982
66 × 40 cm. Medium exercise/illustration for calendar.

Waterproof inks, gouache and airbrush on illustration board.

Prior to this I had no idea how to draw women. This picture was my first success and led to all the others.

(above right) CELTIC QUEEN 1976
Editorial illustration. Collection J.B. Rund, USA.

Waterproof inks, gouache, fabric dyes and airbrush on illustration board.

My favourite part of this picture is the ram's horn helmet which is not strictly historical but is based on Celtic craftsmanship.

(right) STARSHIP CAPTAIN 1981
54 × 35 cm. Illustration for book cover/calendar.

Waterproof inks, gouache and airbrush on illustration board.

This figure was designed to stand under the giant EAGLE MONUMENT shown on page 6. These have never been published together as intended.

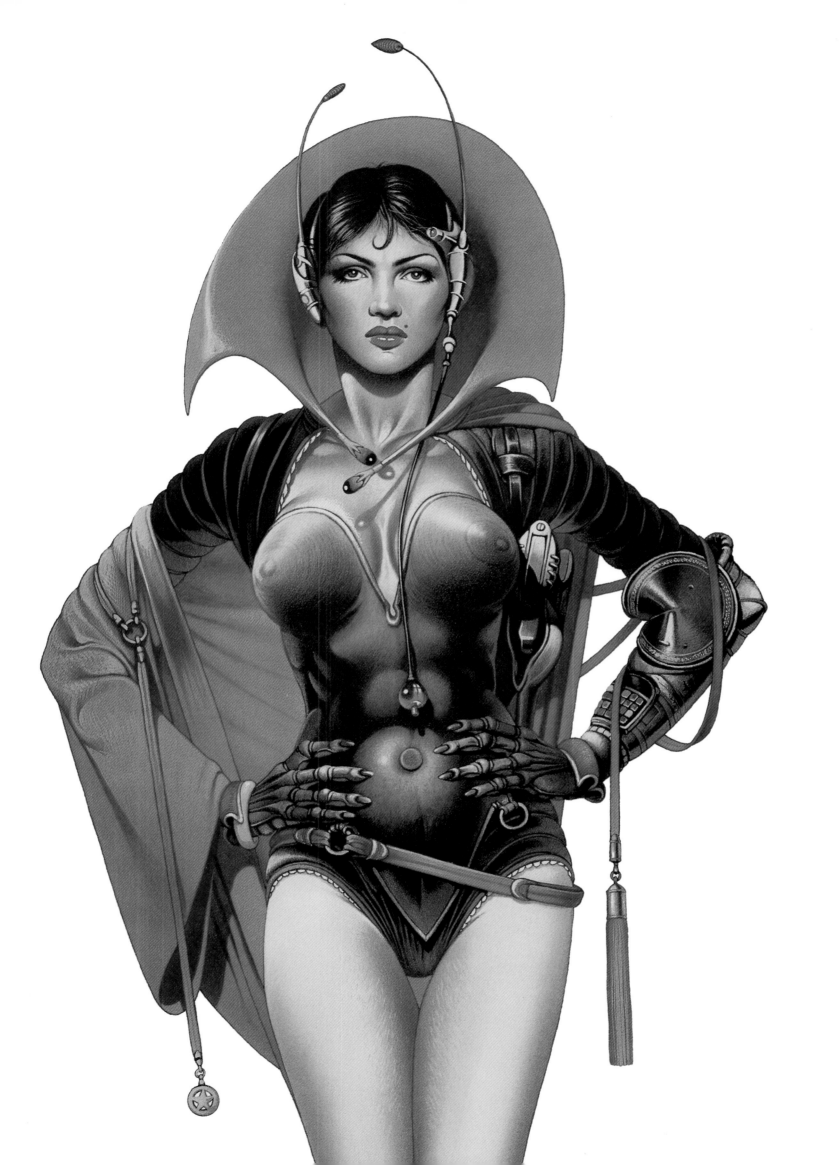

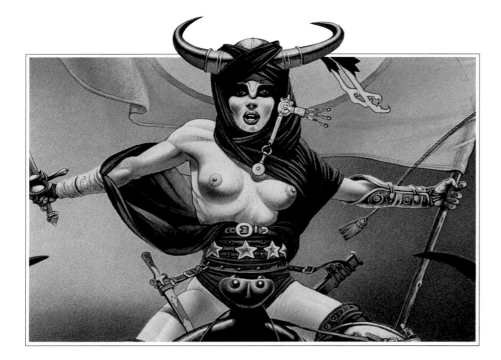

The Maasai woman too (page 81) appeals to this romantic belief. When any wildlife programme comes on television Achilleos tells his children to watch it while they still can because by the time they grow up it will probably all be gone, the Maasai and the Zulu too.

Raven's Oath (page 82) is published here in its entirety for the first time. For the book cover the upper and lower portions had to be chopped off. Achilleos knew this would happen when he began the picture but went ahead anyway for his own satisfaction because this is how he felt it should be. The design of the central figure demanded space above and that in turn demanded that the frame be extended downwards. This was one of the occasions when perfectionism has compelled him to put more into a picture than is strictly justified by the commission, as is usually the case with Moorcock covers because of his admiration for the writer.

The Botanist (page 83) was painted for the *Amazons* portfolio and developed from a speculative idea about genetic engineering. Achilleos imagined a time when the science has become so far advanced that almost any creature can be designed according to need or fancy. This led to the large cockerel-headed bird intended for personal transport. Then he imagined a Startrek-like journey into space to investigate new worlds, and the Botanist taking her bird along as a method of transportation.

(above left) Detail of STANDARD BEARER 1978.

The original look of Raven. The trends of the time demanded more explicit sexuality than now on book covers.

(above) STANDARD BEARER first concept rough.

(right) STANDARD BEARER 1978/1984
76 × 54 cm. Illustration for book cover/jigsaw puzzle.

Ink-line, waterproof inks, gouache, fabric dyes and airbrush on illustration board.

I was approached with a view to having the picture published as a jigsaw puzzle but there were reservations about her exposed breasts, so I changed it to this which would be a more feasible costume in the circumstances anyway.

(overleaf) Detail of RAVEN 1977/1984
76 × 54 cm. Illustration for book cover.

Waterproof inks, fabric dyes and airbrush on illustration board.

This was intended for volume II of the **Raven** *book series but for various complicated reasons was not used, but it was used later on the cover of Uriah Heep's* **Fallen Angel** *LP. It is shown here without the background.*

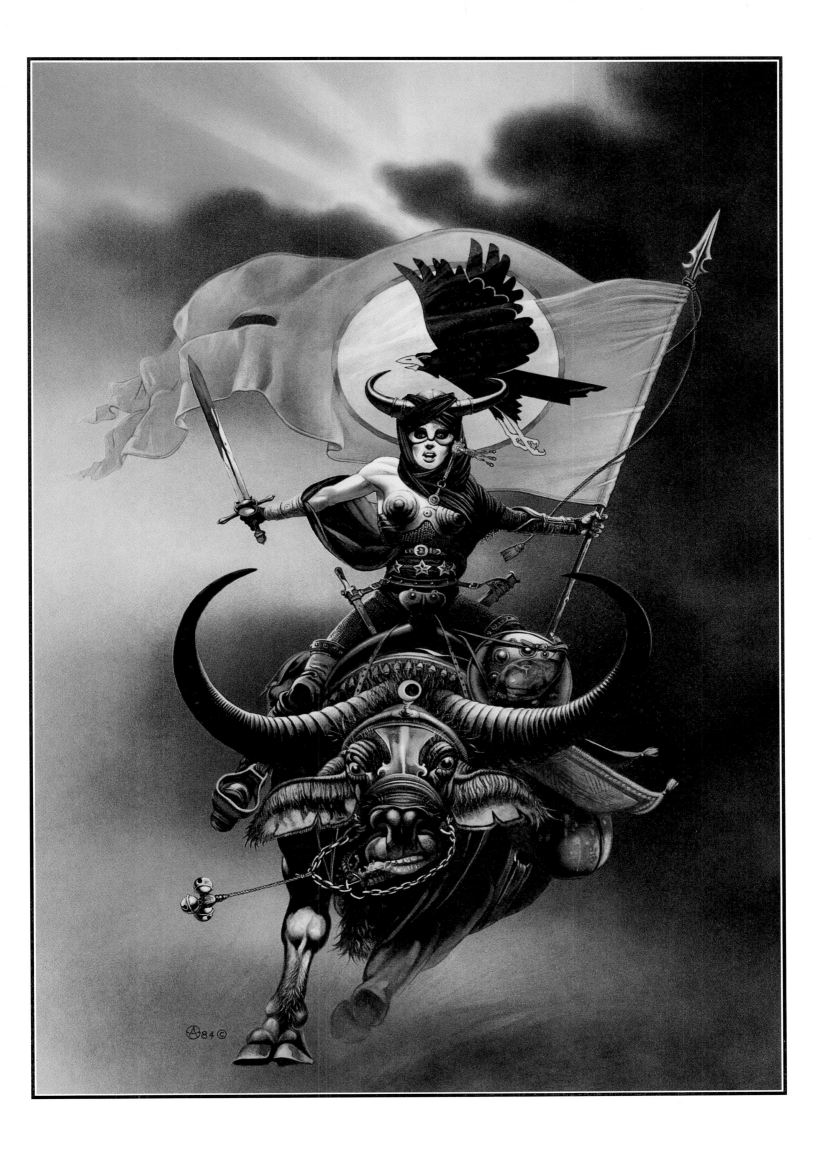

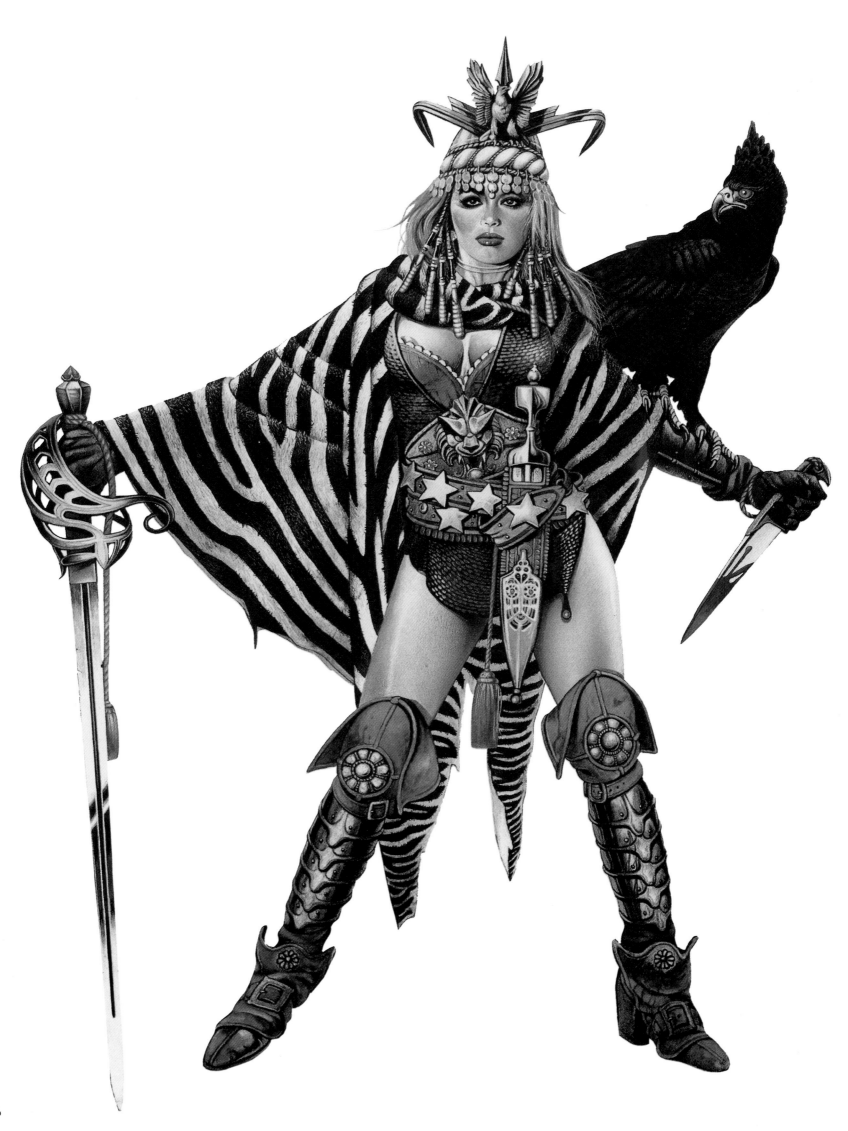

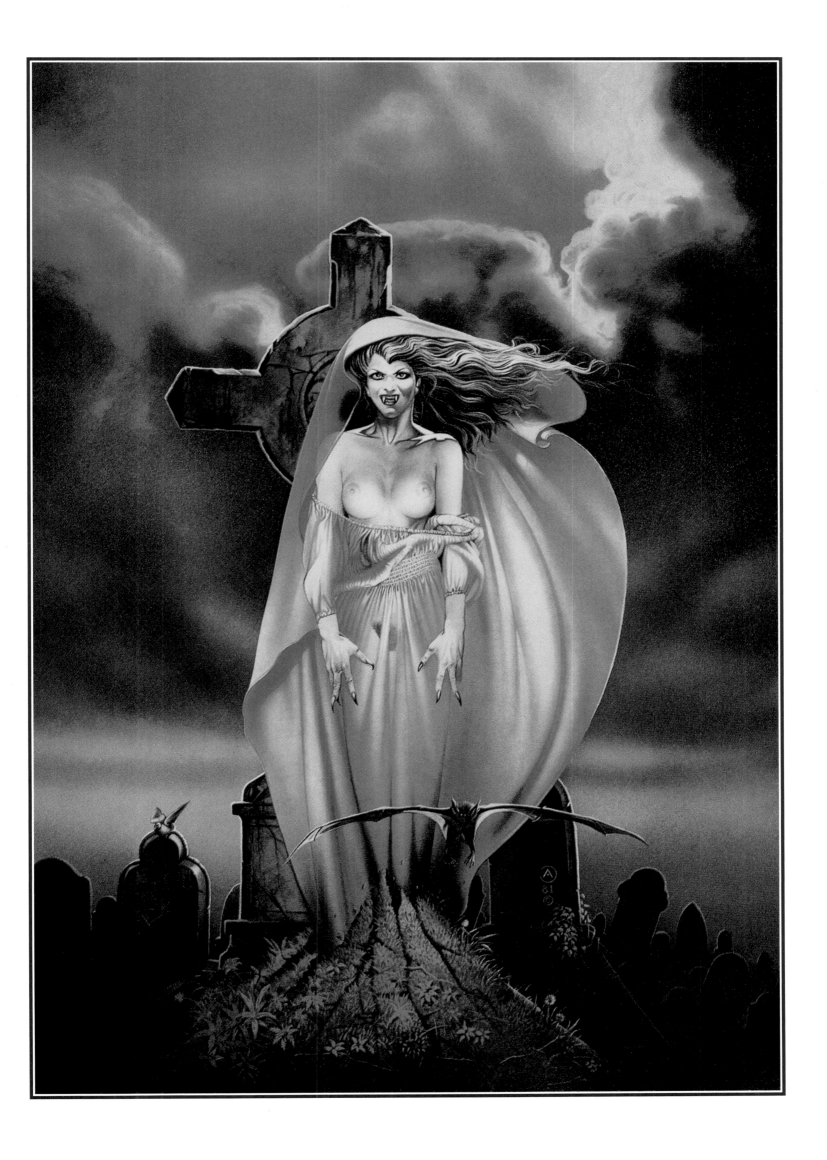

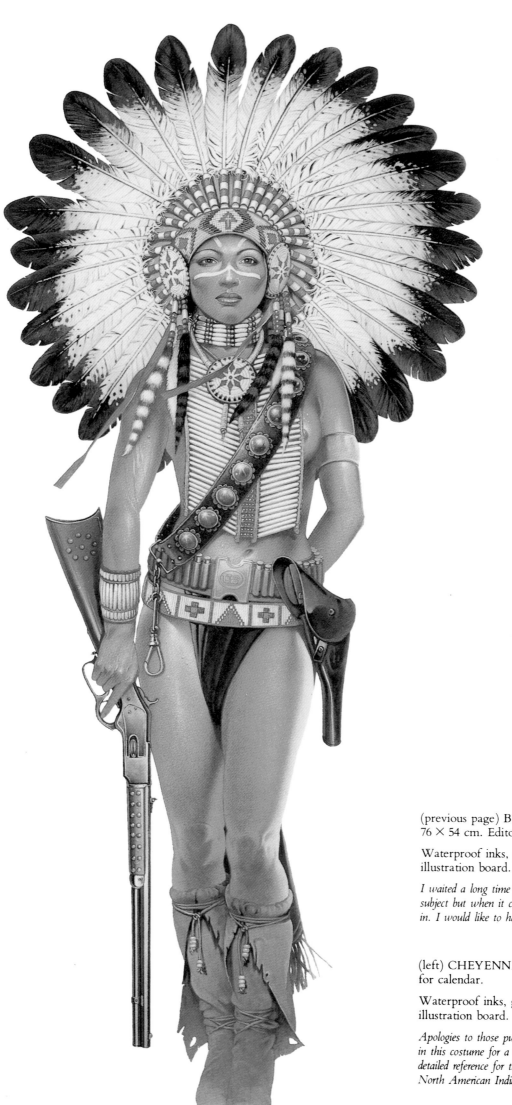

(previous page) BIRTH OF A VAMPIRE 1981
76 × 54 cm. Editorial illustration.

Waterproof inks, gouache and airbrush on
illustration board.

*I waited a long time for an opportunity to paint this
subject but when it came I had only a few days to do it
in. I would like to have another go.*

(left) CHEYENNE 1983 83 × 43 cm. Illustration
for calendar.

Waterproof inks, gouache and airbrush on
illustration board.

*Apologies to those purists who will no doubt find fault
in this costume for a Cheyenne warrior. I could find no
detailed reference for the variation in costume of the
North American Indian tribes.*

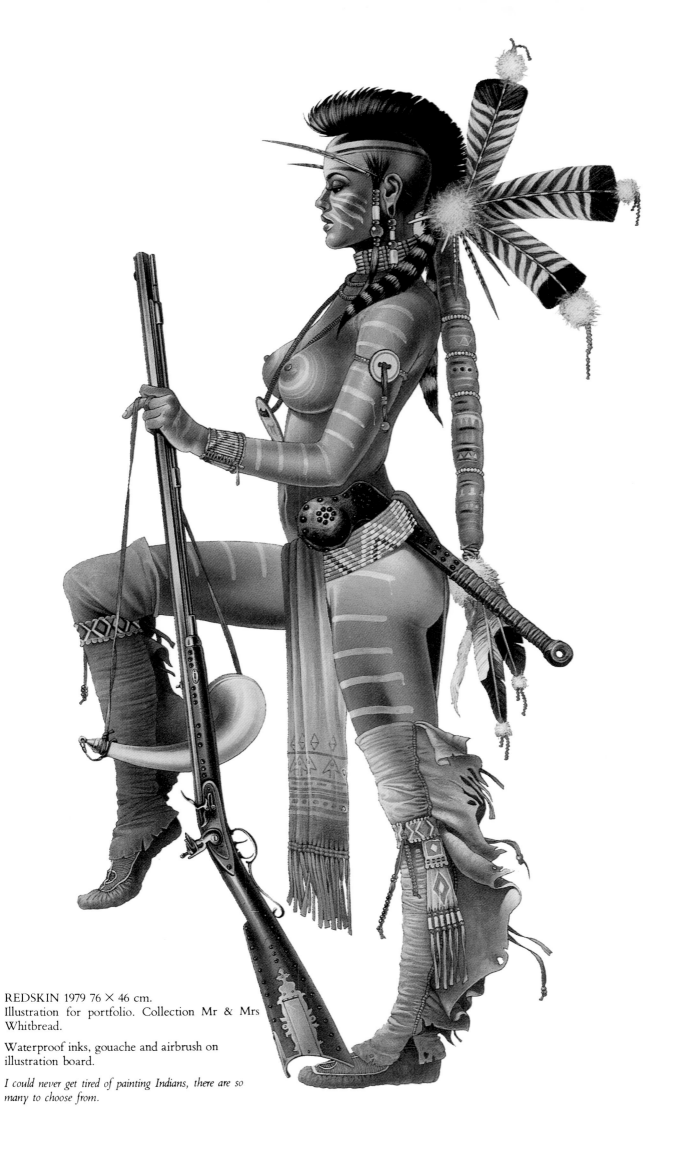

REDSKIN 1979 76 × 46 cm.
Illustration for portfolio. Collection Mr & Mrs Whitbread.

Waterproof inks, gouache and airbrush on illustration board.

I could never get tired of painting Indians, there are so many to choose from.

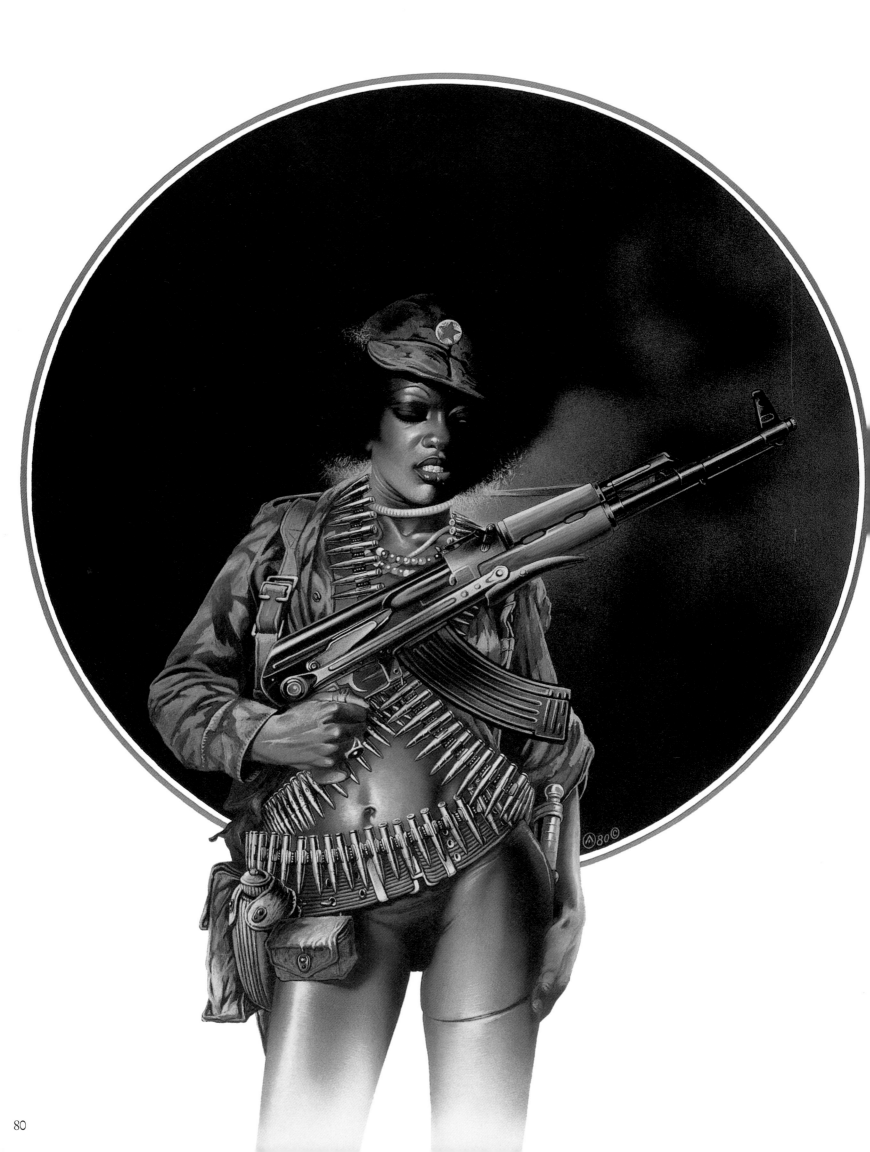

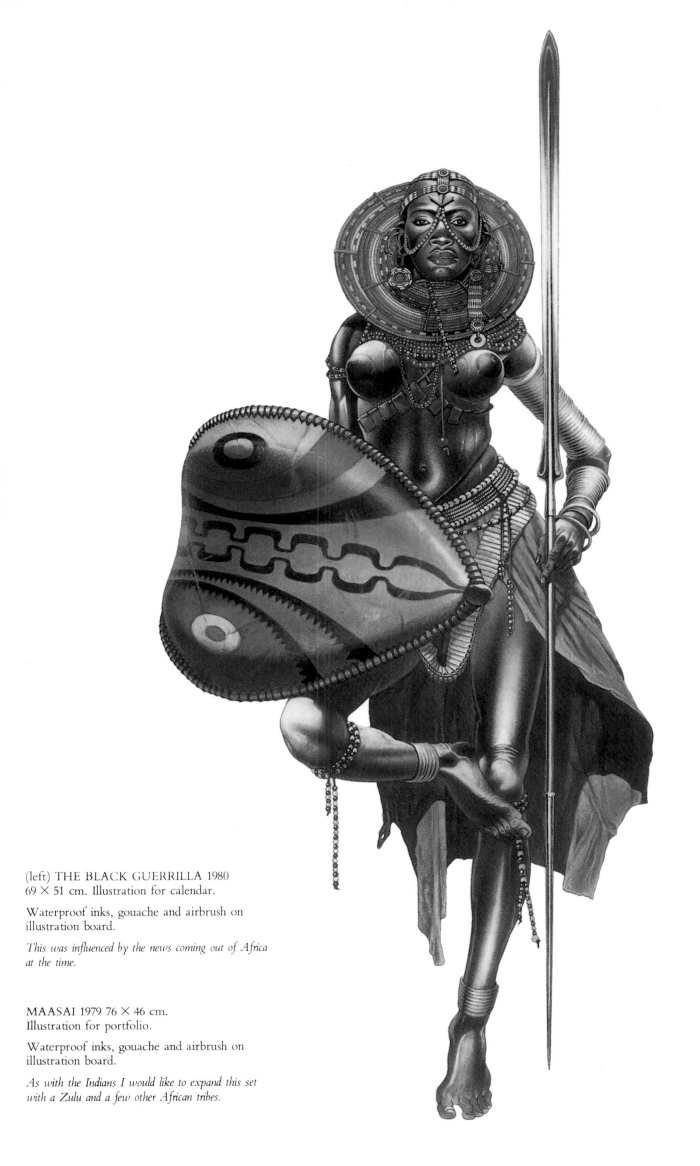

(left) THE BLACK GUERRILLA 1980
69 × 51 cm. Illustration for calendar.

Waterproof inks, gouache and airbrush on
illustration board.

*This was influenced by the news coming out of Africa
at the time.*

MAASAI 1979 76 × 46 cm.
Illustration for portfolio.

Waterproof inks, gouache and airbrush on
illustration board.

*As with the Indians I would like to expand this set
with a Zulu and a few other African tribes.*

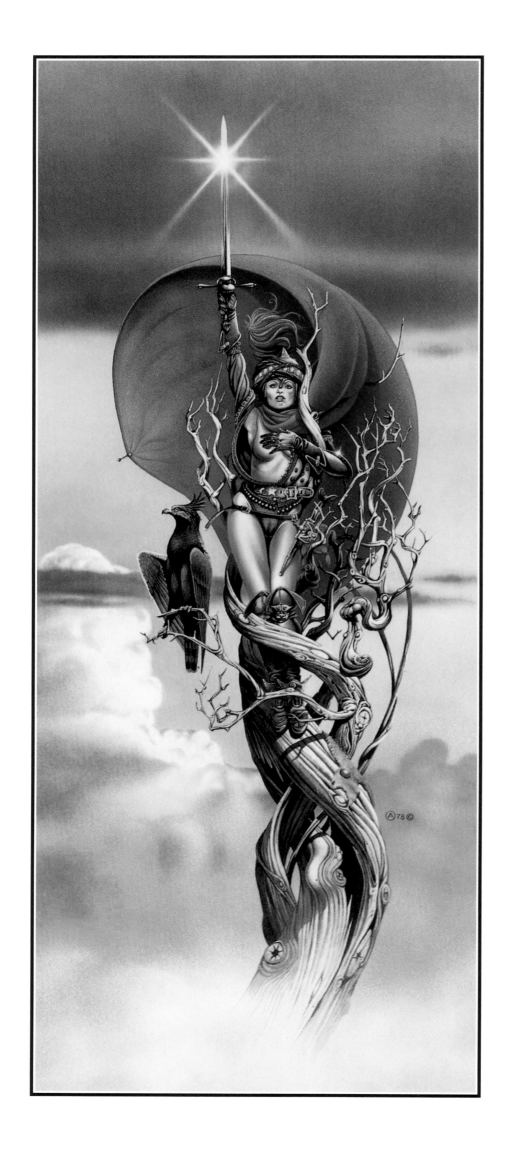

(above) DEADLIER THAN THE MALE 1982
73 × 37 cm. Illustration for book cover.

Waterproof inks, gouache and airbrush on
illustration board.

(left) RAVEN'S OATH 1978 107 × 50 cm.
Illustration for book cover.

Waterproof inks, gouache, fabric dyes and
airbrush on illustration board.

*This picture is shown here in its entirety for the first
time. The design demanded a long narrow picture
regardless of the fact that it could not be shown as such
on the book cover.*

(right) THE BOTANIST 1978 76 × 54 cm.
Illustration for portfolio.

Waterproof inks, gouache, fabric dyes and
airbrush on illustration board.

*The scientist from a deep space exploration vessel
investigating new plant life accompanied by her friend
and personal transport.*

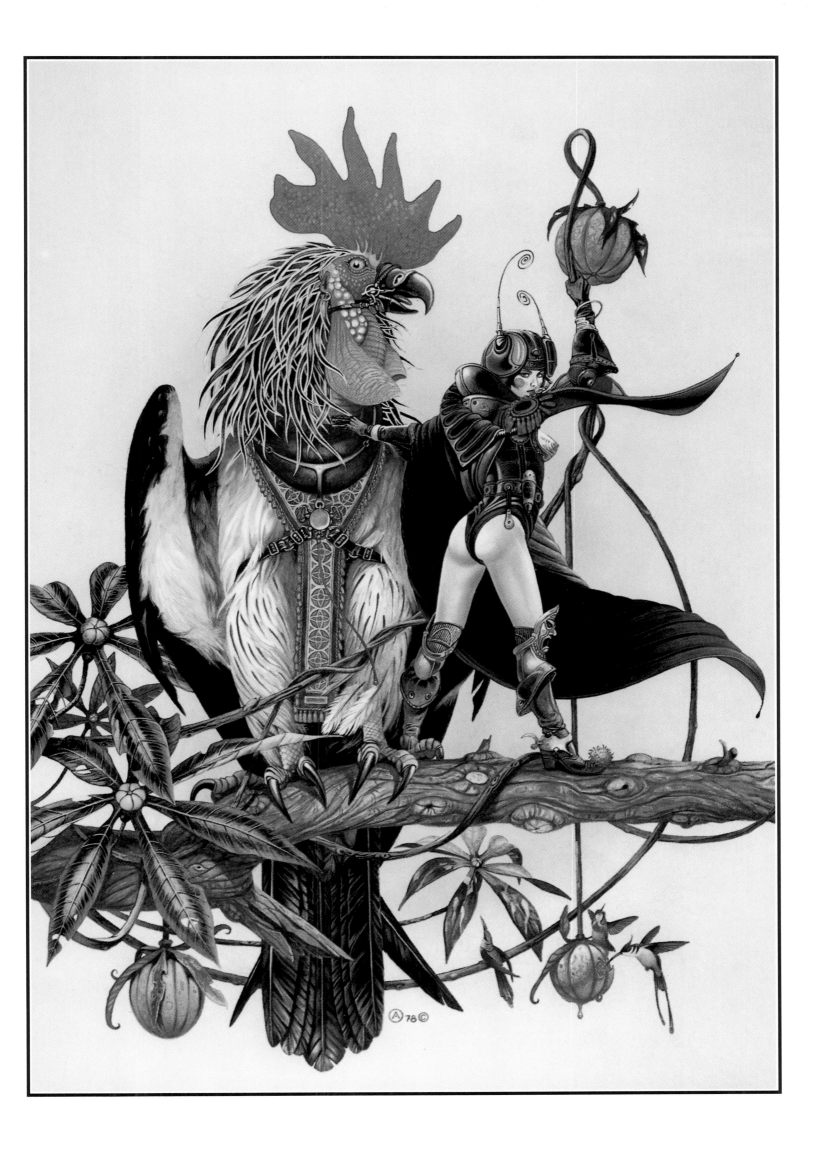

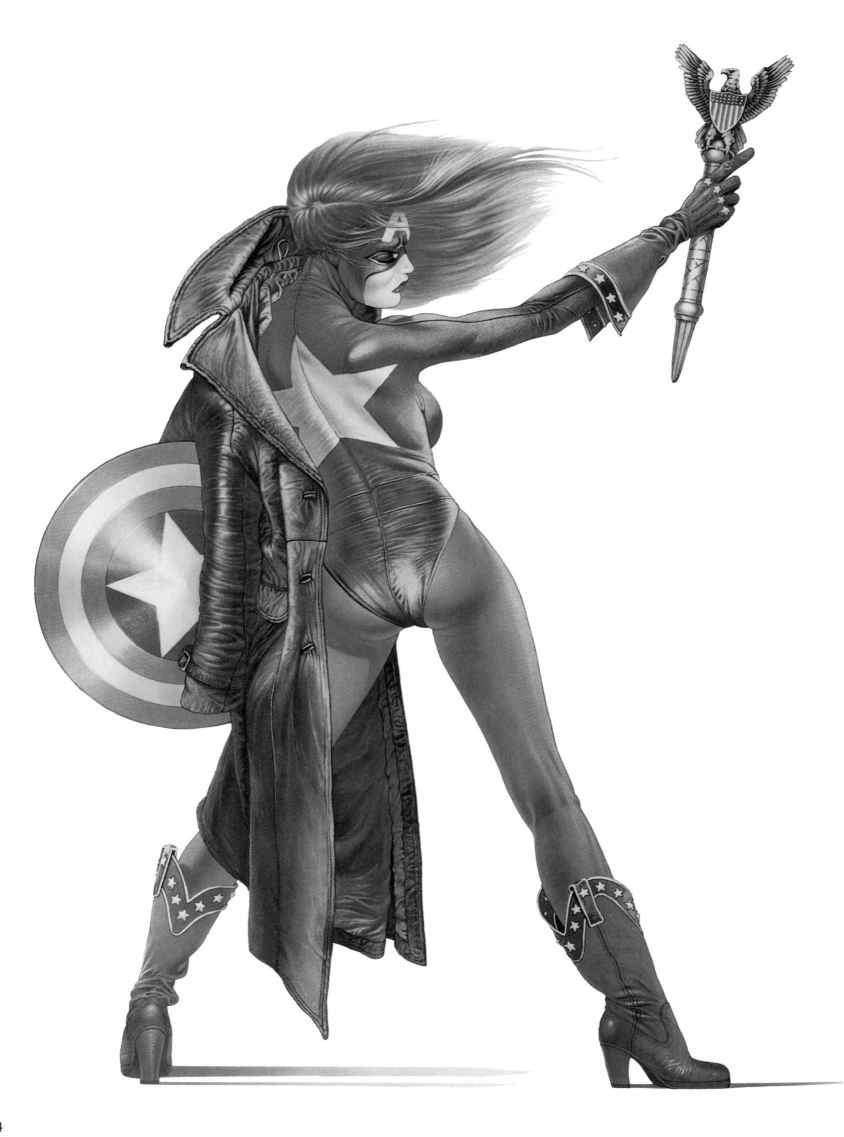

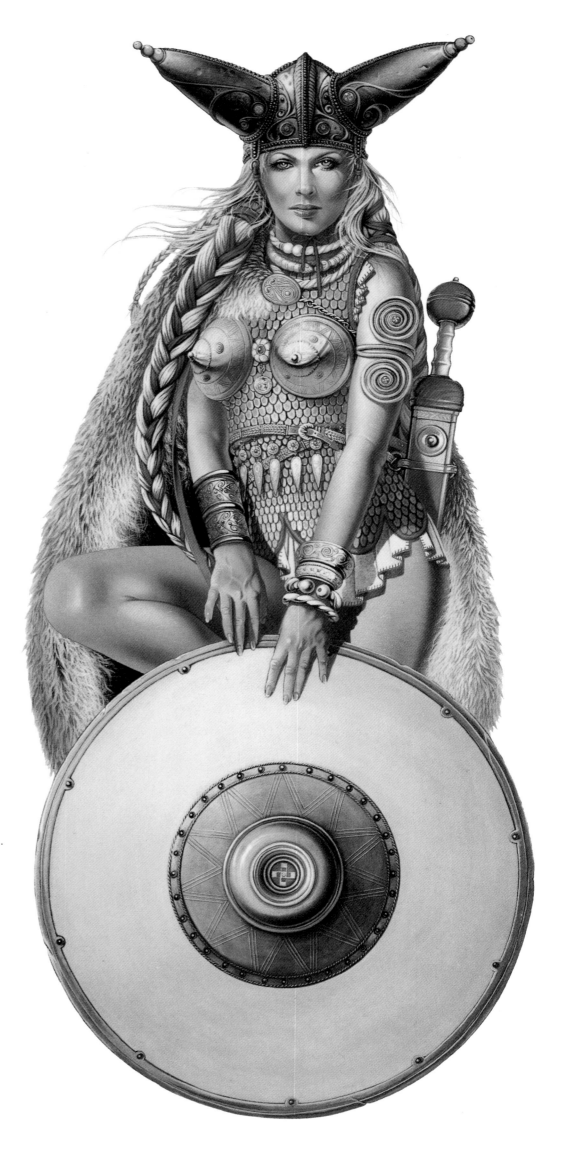

(left) MISS AMERICA 1979 76 × 46 cm.
Editorial illustration. Collection J.B. Rund, USA.

Waterproof inks, gouache and airbrush on
illustration board.

*For this picture I used my wife Angie to model the
leather coat, something I hardly ever do.*

BOADICEA 1982/1985 78 × 38 cm. Illustration
for calendar.

Chroma–colour cell paints, waterproof inks,
gouache, fabric dyes and airbrush on illustration
board.

*This started out as a picture of a Viking but ended up
as a Celt of 60 AD. Since its publication in the 1983*
Amazons *calendar I have revised the costume slightly,
as shown here for the first time.*

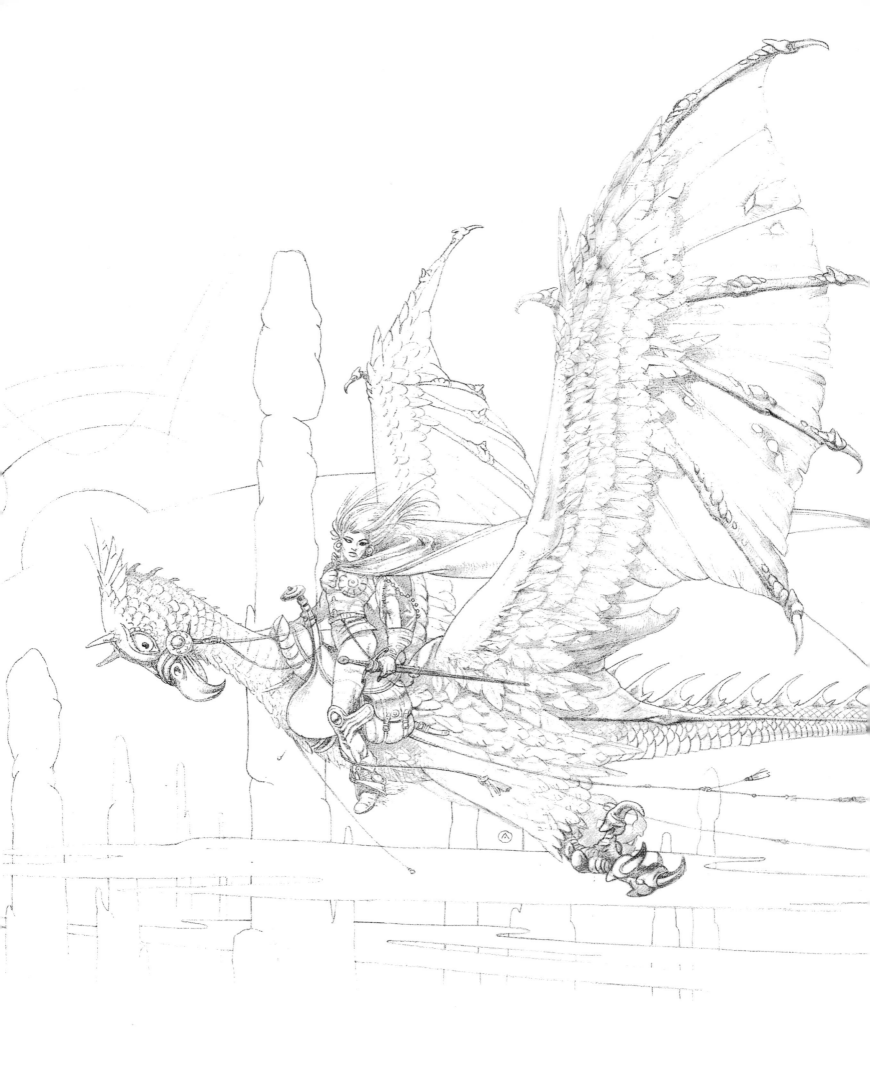

Chapter V

FILM-WORK

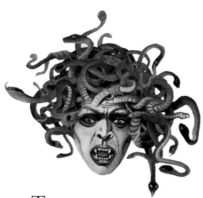

The animated film *Heavy Metal* was one of Achilleos' first involvements with the film industry and also his greatest to date. He was delighted to be offered the commission even though he found himself tripping over the shadow of his old hero again. Frank Frazetta had been offered it first but had been unwilling or unable to take it on.

What the film-makers wanted from him was a female warrior for the final heroic fantasy sequence of the film, an Amazon was to carve a trail of vengeance through a marvellous world that had fallen into barbarism.

Achilleos was flown across the Atlantic and worked with producers and screenwriters in Montreal providing the basis for Taarna and her entourage. Her flying steed was in the end modified from his reptilian original shown opposite because this would have proved far too difficult to animate. It became a simple, stylised bird but for the promotional poster Achilleos was allowed to produce his own more detailed and realistic version of it.

His picture (shown overleaf) was chosen from three produced by different artists working on the film.

Achilleos very much enjoyed his part in the making of *Heavy Metal*; it was marred only by the chance that he might be drawn into legal action being taken by the company against another which wanted to use the same title on a film. By coincidence he had previously done some promotional work for the other film and was possessed of valuable inside information which could be used in court but in the end it was settled before going that far. The other film appeared under the title *Riding High* starring the stunt rider Eddie Kidd and the work he did can be seen on page 93.

The first ever chance Achilleos was given to work in films had come while he was still with Arts of Gold studios. Ray Harryhausen, who was working on the *Sinbad* films needed an assistant and offered him the job. But there was the old problem — the studio would want to keep his original work. So the offer was turned down.

Years later Harryhausen contacted him again while putting the finishing touches to the Medusa sequence in *Clash of the Titans*. The film needed a poster and after seeing a rush at Pinewood studios Achilleos produced a rough concept which met with everyone's approval except the main man from America, who said it was much too frightening for children. Achilleos protested and argued but to no avail. He was left baffled and disappointed by this until he later saw the American poster which was not too dissimilar to his own concept.

(above right) MEDUSA'S HEAD 1981. Detail from CLASH OF THE TITANS rough film concept.

HEAVY METAL early concept drawing 1980 98 × 67 cm.

Graphite on tracing paper.

My first intepretation of Taarna and her flying steed. This character design proved to be much too difficult for the animation process and so, with the creature particularly, was in the end simplified for the film.

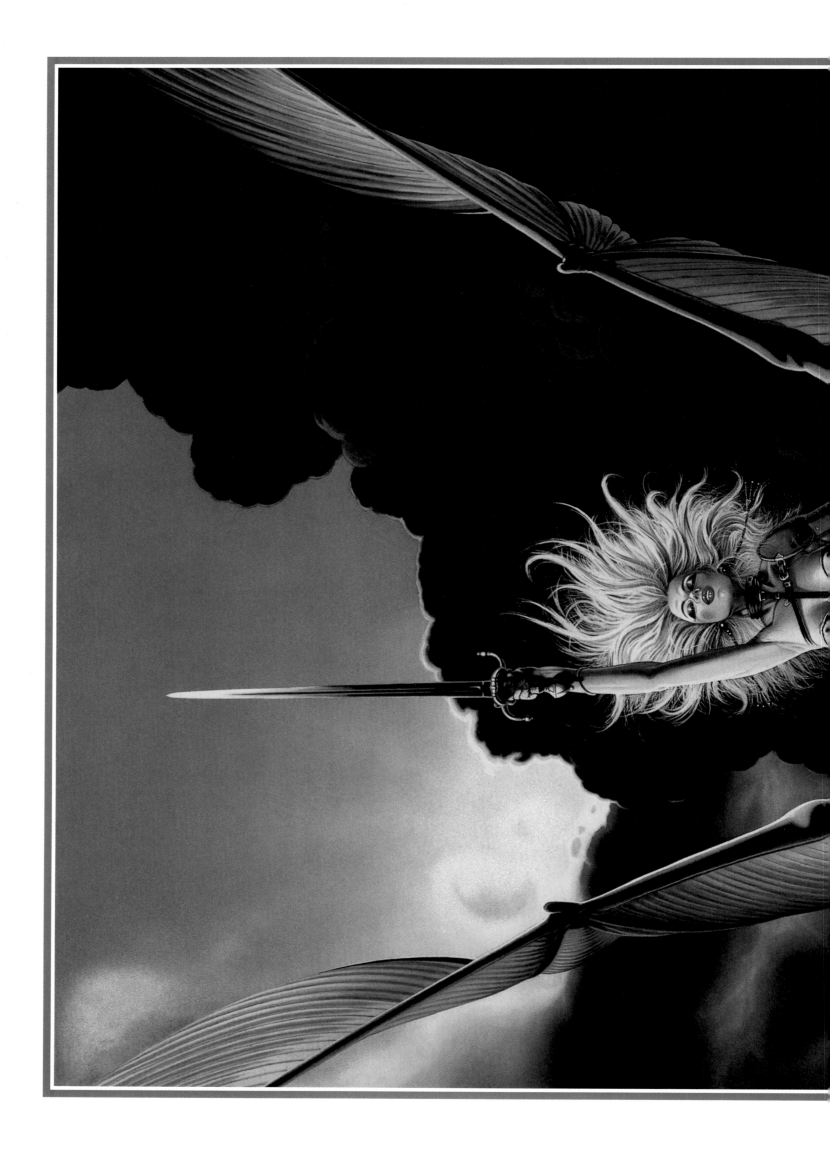

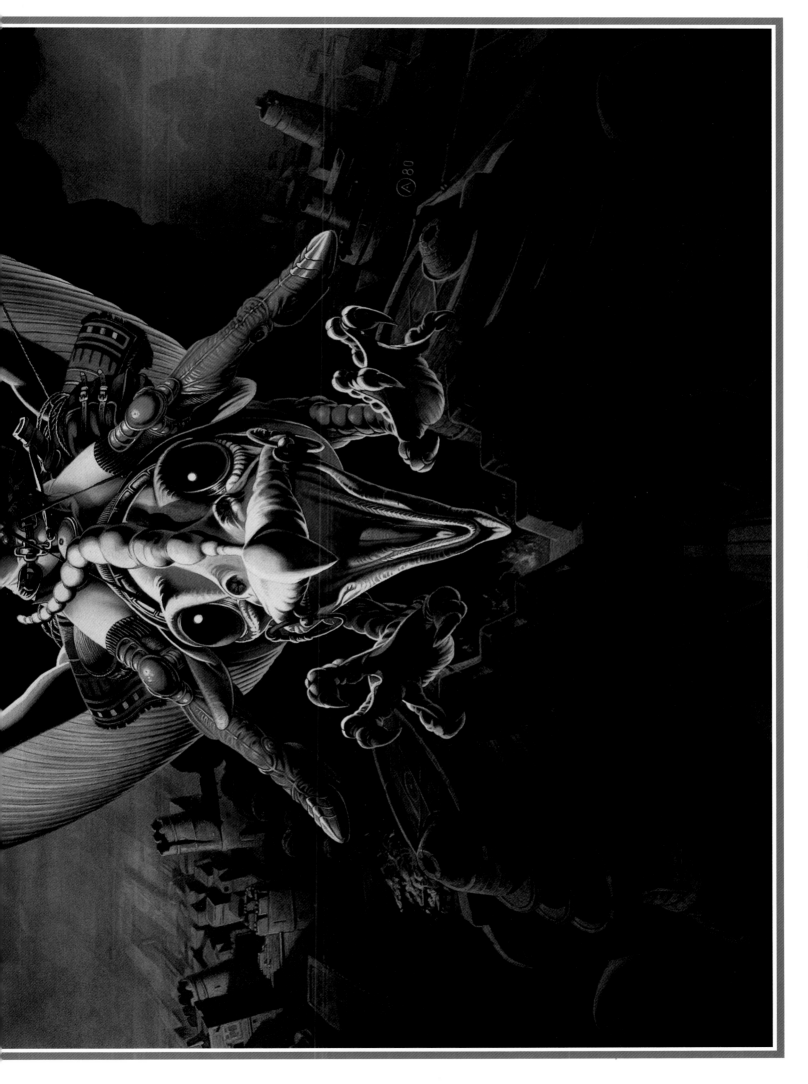

Taarna

His picture is shown on page 98. Above is shown Achilleos' concept drawing for Taarna. She had to be simplified for animation purposes, somehow losing most of her clothing in the process, and there were other changes which in the end prompted Achilleos to ask why a kinky costume hadn't been specified in the first place.

This drawing was taken round Montreal model agencies until a girl was found who bore an uncanny resemblance to it, then she was dressed in the costume and photographed as a base for the animators to work from.

Bladerunner was a film which had proved disappointing in the USA so Achilleos was brought in by Julian Senior of Warner Brothers Distribution to try and give it a new image, something bright and clean and striking.

The story was set in the future but by now films were doing what books had done earlier, they were trying to disguise any Science Fiction content. After a private screening and long discussion Achilleos set to work and came up with the two concepts shown on the opposite page. He still believes they are just what the film needed but in the end it was decided to play safe and use the American promotion material, a standard montage poster which was exactly what he had been briefed to avoid from the outset.

This was a disappointment as he believed the film deserved greater success and would have liked to have played a small part in making it one.

To an extent Achilleos sees film posters and book covers as being similar. Both have to grab the attention of passers-by and make them want to find

(previous page) TAARNA 1980 98 × 67 cm. Illustration for film poster.

Waterproof inks, gouache and airbrush on illustration board.

For this dramatic image of Taarna I would like to thank my friend Pam who posed for me, something I rarely do but I felt it necessary for this very important commission.

(above left and right) A & B TAARNA character and costume designs.

Graphite on tracing paper.

Just two of the many sketches I did for the development of the main character and her costume. I was briefed to design a suit of armour for her but in their hands this grew less and less until she was hardly dressed at all. Not that I minded, I just wished they'd told me in the first place.

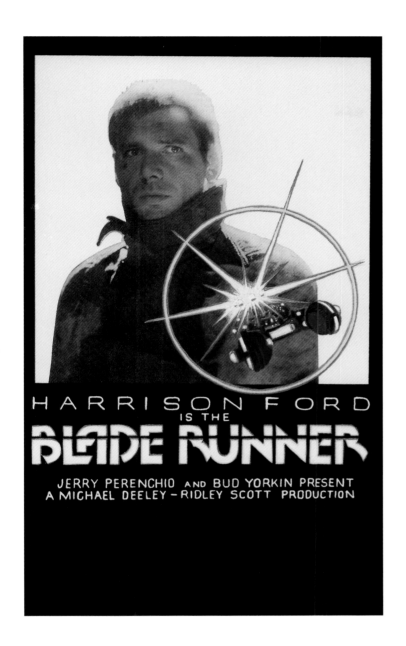

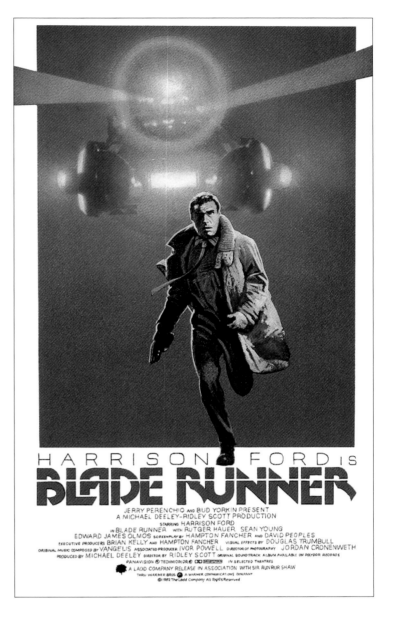

(above left and right) BLADERUNNER 1982
A 45 × 28 cm. B 53 × 22 cm.
Concept illustrations for film poster.

Waterproof inks, gouache and airbrush on
illustration board.

*These were the main designs that I did for an alternative
concept to the montage type normally used in film
posters. I feel this was a great film but unfortunately an
extremely difficult one to promote. I was very
disappointed they did not choose my personal favourite,
B. In the end it was decided to simply use the existing
poster, the one used in America.*

out more, but the pressure in films is far greater because one image has to
sell a multi-million dollar project and so much depends on the initial
launch. On the cinema circuit films are perishable goods. They cannot just
sit on the shelf until something else sparks interest in them. Unlike books
they cannot hope for a gradual build-up in demand generated by word of
mouth recommendation, nor can they be re-jacketed and relaunched.
Everything has to be got right first time.

A poster, he says cannot make a film successful when it is fundamentally
uncommercial but it can help draw in the first wave of audiences who will
then go out and tell their friends if they like the film or not. That is a
poster's objective. After that the film stands or falls on its own merits. It
can only help enhance the success of a successful film.

Because of the tremendous stakes, the chances of any one poster concept
being used by a film's promoters are always extremely slim. Companies
usually commission several different artists to come up with ideas from
which they can pick and choose, and then as much depends on how they
want to sell the film as on the value of any idea in itself. Then the brief is
quite likely to be out of favour by the time the work is done. It is a field full
of frustration but the satisfaction of occasional success has so far been
enough to make Achilleos persevere.

What Achilleos most likes when commissioned for a film poster is to get
involved while the film is still being made so he can get a good feel of it and
take his own photographs, but this happens rarely. Usually the film is in the
can and everyone has packed up and gone home by the time he is brought

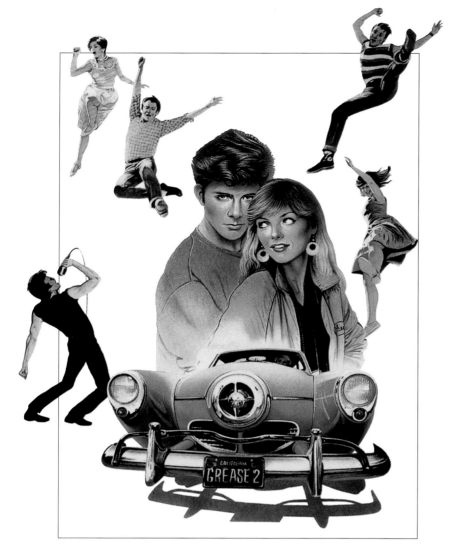

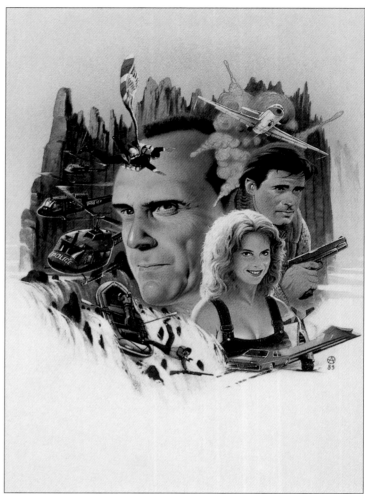

in. Or else the job is to devise a new presentation for a film which has not done well in America. Either way, all he usually has to work on is a private showing of the film and a handful of stills.

He almost became involved with *Greystoke: The Legend of Tarzan* but then it was decided to use a photograph on the poster. However Joel Wayne, another main man from America (to use Achilleos' description) saw his work and thought he might be right for *Supergirl*. Although he had only a few stills to work from he produced three paintings but as he was putting the finishing touches to them the film was sold and publicity went elsewhere. Two of his designs are shown here for the first time on pages 94 & 95.

The Protector (page 99) was Achilleos' first success with Warner Brothers, on which he worked with Julian Senior of their British distributors to project a new image after it had proved a disappointment in the USA.

Of other people's posters, one of his favourites is that which promoted Ridley Scott's *Alien*, which he admires for its utter simplicity and the way it succeeds in grabbing attention without revealing anything at all about the storyline. The film itself is also one of his favourites.

Achilleos' favourite film of all time is David Lean's *Lawrence of Arabia* which he never tires of seeing. It is, he says, one of the few films he enjoys in its entirety rather than just certain sequences as is often the case.

He admires Lean's work generally. Another director who became a favourite in college days is Akira Kurosawa who made *The Seven Samurai* and *Yojimbo*, identifying with the Samurai's ideals which he also sees portrayed in updated form in the western *Once Upon a Time in the West*.

Other favourites include Walt Disney's *Fantasia*, *Distant Drums* (an offbeat western which he has not managed to see again for years), *The Naked Prey*, *Citizen Kane*, *Jason and the Argonauts*, *Zulu*, large scale costume epics like *Cleopatra*, *Ben Hur* and *El Cid*; and the more recent *Mad Max II*, *American Werewolf in London*, and the films of Stephen Spielberg and George Lucas.

(above left) GREASE TWO 1982
76 × 53 cm. Illustration for advertising.

Waterproof inks, gouache and airbrush on illustration board.

This was not commissioned for a film poster but an advertising campaign involving a motorcycle manufacturer and a denim jeans company with the film.

(above) THE PURSUIT 1985 68 × 53 cm. Illustration for video cassette cover.

Waterproof inks, gouache, acrylics and airbrush on illustration board.

This is an example of the type of montage commonly used in film promotion.

(right) RIDING HIGH 1980 76 × 54 cm. Illustration for film poster.

Waterproof inks, gouache and airbrush on illustration board.

The star of this film was Eddie Kidd, the famous motorcycle stunt man, who was most co-operative. I wish I could say the same about the producers of the film.

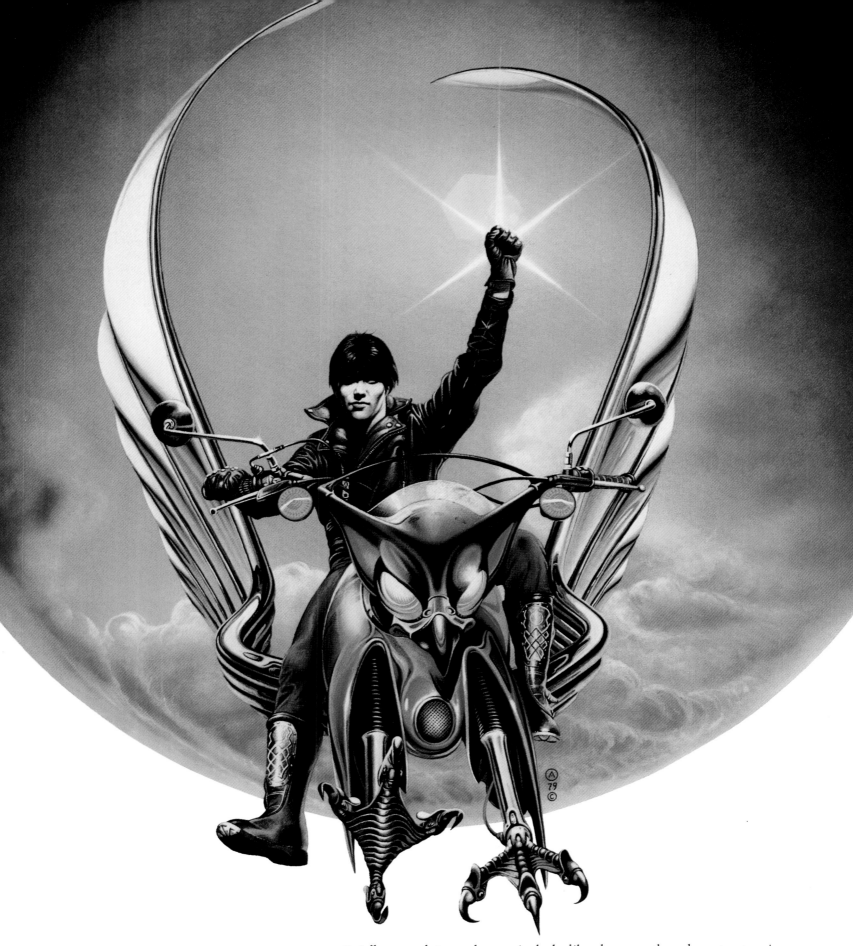

(overleaf left and right) SUPERGIRL 1984
page 94 77 × 61 cm.
page 95 107 × 77 cm.
Illustrations for film poster. Previously
unpublished.

Waterproof inks, gouache, pastels and airbrush
on illustration board.

*Warner Brothers sold the film while I was finishing off
these pictures. Consequently they were never used and
are shown here for the first time.*

Spielberg and Lucas he particularly likes because they do not patronise
children in their films, they do not try to get away with second-rate work
as so often happens in films aimed at children. They credit children with
intelligence and address them on their own level. Also they bring to their
work a deep love of Science Fiction/Fantasy which Achilleos regards as
essential for anyone working in the genre. All too often, he says, people are
brought in to work on SF films purely because of their technical expertise,
lacking any real sympathy or respect for the subject, and this shows in the
finished product.

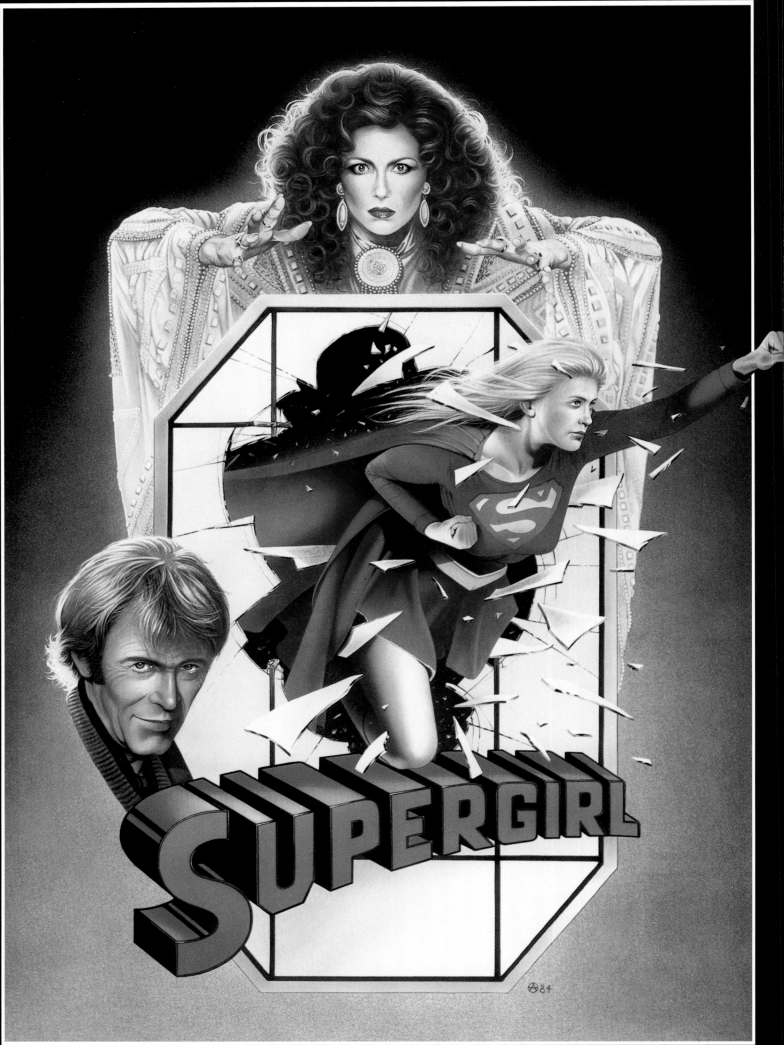

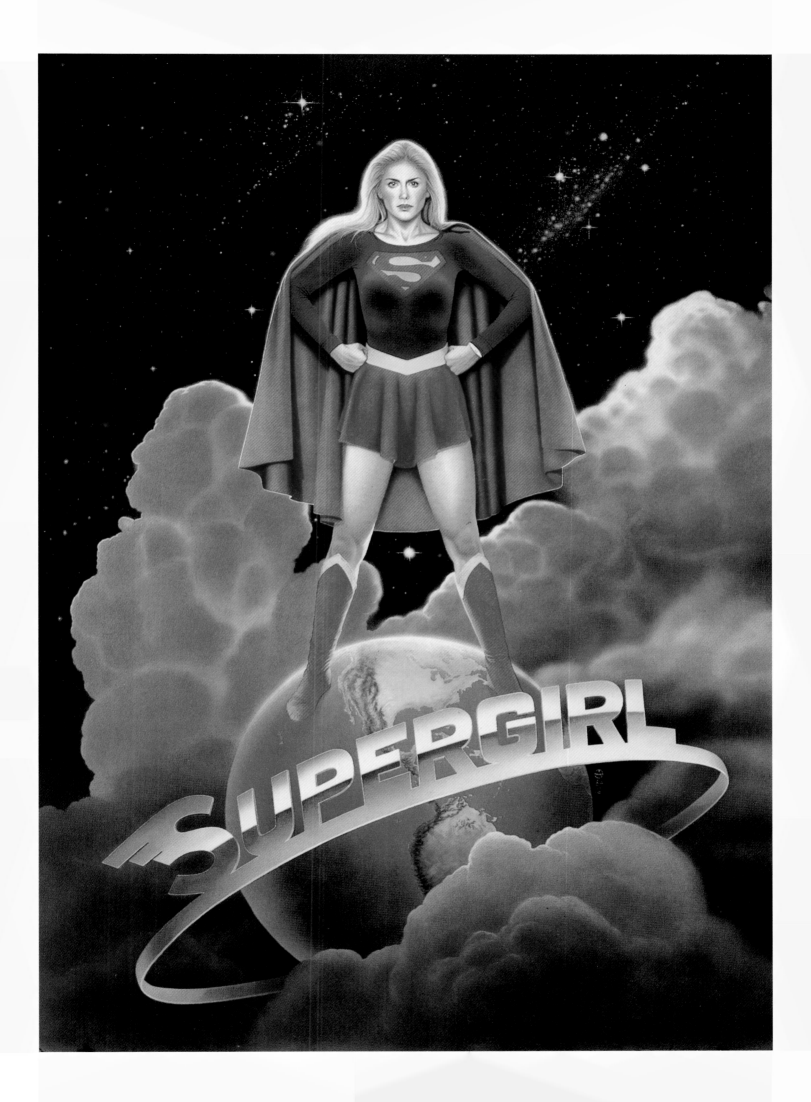

More favourites are *King Kong*, the Charles Laughton *The Hunchback of Notre Dame*, and the original *Frankenstein* for their beauty and the beast themes; and Zefferelli's *Jesus of Nazareth* which stands out a little oddly from the rest but is loved for its sheer quality.

The future for the cinema, Achilleos feels, lies in large scale epics where full advantage is taken of the big screen's superiority over the crystal bucket in the corner of the living room. Three hour epics or longer even, with restaurants and bars in cinemas so that going to see a film becomes the grand event it used to be in the days of the great silent classics like Griffiths' *Birth of a Nation*. The cinema, he feels, still has a vital place in the age of home videos which has yet to be fully recognised.

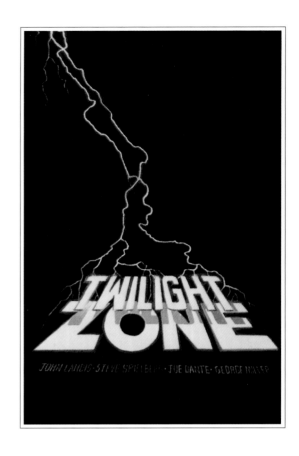

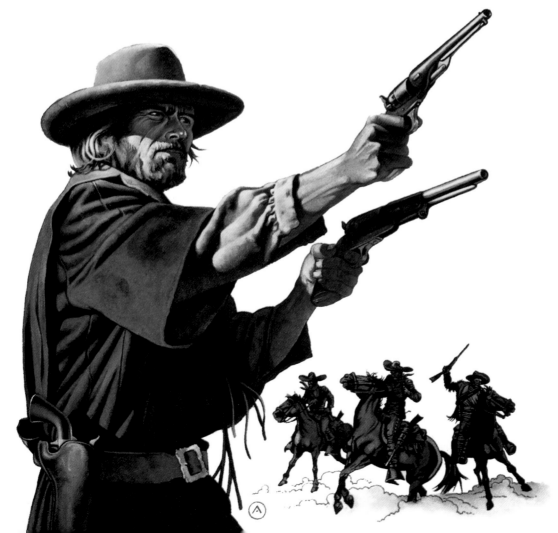

(left) OUTLAW JOSIE WALES 1976
50 × 32 cm. Illustration for book cover. Collection R. Moy.

Acrylics on illustration board.

This illustration was done for the book of the film.

(above) TWILIGHT ZONE 1983 22 × 15 cm. Rough poster concept.

Waterproof inks and gouache on illustration board.

(right) TWILIGHT ZONE detail 1983 108 × 77 cm. Illustration for film poster.

Waterproof inks, gouache and airbrush on illustration board.

The film is divided into four nightmarish stories. I chose to show the main character from each.

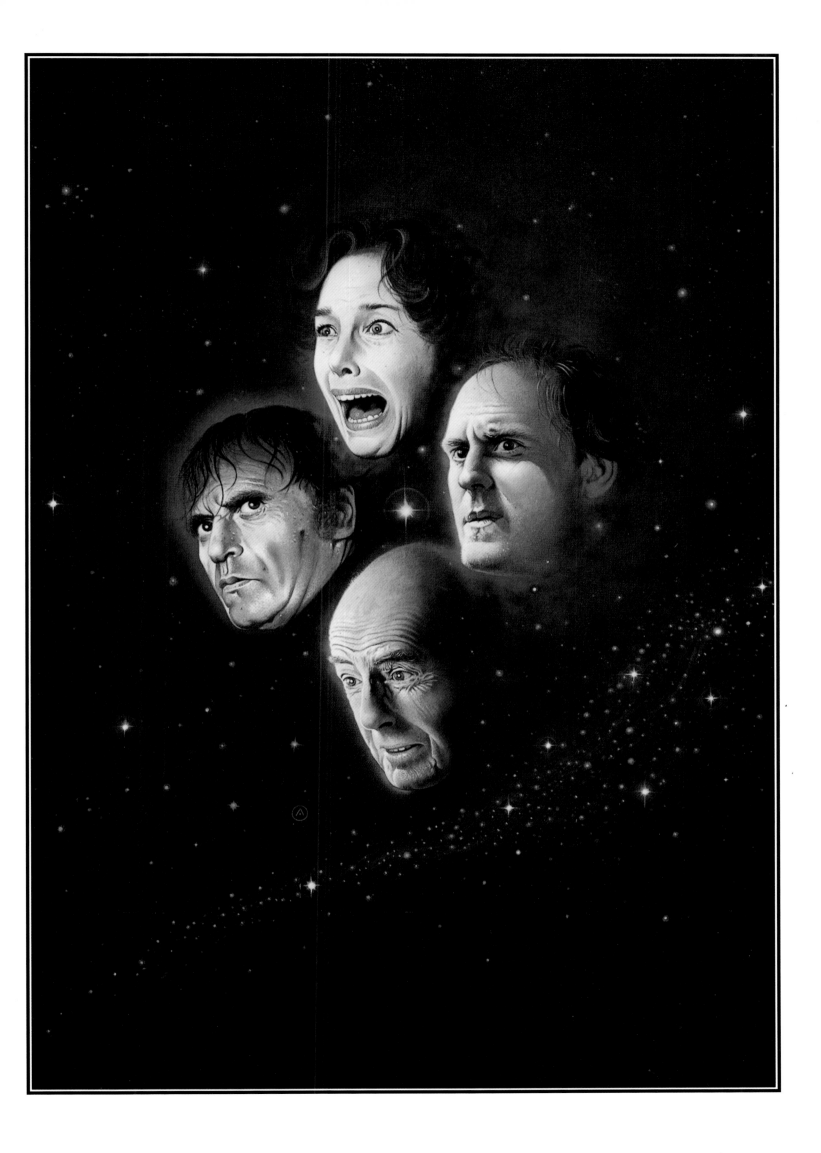

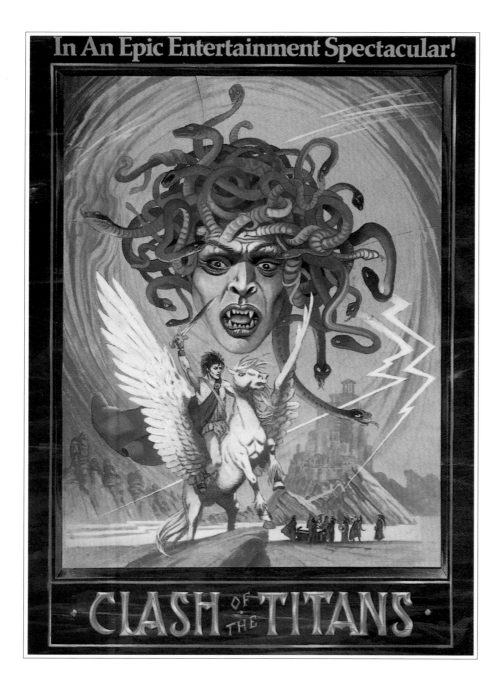

In An Epic Entertainment Spectacular!

CLASH OF THE TITANS

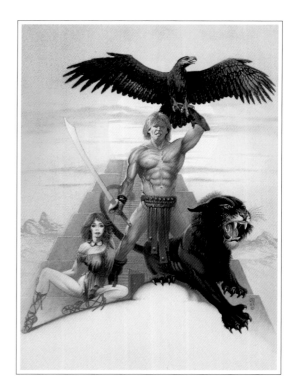

(above) BEASTMASTER 1984
Illustration for film poster. Missing.

Waterproof inks, gouache and airbrush on illustration board.

I did this for a new client in Sweden. To this day I do not know if it has been used anywhere and the original was never returned to me.

(above left) CLASH OF THE TITANS 1980 79 × 54 cm. Rough concept for film poster.

Waterproof inks and gouache on coloured paper.

This was Ray Harryhausen's last large-scale film project and I would have loved the privilege of having my artwork on the poster.

(left) THE JUPITER MENACE 1982
69 × 53 cm. Illustration for video cassette cover.

Acrylics on illustration board.

I have done quite a few video cassette designs but there has only been room to show a couple.

(right) THE PROTECTOR Detail 1985
89 × 64 cm. Illustration for film poster.

Waterproof inks, gouache and airbrush on illustration board.

This is an offbeat New York cop thriller film featuring Jacky Chan, the latest martial arts hero.

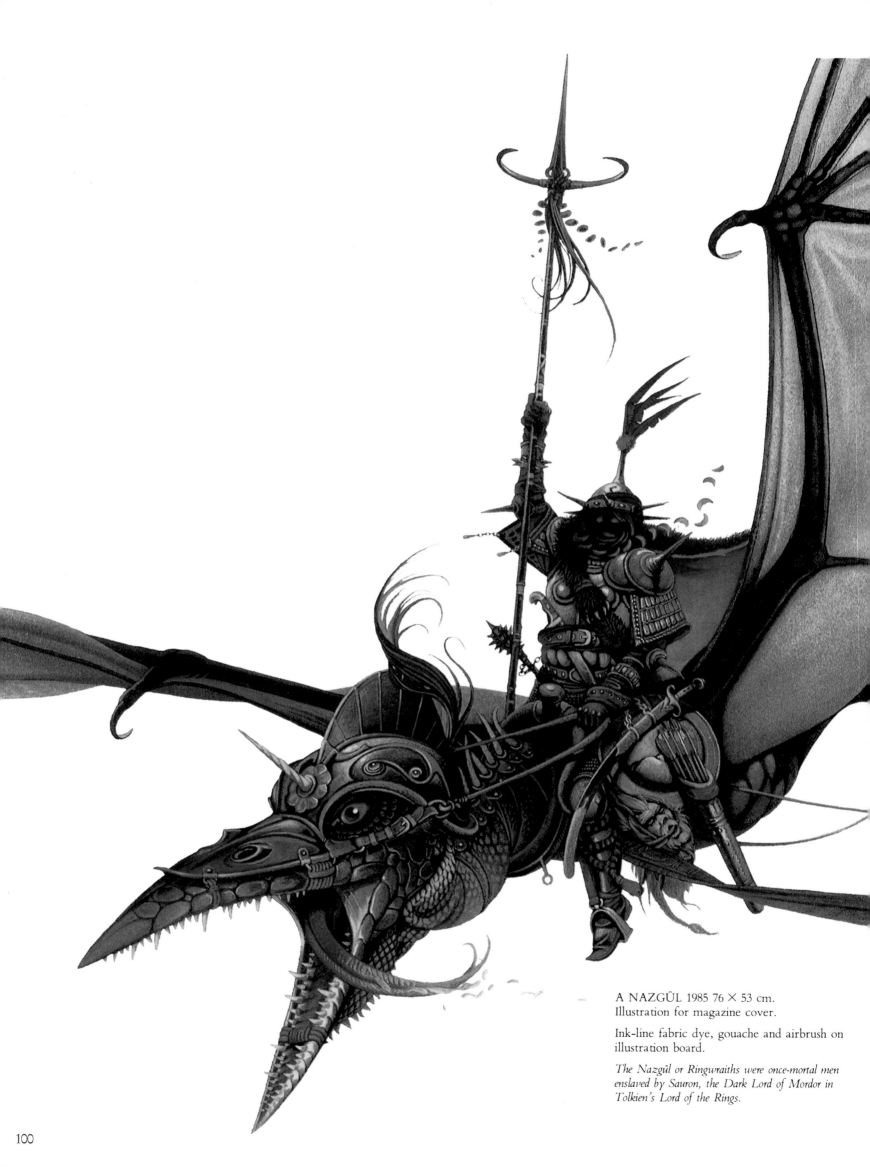

A NAZGÛL 1985 76 × 53 cm.
Illustration for magazine cover.

Ink-line fabric dye, gouache and airbrush on illustration board.

The Nazgûl or Ringwraiths were once-mortal men enslaved by Sauron, the Dark Lord of Mordor in Tolkien's Lord of the Rings.

Chapter VI

FIGHTING FANTASY

Achilleos' involvement with Fighting Fantasy came about through a photographer, Mike Dyer, whose services he shared with Steve Jackson and Ian Livingstone, the founding fathers of Fighting Fantasy in Britain. Seeing a photograph of them at Dyer's studio, Achilleos suggested mentioning his name to them to see if they might be interested in using his work. As it turned out, they not only knew his name already but loved his pictures and the only reason they had not thought of contacting him before was that they assumed he lived in some distant, exotic clime and was unattainable.

This came at a time when, as mentioned earlier, Achilleos' Fantasy work had been out of demand with book publishers for a while and he had hardly produced any new fantasy material for years. Fighting Fantasy breathed new life in to it.

Steve Jackson's opinion of Achilleos is that he is among the top three Fighting Fantasy artists in the country, along with Ian McCaig and John Blanche. What he most admires in Achilleos' pictures are the strong central images. Detail, he says, is important but secondary; many Fantasy artists have the same quality of detail but not Achilleos' power and energy which to his mind captures perfectly the spirit of Fighting Fantasy.

When Ian Livingstone first visited him, Achilleos says he felt like Robinson Crusoe discovering someone washed up on the shore. He had begun almost to believe he was the only person left with a love of Fantasy but Livingstone not only shared his enthusiasm but opened to him a whole world where it was alive and kicking. Normally Achilleos is cautious about parting with original artwork but he was so won over by Ian Livingstone that he sent him away loaded with originals and transparencies which soon began appearing regularly on the cover of the Fighting Fantasy magazine *White Dwarf*.

The magazine covers were all pictures which had been used before on books, but soon Achilleos was being asked by Livingstone for original material, most notably for the *Middle Earth* and *Talisman* games and for the Jackson and Livingstone books published by Puffin. *Talisman*, Jackson says, set new standards in box-cover design.

Another game box with an Achilleos cover is *Warrior Knights* which uses his picture *Trial by Combat* (page 49). In Jackson's opinion it is one of the best boxes produced by Games Workshop. Not only is the action tremendous,

(above) Detail from THE HOST OF MORDOR on pages 104–5.

(overleaf) WHO DIES FIRST? 1984
73 × 51 cm. Illustration for game-box cover.

Waterproof inks, fabric dyes, gouache and airbrush on coloured stretched paper.

This was done for a new role-playing game created by Citadel Miniatures, who provided me with tiny models of the key characters to base my designs on.

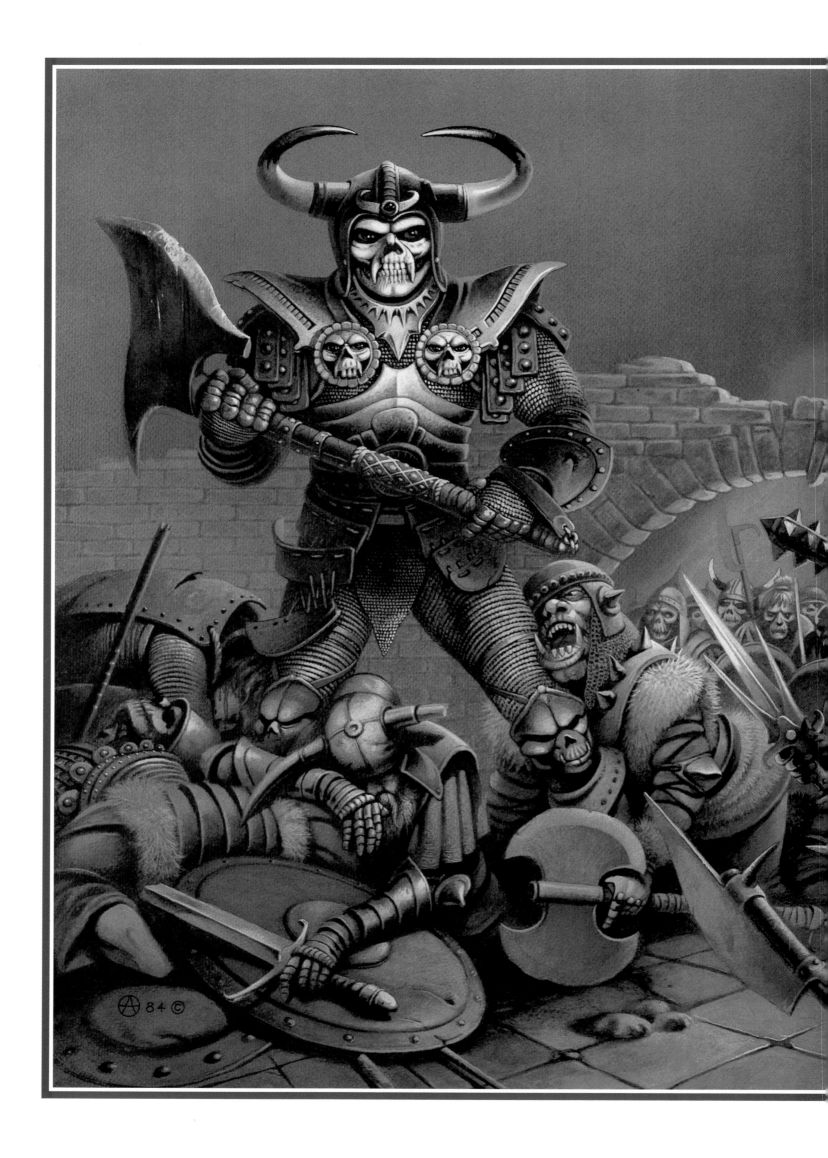

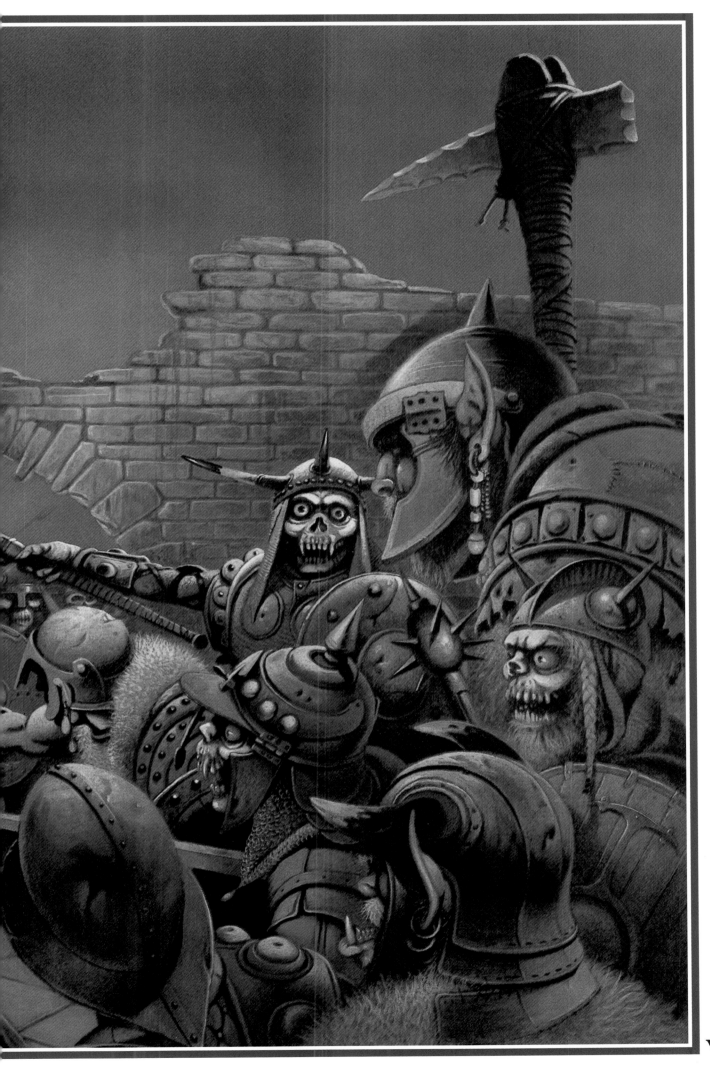

Who Dies First?

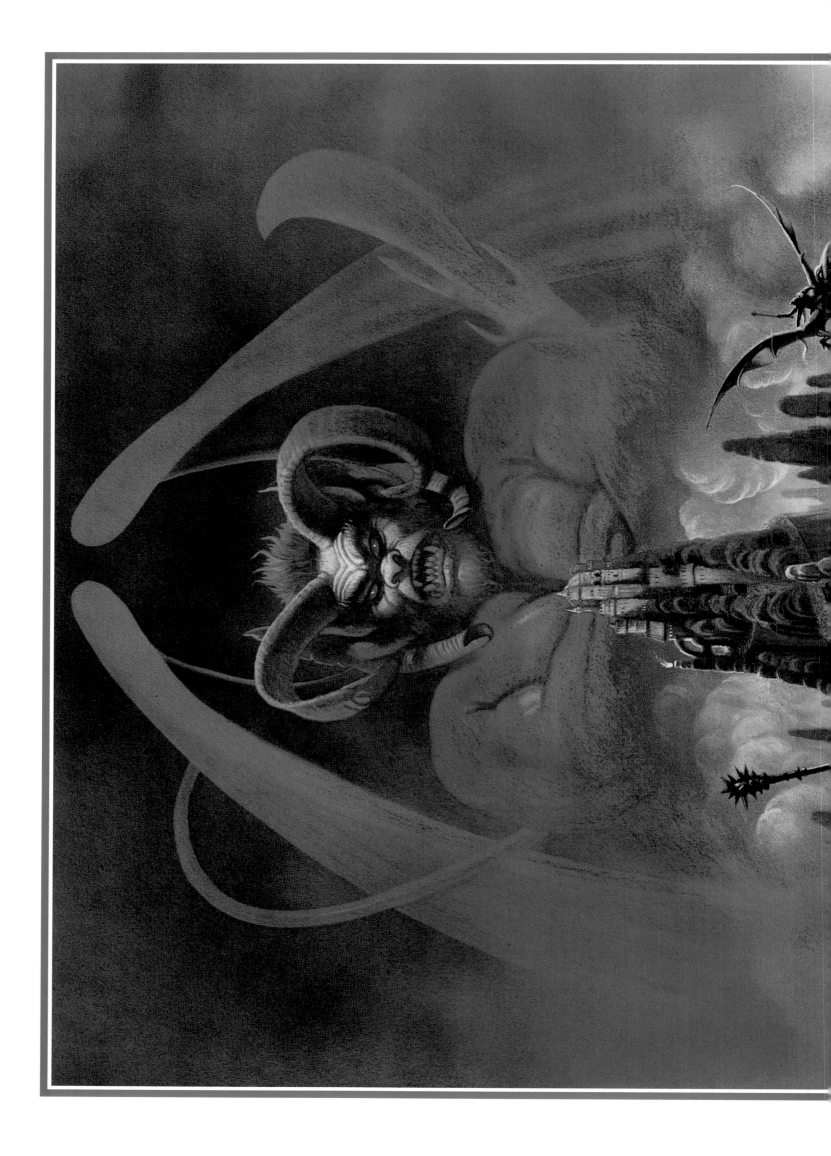

The Host of Mordor from THE LORD OF THE RINGS

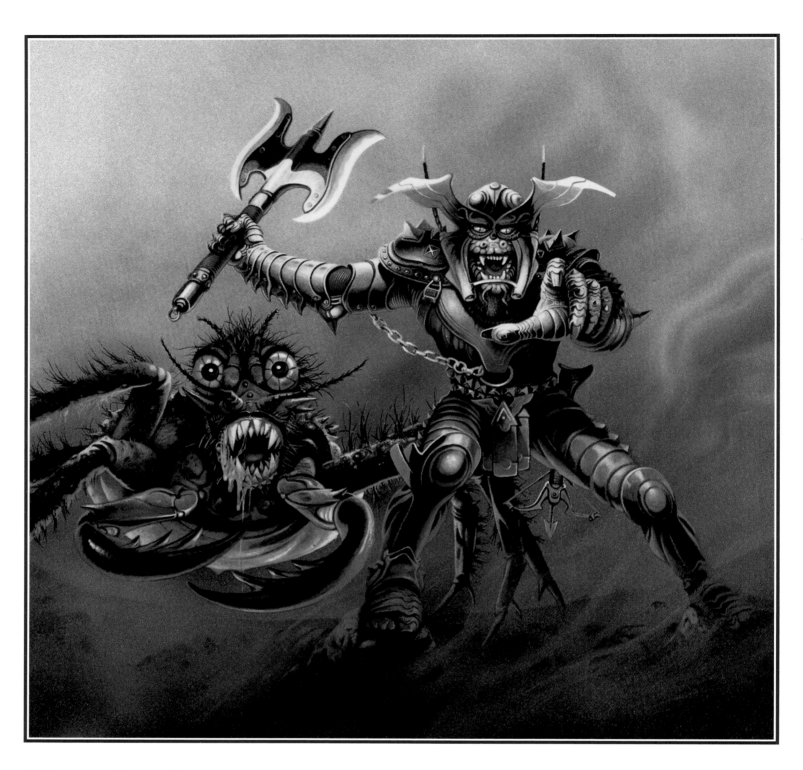

all the more so because the battling knights are not obviously on the side of good and evil, but there is the mysterious helmeted figure brooding over the combat forcing one to wonder who or what it is.

Steve Jackson and Ian Livingstone, the founders of *White Dwarf* and Games Workshop and the inventors of Fighting Fantasy gamebooks, were school friends in Altrincham, Greater Manchester but their partnership did not begin till some years later after university. Then, back in Manchester, they began to meet in a pub and indulge their mutual passion for games like Diplomacy, American war-games and others. Then after various moves, which for Jackson included a three month stint at a Dorset bird sanctuary where he rediscovered a taste for big city life after having almost no-one but Terns to talk to, they moved into a shared ·flat in Shepherds Bush, London, in late 1974.

This was the year of their discovery of Dungeons & Dragons which soon became a complete obsession. Wondering what to do with their lives, they decided to start a games company since that was their main preoccupation. So, with a third friend from Altrincham who later dropped out, they put up £50

(previous page) THE HOST OF MORDOR 1984 76 × 53 cm.
Illustration for the game 'Middle-Earth' by Games Workshop.
Waterproof inks, fabric dyes, gouache and airbrush on illustration board.

(above) VIDEO MONSTERS 47 × 47 cm.
Illustration for advertising.
Waterproof inks, gouache and airbrush on illustration board.
I just couldn't make these guys ugly enough for the client.

(right) GUARDIAN OF THE GATE 1984 62 × 48 cm. Illustration for book cover.
Collection I. Livingstone UK.
Waterproof inks, gouache and airbrush on stretched coloured paper.
Ian Livingstone left the design of this monster the me, then described it in his book. The creature's eyes I copied from my cat, Spike.

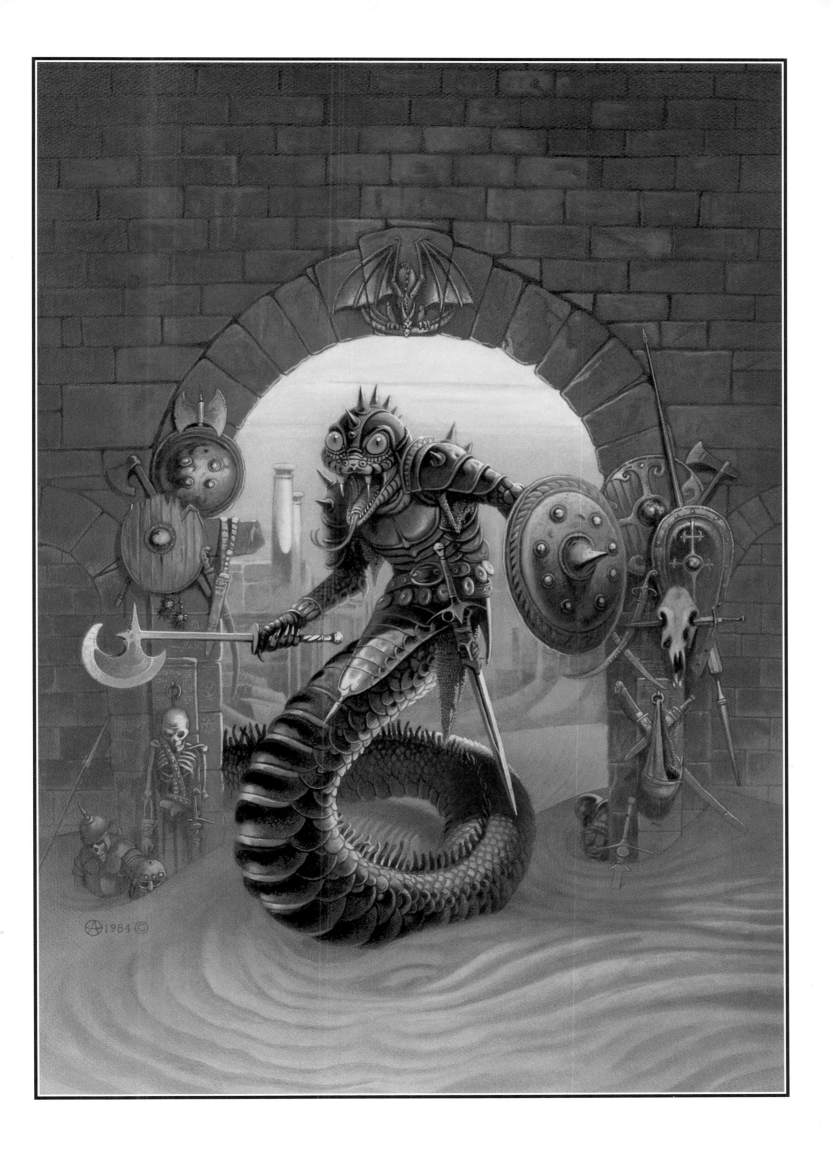

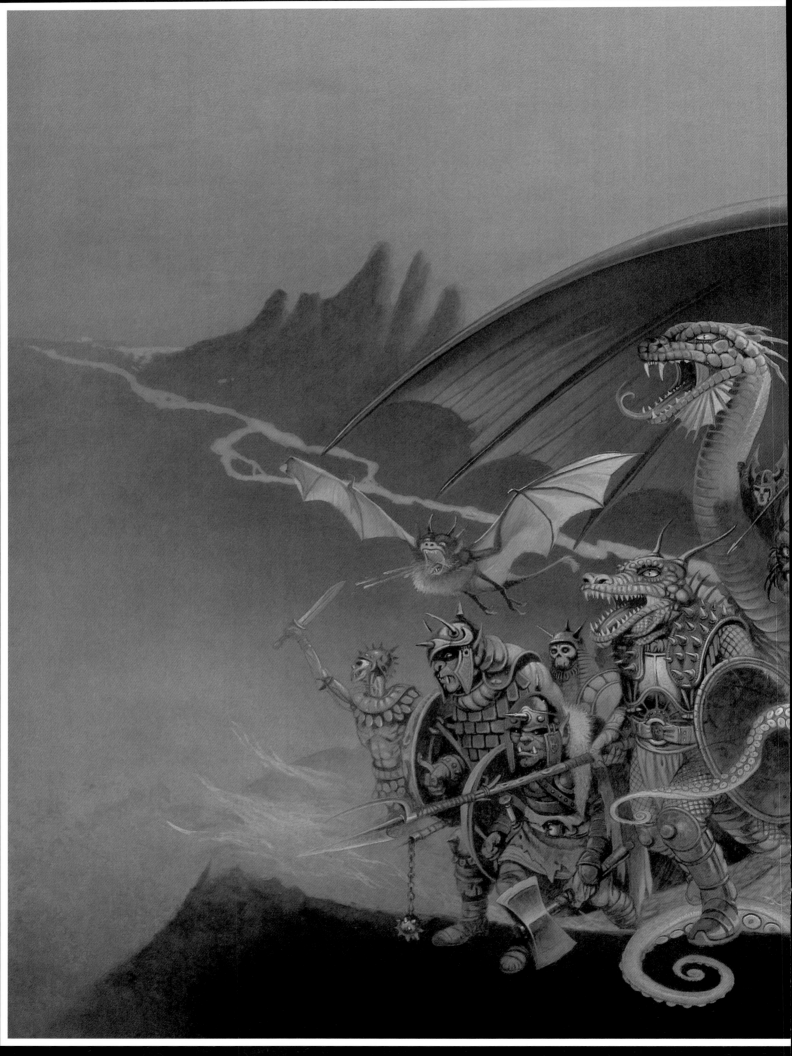

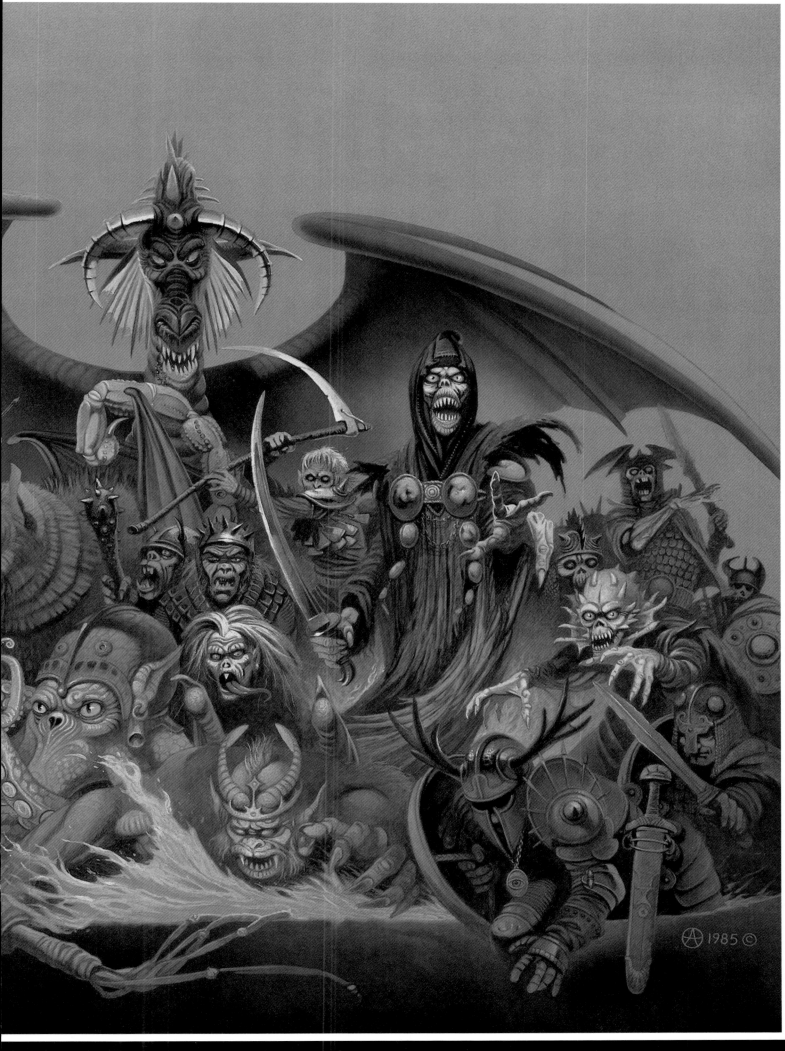

and Super Creeps

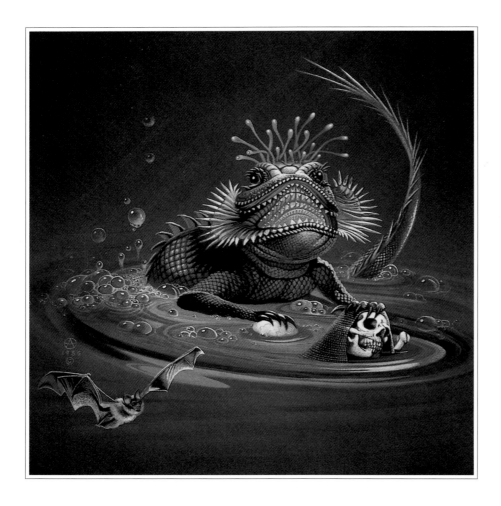

each and founded Games Workshop. Also they began a games fanzine, *Owl & Weasel*.

One of their first major investments (considering the state of their finances) was in three Dungeons & Dragons sets which won them the UK agency from the American manufacturers, TSR. The games were sold in three days and they were in business.

After a while Livingstone and Jackson abandoned their flat, packed the business into a van and went to America, to the TSR headquarters at Lake Geneva, Wisconsin. While there they visited some of the many other small games firms that were springing up and also secured exclusive UK selling rights to their products.

Returning to Shepherds Bush they revived the business in their first office, a small room behind an estate agent. No living accommodation could be found so they camped in the van parked outside in the street, which meant passing the estate agent's office every morning in a rather dishevelled state in order to clean their teeth; and having to join a squash club in order to make use of its showers. This was no great hardship though, because business was mushrooming and there was little time for anything but work.

Games Workshop secured a three year licence to produce Dungeons & Dragons in the UK and then one day Ian Livingstone announced his intention of changing the name of their magazine to *White Dwarf* and going for a much larger circulation.

The first issue of *White Dwarf* hit the streets in June 1977 with a cover picture showing a Dwarf hacking a Wizard's head off. Four thousand copies were printed, which was a tremendous financial gamble, but they were sold out in two months and the magazine has since gone from strength to strength, now exceeding 50,000 copies per month. Jackson attributes much of its success to luck of timing. A little earlier, he says, and there would have been too few people who knew anything about Fighting Fantasy to buy it; a little later and someone else could have beaten them to it.

(previous pages) SCARY MONSTERS AND SUPERCREEPS. 1985 47 × 47 cm. Illustration for book cover.

Chroma-colour cell paint, waterproof inks, gouache and airbrush on illustration board.

A collection of creatures and monsters from the wonderful world of fighting fantasy.

(above left) BOG CREATURE 1985 70 × 51 cm. Illustration for magazine cover.

Waterproof inks, gouache and airbrush on coloured stretched paper.

(above) ORC CHARGE Painting in progress.

(right) ORC CHARGE 1985 50 × 71 cm. Editorial illustration.

Waterproof inks, fabric dyes, gouache and airbrush on coloured stretched paper.

Orcs are disgusting, filthy creatures with vile habits to match. They delight in the pain of others, even weaker members of their own race etc.

(overleaf left) DO YOU RUN OR BLUFF? 1984 66 × 50 cm. Illustration for book cover.

Waterproof inks, gouache and airbrush on illustration board.

(overleaf right) THE RED DRAGON CHALLENGE 1985 63 × 56 cm. Illustration for the game 'Talisman' by Games Workshop.

Waterproof inks, gouache and airbrush on illustration board.

I had a very difficult design problem with this as it was to be used for two boxes, one landscape and one portrait format.

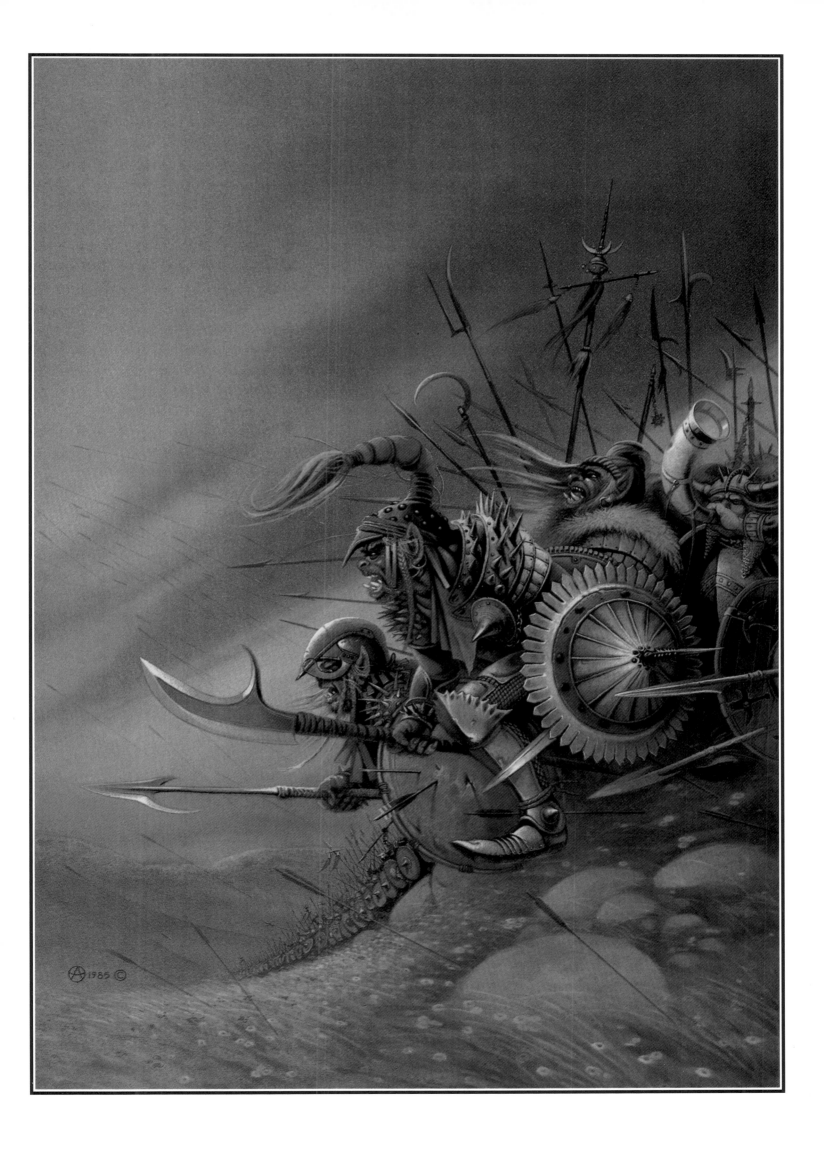

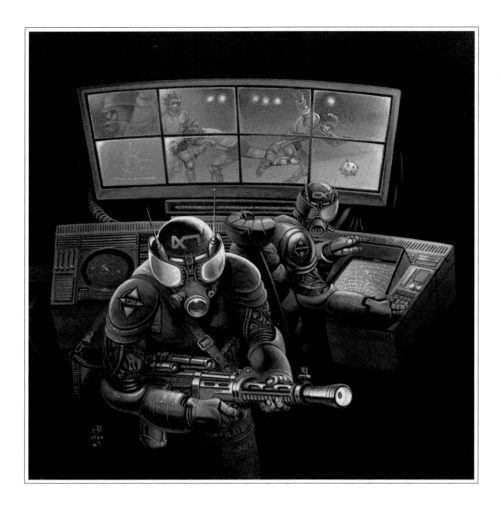

By now their office was bursting at the seams and often someone had to go out shopping to make room for visitors, so the estate agent, probably not entirely out of the kindness of his heart, found them a new office and shop in Hammersmith which became the first role-playing game shop in Europe and was greeted with astonishing enthusiasm by the public. Now it is the smallest of seven run by Games Workshop.

A blow to Jackson's and Livingstone's progress came when the three year licence from TSR expired. An American attempt was made to negotiate a merger between the two companies but when Games Workshop turned the offer down TSR founded its own UK distribution company.

Games Workshop was thus forced to begin producing its own games, at which it proved as successful as in everything else despite attempts by larger traditional games manufacturers to muscle in on the market. Jackson sees the strength of their company being that its people are genuinely in love with their subject, Fantasy, and have never merely been trying to cash in on a trend. This love is what gives their Fighting Fantasy games an edge over much of the opposition. Also Games Workshop is very particular about its artwork, setting high standards from the beginning and refusing to lower them. This is where the Achilleos connection is valued. Although they have approached Fantasy from different angles, their feeling for the subject is almost identical.

The most notable of Livingstone's and Jackson's recent enterprises is their invention of the incredibly successful Fighting Fantasy gamebooks which have been translated into many different languages. The first, *The Warlock Of Firetop Mountain*, has sold over a quarter of a million copies in Japan alone to date. Jackson is modest about the invention, saying it was a logical progression from role-playing games, and sees many other possible lines of development for the future since, he says, interest in Fantasy is fundamental; it is here to stay. Not that it has escaped criticism. In America the Fighting Fantasy cult has been castigated as an instrument of Satan and even in Britain there have been similar accusations.

The Red Dragon Challenge

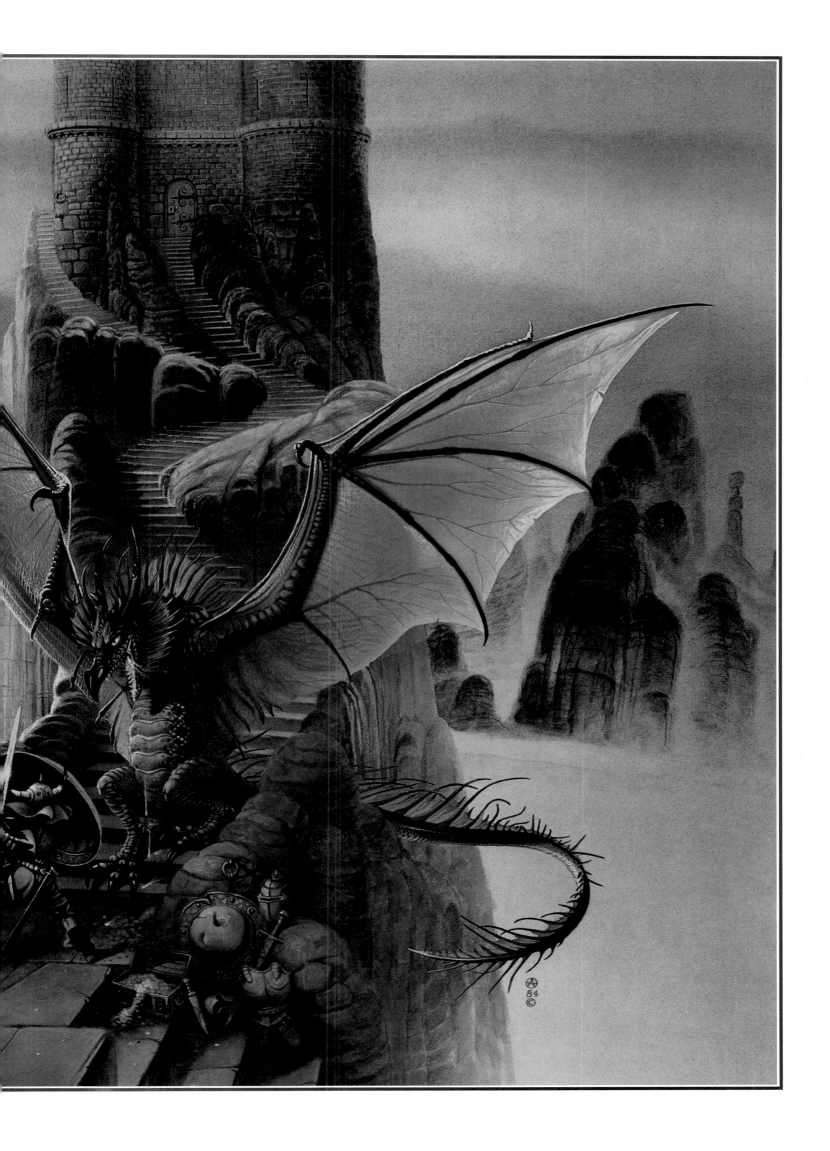

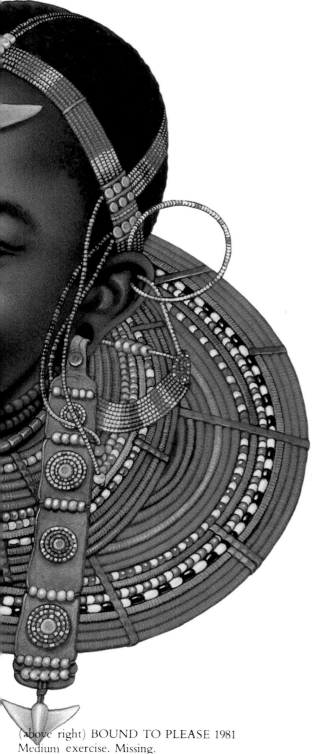

Chapter VII

PIN-UPS

*M*en *Only* was the first magazine to take a pin-up picture from Achilleos and has remained his most consistent customer ever since. This follows from the mutual friendship and respect between himself and the magazine's art director, Roger Watt, who has given him a loose rein from early on in their association and generally trusts Achilleos enough not to demand to see the roughs before an illustration is taken to completion. Only occasionally has he had to be nudged back into line when his imagination has begun to stray from the magazine's requirements.

Another reason is that *Men Only* have always returned his originals undamaged, unlike certain other magazines. With one, Achilleos exacted a promise before submitting his original but when the time came for it to be returned he was told it had been unaccountably 'lost'. Only when he sent in an extremely large bill was it miraculously found again.

When he began this line of work Achilleos had never bought a girly magazine in his life and admits to having had a few qualms about it, but painting pin-ups soon became one of his most enjoyable occupations.

He once made the mistake of giving an interview over the telephone about a record sleeve he had done in a similar style for the group Whitesnake's record, *Love Hunter*. Not suspecting anything, he said his piece and was astonished to find himself portrayed in the subsequent article as an exploiter, debaser and trivialiser of women in his work. He denies all this strongly. To him his portrayal of women is no different to his portrayal of any other aspect of nature. His approach is the same as if he were painting a tiger or an armadillo or any other animal, except to the extent that being a man he finds the female form more attractive than any other. There is no other conscious motive behind his painting of pin-ups. He loves women's beauty and loves celebrating it in his work, it is as simple as that. He loves all nature but women in particular. If he was an armadillo, he says, he would probably spend the same amount of time painting female armadillos. Although he is given a pretty free hand by *Men Only* he is, nevertheless, expected to keep a weather eye on prevailing fashions. Since the 1970s Science Fiction and Fantasy elements have been banned from pin-ups and, as may be seen from the examples here, erotic fantasy is now for some reason only allowed to revolve around objects of the everyday world. Achilleos does not mind this completely since it is another field to explore and it often leads to a humour which was rare in the earlier work, but it is limiting and he finds he produces fewer pin-ups these days.

Achilleos finds the original paintings of his pin-ups more in demand, for

(above right) BOUND TO PLEASE 1981
Medium exercise. Missing.

Waterproof inks, gouache and fabric dyes on illustration board.

(opposite) LIGHT AND SHADE 1983 57 × 46 cm.
Editorial illustration.

Waterproof inks and gouache on illustration board.

The erotic adventures of a Victorian chambermaid in the service of an African explorer.

some reason, than his other work. Often this means their disappearance in the labyrinths of the publishing process but he is also approached honestly, and dishonestly with offers to buy them.

But not by art galleries, the fine art world remains blind to the obvious power and quality of his work and the work of other illustrators like him.

This lack of even respect can sometimes rile him. Many people, particularly in the fine arts, seem to think the work he does is easy and not the result of intense discipline and effort and skill. He sees working to deadlines as being far harder than taking your own time, as fine artists seem able to do, but he is given credit for neither effort nor skill.

Still, he was mistrustful of the fine art world from the beginning and has never sought to make his home in it, so this is no more than a cause for occasional irritation.

Watch the Birdy on page 121 was responsible for an interesting twist in the often uneasy relationship between illustrators and photographers. Since Achilleos rarely has time to go out collecting research material at first hand he relies heavily on his collection of photographic references. This is a common practice but it sometimes leads photographers to accuse artists of stealing their material. With this picture the reverse has happened.

It was done over a couple of years in his spare time, making use of his technical illustration skills as much as his more familiar pin-up style. The camera is his own which he decided had served him well enough to keep its brand name. The female was composed in his usual 'Frankenstein' way from bits and pieces of various photographs in his collection.

A while after *Watch the Birdie* was published an almost identical picture appeared on the cover of a book about erotic photography, but this was a posed photograph with a model in exactly the same position and some darkroom juggling to bring her into the same proportion with the camera.

Achilleos was rather pleased to see his understanding of anatomy proved accurate enough to be duplicated so closely by the live model, and amused to find his theory of everyone in the arts being influenced by everyone else confirmed. With the theft of this idea he sees illustration and photography coming full circle, his picture being copies from bits and pieces of photographs and then being itself copied by a photographer.

The original sketch for *Watch the Birdie* was just one of a drawer-ful of

FILM STRIP 1981 75 × 54 cm. Editorial illustration. Collection Roger Watt.

Waterproof inks, gouache and airbrush on illustration board.

This was for an article about film director Walerian Borowczyk's version of the Robert Louis Stephenson classic – Dr Jekyll et les Femmes.

(right) STILL LIFE 1982 66 × 50 cm. Editorial illustration. Collection J. Senior.

Waterproof inks, gouache on illustration board.

This is a popular picture which appeals to a very wide range of people and might make a good poster or print some day. It had to be done in a great hurry and is an example of how sometimes working under pressure can produce a good result.

unrealised ideas which happened to be noticed by Roger Watt who encouraged Achilleos to finish it.

Sometimes these ideas lie untouched in the drawer so long that they are overtaken by other people's work. This happened with *Model 2000* (page 46) whose sketch gathered dust for years before Achilleos was reminded of it by some work by Hajime Sorayama, the Japanese airbrush artist specialising in super-realistic chrome figures and robots, whom Achilleos greatly admires. This prompted him to complete his own picture but unfortunately a touch of Sorayama crept into it. As he says, we are influenced by all we see.

What would Achilleos' recipe be for anyone wanting to follow in his footsteps? His reply is crisp through having met the question before. Three things; first, basic talent which he believes is not as rare as most people seem to believe. By talent he means visual imagination which he thinks many children have in at least as great a measure as himself but have no cause to develop it. So, secondly he believes the right external circumstances are necessary. In his own case this was being forced to take refuge in drawing by the cultural shock of coming to live in London. If he had been left happily at home in Cyprus he believes he might happily have become a car mechanic. Several of his friends there could draw just as well or better than he.

Third, application. Discipline. The ability to work completely alone all day and as hard as a job requires. All the things that youth generally dreads. Achilleos sees no alternative to hard work and practice and patient learning. He says art students cannot go to the pub or disco every night with their friends if they ever hope to become successful illustrators. Not only is discipline required to learn the necessary skills but even more is needed to be able to get jobs done in the available time.

All of which sounds rather grim and forbidding. Whether it is worth it may be judged by the work shown in this book and *Beauty and the Beast*.

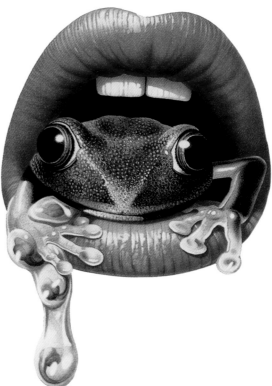

(top) CRETE LOVER 1983 52 × 76 cm. Editorial illustration.

Waterproof inks, gouache and airbrush on illustration board.

This picture hardly needs an explanation.

(above) FROG IN THROAT 1978 Editorial illustration. Collection D. Tate.

Waterproof inks, gouache and airbrush on illustration board.

(above) STRANGER ON THE SHORE 1982
77 × 51 cm.
Editorial illustration.

Waterproof inks, gouache, pastels and airbrush
on illustration board.

*This was for a story about a Robinson Crusoe-like man
stranded alone on a desert island until a slave galley
founders on the rocks and this lovely creature is washed
ashore.*

*The finished drawing of this showed much more
wreckage scatter around but I felt it wasn't necessary to
include it in the final painting.*

What does Achilleos make of the suggestion that as a freelance
illustrator he is not so far removed from his ideal of the hunter-gatherer,
given his context of London in the late Twentieth century and bearing in
mind that there is a similar insecurity about the future and a constant need
to find new quarry?

He agrees about the insecurity because he can never be sure from one
year to the next whether his work will still be in demand, but there is one
major difference. To be a hunter requires physical prowess, imagination
and patience; to be an illustrator requires only the last two qualities.
Physical activity is something he misses and remembers most vividly from
his childhood when he and his friends were all little hunter-gatherers
running about on Cyprus, fighting, hunting and fishing.

Finally, now he has come to the end of his second book, what does he
hope it will achieve?

His reply is diffident. He hopes it will give pleasure mainly, and he hopes
no-one will be offended by anything in it. This sometimes happens because,
he believes, some people take his pictures too seriously. To him they are
serious only to the extent that they are his work and not simply done for his
own pleasure, but they are rarely meant to be taken seriously by others. His
Fantasy work and pin-ups are for entertainment and to take them too
seriously is to misunderstand them. There is a more serious side to his
character which he hopes one day to express in his work but so far he has
revealed only glimpses of it.

MERRY CHRISTMAS 1979 68 × 48 cm.
Editorial illustration/greetings card.

Waterproof inks, gouache and airbrush on
illustration board.

This began life as an editorial illustration for **Men
Only***, then appeared in my calendar for December.
Now it is available as a greetings card from Ink Drop
Productions.*

(right) WATCH THE BIRDY 1982
86 × 56 cm. Editorial illustration/greetings card.

Ink-line, waterproof inks, gouache and airbrush
on illustration board.

*This was not done for a specific article. It was one of
those ideas locked away in a drawer which I took out
and worked on between jobs over a long time. I dated it
'82 but in fact it was not finished till 1983. Roger Watt
had no problem finding an article for it to illustrate.*

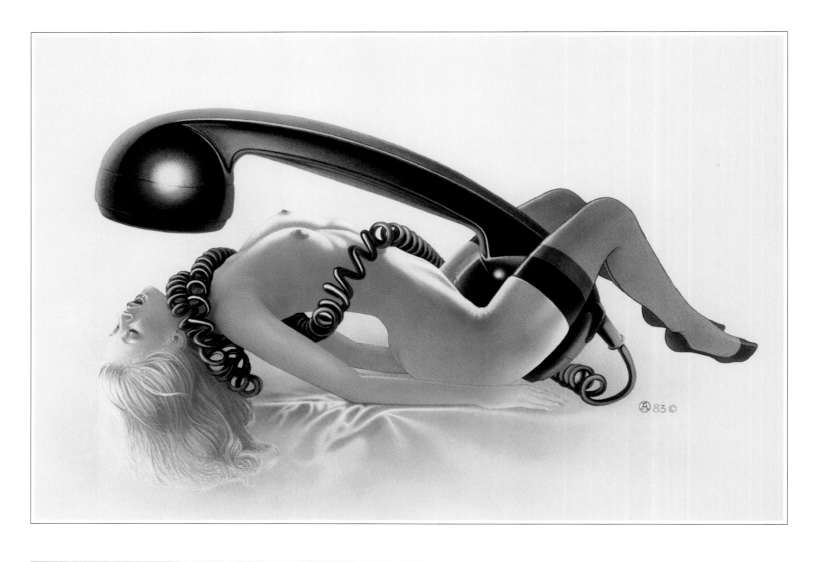

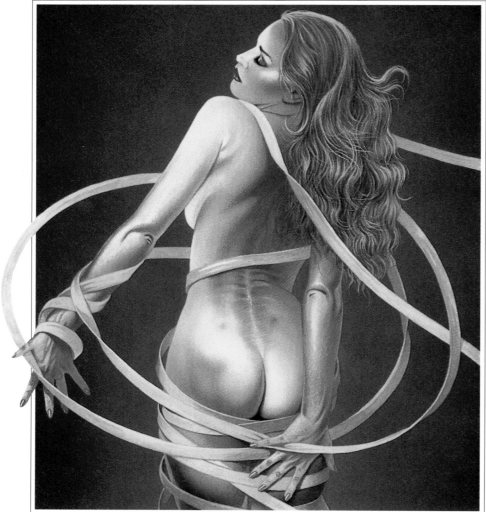

(above) EROTIC PHONE CALL 1983
69 × 50 cm. Editorial illustration.

Waterproof inks, gouache and airbrush on
illustration board.

(left) BREAKING FREE Detail 1982
76 × 53 cm. Editorial illustration.

Waterproof inks, gouache and airbrush on
illustration board.

*This design was made successful by the ribbon wrapped
around the figure as if it were a mummy.*

(right) EROTIC MEMOIRS 1982
65 × 38 cm. Editorial illustration.

Waterproof inks, gouache and airbrush on
illustration board.

*This illustrated an article about the memoirs of an upper-
class lady. For some reason a lot of people tend to turn it
the other way up.*

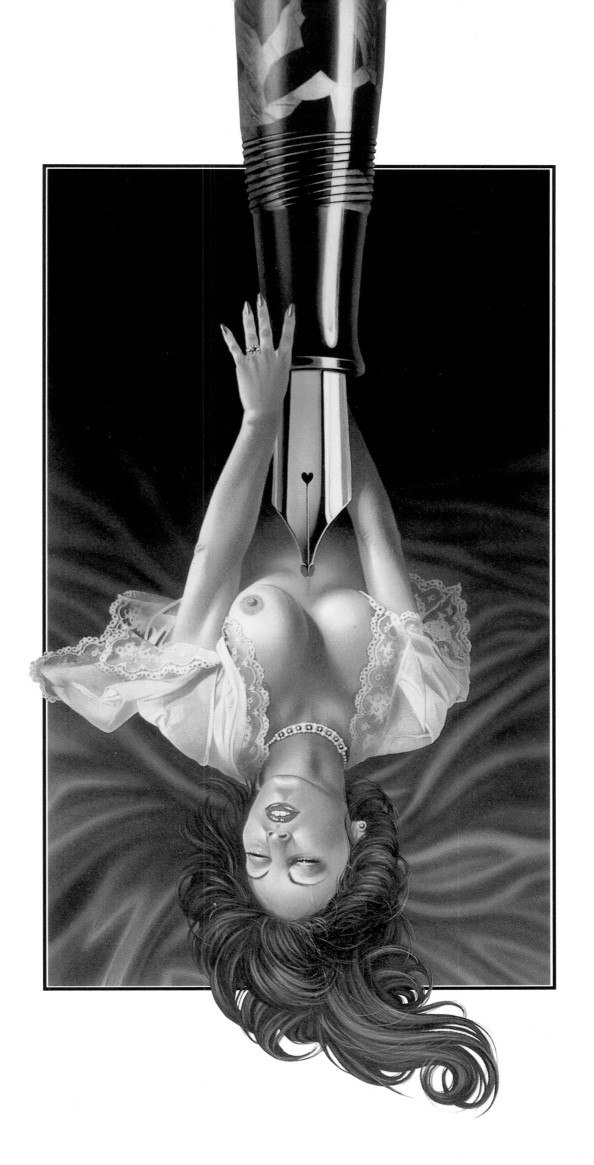

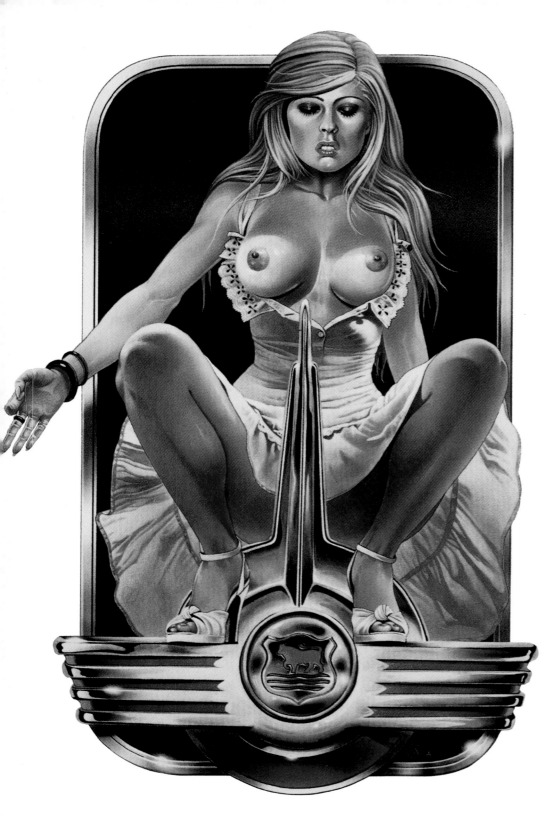

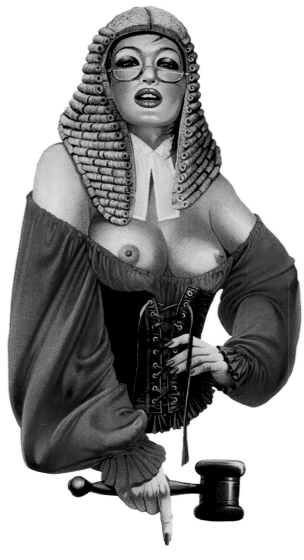

(above) THE JUDGE 1982 68 × 46 cm.
Editorial illustration. Collection A. Rosen.

Waterproof inks, gouache and airbrush on
illustration board.

(left) BACKSEAT YOGA 1977
Editorial illustration. Private collection USA.

Waterproof inks, gouache and airbrush on
illustration board.

*Those familiar with Morris Minors will recognise the
chrome badge which I borrowed off the Traveller I had
at the time to copy.*

(right) THE JOKER 1981 75 × 54 cm. Editorial
illustration. Private collection, Holland.

Waterproof inks, gouache and airbrush on
illustration board.

*This idea was prompted by a song '...the joker laughs
ha ha!' Given the opportunity I would like to design a
complete pack.*
 It has also appeared as a poster.

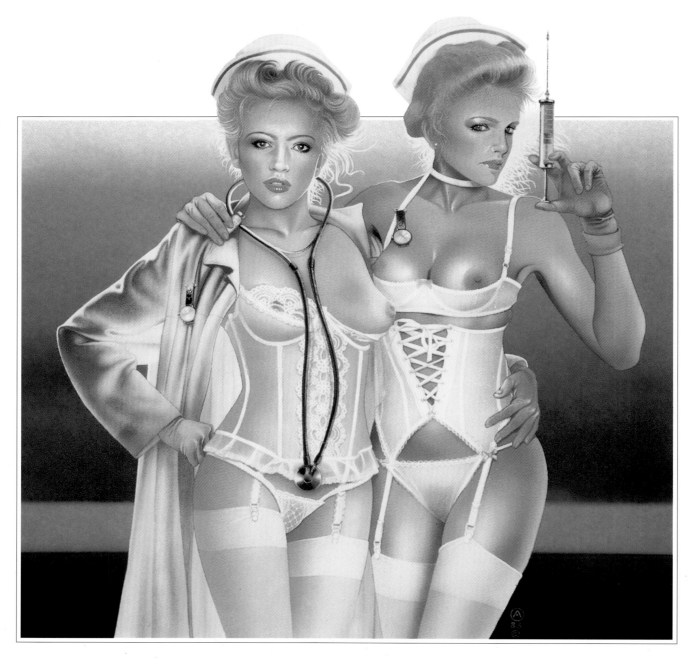

(above) PRIVATE MEDICINE 1983
60 × 55 cmm. Editorial illustration/greetings
card. Collection D. Tate UK.

Waterproof inks, gouache and airbrush on
illustration board.

(left) BANGKOK 1980 53 × 54 cm. Editorial
illustration.

Waterproof inks, gouache and airbrush on
illustration board.

*Here I tried to show the two faces of Bangkok, the
playground of the Far East.*

(right) BIKINI 1982 41 × 26 cm. Editorial
illustration.

Waterproof inks, gouache and airbrush on
illustration board.

No clever idea here, just a beautiful body.

(overleaf) THE MISTRESS 1978 68 × 44 cm.
Illustration for book cover.

Waterproof inks, gouache and airbrush on
illustration board.

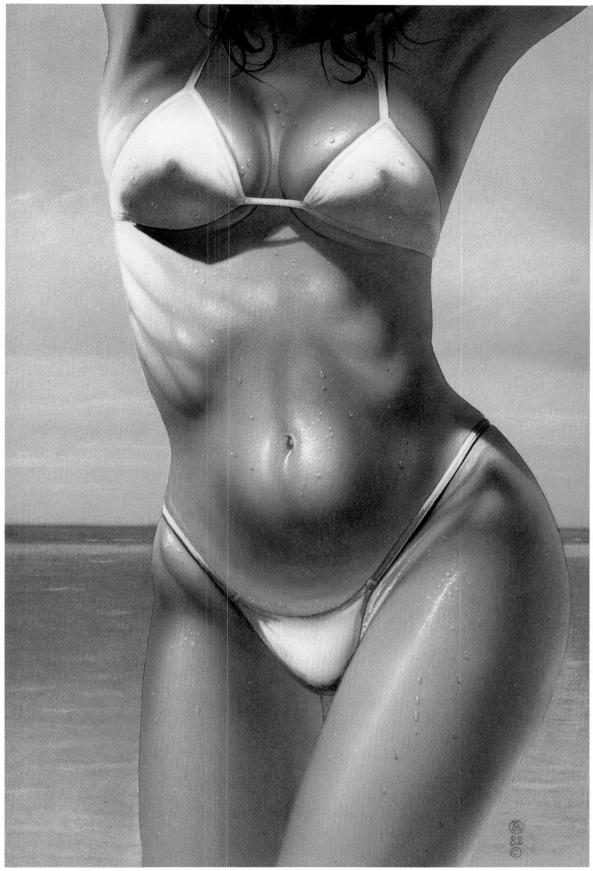

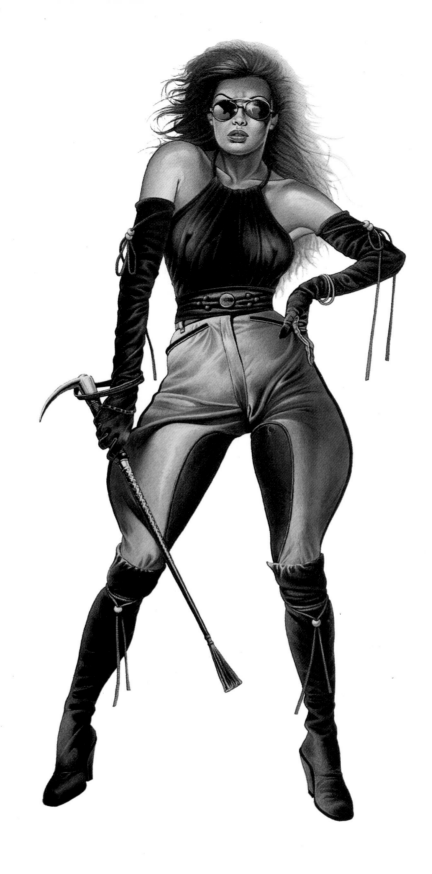

ACKNOWLEDGEMENTS

This book and my previous, BEAUTY AND THE BEAST, consist mainly of illustrations commissioned directly or otherwise by the following people whom I would like to take this opportunity to thank, for without their patronage this work would never have been created.

Steve Abbis, Dennis Barker, Roland Blunk, Brian Boyle, David Cox, Roger Dempsey, Phillipa Dickinson, Michael Gross, Ray Harryhausen, David Howe, Ian Hughes, Steve Jackson, Elizabeth Laczynska, Steve Lang, Ian Livingstone, Tim Metcalfe, Michael Moorcock, John Munday, Dom Rodi, Julian Senior, Ken Simms, Mike Souch, Roger Watt.

C.A.